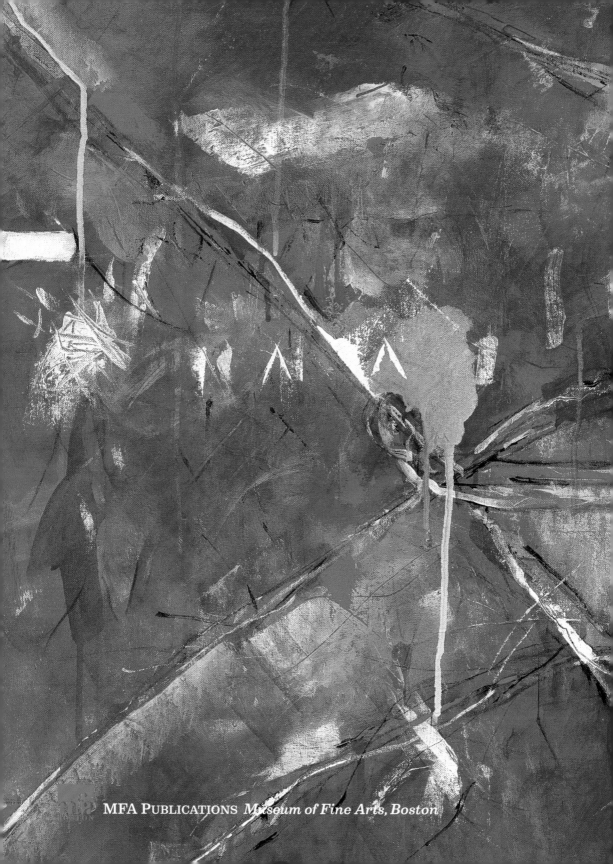

MFA PUBLICATIONS *Museum of Fine Arts, Boston*

MFA
HIGHLIGHTS native american art

Gerald W. R. Ward

Pamela A. Parmal

Michael Suing

Heather Hole

Jennifer Swope

Frontispiece: Detail from Rick Rivet,
String Game—2 (Kayaker), 2001 (p. 35)

MFA Publications
Museum of Fine Arts, Boston
465 Huntington Avenue
Boston, Massachusetts 02115
www.mfa.org/publications

Generous support for this publication was
provided by Arthur R. Hilsinger and
Barbara J. Janson.

© 2010 by Museum of Fine Arts, Boston
Library of Congress Control Number:
2009942111
ISBN 978-0-87846-751-8

All photographs are by the Photographic
Studios, Museum of Fine Arts, Boston,
unless noted otherwise.

Grateful acknowledgment is made to the
copyright holders for permission to
reproduce the following works:

Ansel Adams, *Cliff Palace, Mesa Verde
National Park, Colorado*, 1941, © 2009 The
Ansel Adams Publishing Rights Trust, The
Lane Collection

Aaron Leonard Freeland, *My Mother's
Uncle When He Was Young*, 2004,
© www.AaronFreeland.com 2005

Rick Rivet, *String Game—2 (Kayaker)*, 2001,
Copyright owned by Rick Rivet

Edited by Jodi Simpson
Copyedited by Dalia Geffen
Composition by Fran Presti-Fazio
Designed by Terry McAweeney
Produced by Jodi Simpson
Series design by Lucinda Hitchcock
Map by Mary Reilly, based on Michael G.
Johnson and Richard Hook, *Encyclopedia of
Native Tribes of North America* (1993; 3rd rev.
ed., Buffalo, NY: Firefly Books, 2007), 18–19

Printed and bound at CS Graphics PTE LTD,
Singapore

Trade distribution:
Distributed Art Publishers / D.A.P.
155 Sixth Avenue, 2nd floor
New York, New York 10013
Tel. 212 627 1999 Fax 212 627 9484

FIRST EDITION
Printed in Singapore
This book was printed on acid-free paper.

Contents

Director's Foreword 7

Acknowledgments 9

Native American Art and the Museum of Fine Arts, Boston 13
Gerald W. R. Ward

Note to the Reader 24

1. Native American Artists in the Contemporary Art World 27

2. Beginnings: The Ancient Southwest 49

3. The Southwest and Far West 65

4. Northeastern and Southeastern Woodlands 109

5. Plains, Prairie, and Plateau 131

6. The Northwest Coast, Arctic, and Subarctic 151

Map 175

Further Reading 177

Figure Illustrations 183

Index 187

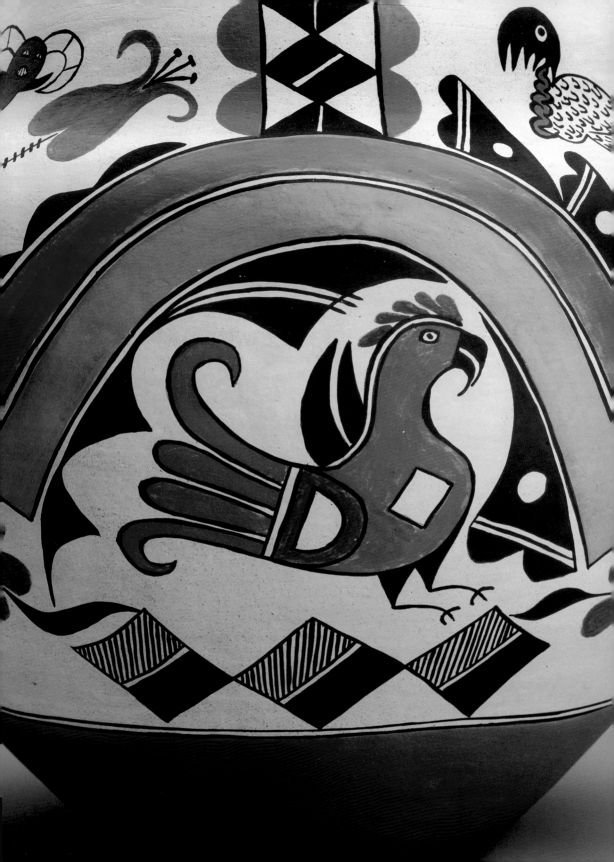

Director's Foreword

Art is for everyone, and it is in this spirit that the MFA Highlights series was conceived. The series introduces some of the greatest works of art in a manner that is both approachable and stimulating. Each volume focuses on an individual collection, allowing fascinating themes—both visual and textual—to emerge. We aim, over time, to represent every one of the Museum's major collections in the Highlights series, thus forming a library that will be a wonderful resource for the understanding and enjoyment of world art.

It is our goal to make the Museum's artworks accessible by every means possible. We hope that each volume of MFA Highlights will help you to know and understand our encyclopedic collections and to make your own discoveries among their riches.

Malcolm Rogers
Ann and Graham Gund Director
Museum of Fine Arts, Boston

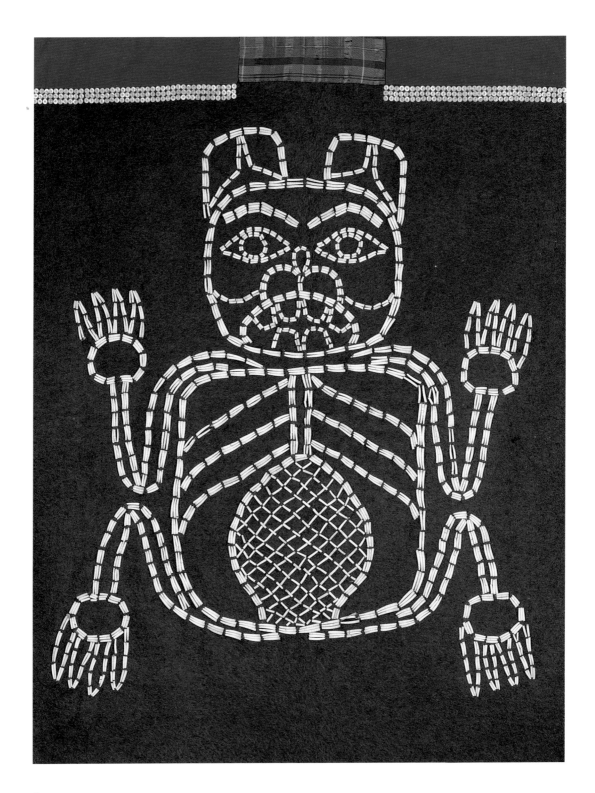

Acknowledgments

We are especially grateful to Malcolm Rogers, Ann and Graham Gund Director, for his vision in creating a series of "highlights" books featuring the Museum's diverse collection. He, along with Katie Getchell, deputy director, curatorial, have given their enthusiastic support to this endeavor.

This book has been a cooperative effort among five Museum curatorial departments as well as many other members of the Museum staff. My coauthors took time from their busy schedules to make valuable contributions to this book: Pamela A. Parmal, David and Roberta Logie Curator of Textile and Fashion Arts, wrote the substantial number of entries on the objects in her care; Michael Suing, curatorial research fellow in the Department of Musical Instruments, prepared the material on the flutes, rattles, drum, and other musical instruments; Heather Hole, assistant curator of paintings in the Department of Art of the Americas, contributed entries on the paintings and works on paper; and Jennifer Swope, Department of Textiles and Fashion Arts, wrote the entry on the important Wendat (Huron) moccasins.

Each of us benefited from the assistance of many people within our respective departments. In Art of the Americas, we are most grateful for the support of Elliot Bostwick Davis, John Moors Cabot Chair; Nonie Gadsden, Carolyn and Peter Lynch Curator of Decorative Arts and Sculpture; Kelly H. L'Ecuyer, Ellyn McColgan Curator of Decorative Arts and Sculpture; Dennis Carr; and Michelle Finamore. Toni Pullman, Katie DeMarsh, Erin McCutcheon, and Danielle Kachapis cheerfully offered help at every stage, as did our paintings colleagues Erica Hirshler, Croll Senior Curator of Paintings; Karen Quinn, Kristin and Roger Servison Curator of Paintings; Cody Hartley; and Janet Comey.

Darcy Kuronen, curator, Musical Instruments, was supportive of this project throughout its gestation, as were Clifford Ackley, Ruth and Carl J. Shapiro Curator of Prints and Drawings, and Elizabeth Mitchell in the Department of Prints, Drawings, and Photographs. Yvonne Markowitz, Rita J. Kaplan and Susan B. Kaplan Curator of Jewelry, was helpful in areas of her expertise. Edward Saywell,

William Stover, and Winona Packer in the Department of Contemporary Art and MFA Programs graciously allowed us to write about paintings that officially are in their domain.

Many staff members in the former Department of American Decorative Arts and Sculpture (1971–99) collected objects and conducted research that was vital in the preparation of this volume. Jonathan L. Fairbanks, now Katharine Lane Weems Curator Emeritus, renewed the Museum's interest in Native American art in the 1970s and pursued it throughout his tenure. Edward S. Cooke, Jr., Jeannine Falino, Anne Dort Moffett, Rebecca Reynolds, and Rachel Monfredo also made valuable contributions to the Museum's holdings and files that have been drawn on extensively here. It is a special pleasure to acknowledge the efforts of Linda Foss Nichols, who during the 1990s served as a strong voice within the Museum for Native American affairs. Along with Linda Thomas, then the Museum's registrar, Linda spearheaded the MFA's initial compliance with the Native American Graves Protection and Repatriation Act. Linda was also the curator for the major exhibition "Voice of Mother Earth," shown at our sister museum in Nagoya, Japan. Her research on the collection as a whole has proven to be invaluable, and her unpublished paper on collecting Native American art at the MFA provided much of the background for this book's introduction.

A number of scholars, artists, and others have contributed to our efforts. We were fortunate to have Joe Horse Capture (A'ani [Gros Ventre]), associate curator of African, Oceanic and Native American art at the Minneapolis Institute of Arts, as a reader for our manuscript. Joe made many improvements to our drafts, helped us to better organize the book, and was a wise source of counsel on many issues large and small. While we profited greatly from Joe's advice, we take full responsibility for any mistakes that may remain.

Others who have been most helpful include Bill Holm, University of Washington; Judy Thompson, Canadian Museum of Civilization; Ruth B. Phillips, Carleton University; Solange Skinner; Douglas Deihl, Skinner Auctioneers and Appraisers; and Joe David. Barbara McLean Ward read the manuscript in its entirety and provided many useful comments and corrections.

All our work has reached fruition through the efforts of MFA Publications, including Mark Polizzotti; Emiko Usui; and Terry McAweeney, who designed this

volume. In particular, we are grateful to Jodi Simpson for her careful and skill-ful editing and to Dalia Geffen for her copyediting. The beautiful photographs by John Woolf, Dave Mathews, Mike Gould, and Greg Heins present this diverse body of material to its best advantage.

Any project at the Museum involving works of art is heavily indebted to the talented body of conservators and collections care staff, including Matthew Siegal, Mei-An Tsu, Meredith Montague, Joel Thompson, Alison Murphy, and Masumi Kataoka.

Julia McCarthy, manager of collections documentation, has helped (as always) in many ways. Patricia Doyle and David Blackman in the Museum's Development department have also played important roles.

We are indebted to all the donors whose gifts of works of art or funds to pur-chase objects have shaped this volume: in particular, Ruth and Bert Malenka, Arthur and Teri Beale, James and the late Margie Krebs, Dale and Doug Ander-son, Tim Phillips, and various anonymous collectors. The legacy of many others, dating back to the 1870s, is reflected in the credit lines attached to each object's description. Although their names are not repeated here, we are no less grateful to these pioneering donors.

Finally, it is a pleasure to acknowledge with gratitude the significant support of Arthur R. Hilsinger and Barbara J. Janson, who made the publication of this book possible. We hope that their love for Native American art is adequately expressed in this volume. By also establishing the Hilsinger Janson Fund for Native American Art in 2008, they have ensured that the MFA will, in perpetuity, be able to research and display Native American works of art and continue to publish related materials.

Gerald W. R. Ward
Katharine Lane Weems Senior Curator of
American Decorative Arts and Sculpture

Native American Art and the Museum of Fine Arts, Boston
Gerald W. R. Ward

The story of collecting Native American art at the Museum of Fine Arts, Boston, is a tripartite history of birth, death, and resurrection. Initially very much a part of the new Museum's purview in the last quarter of the nineteenth century, by the early twentieth century Native American art had lost its place within the pantheon of Art favored within the Museum's halls. Between World War I and the 1970s, the presence of Native American art within the MFA was nearly, if not completely, nonexistent. Few objects were acquired, and those works still in the collection—those that had not been lent to natural history museums or sold—remained slumbering in storage. Following changes in society as a whole, that situation reversed itself. In the 1970s, and with an accelerated pace from the 1980s until today, Native American art regained a place of prominence within the Museum as an important artistic tradition worthy of the institution's resources in terms of gallery space and acquisitions.

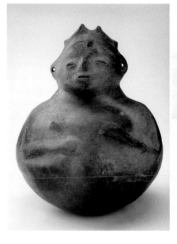

fig. 1. **Effigy, Mississippian Tradition,** Diehlstaat, Missouri, 900–1400.

Although the Museum's collecting of Native American art followed its own trajectory, its experience, in general, mirrors the paradigm shifts that have occurred since the late nineteenth century. The Museum's acquisitions of Native American art began in 1877, the year after the Museum opened. The objects were acquired with at least two main "strategies" in mind, although these were not formally articulated in any detail. Initially, American Indian materials were added to the collection—usually as gifts but on at least one occasion as a purchase with the Museum's perpetually limited funds—as specimens representing both ancient and threatened cultures.[1] This must have been the reason behind the gifts of a substantial body of pottery from the Mound Builders' culture in 1877 and in 1895. In 1877, Mrs. Gardner Brewer and Miss Caroline A. Brewer (later Mrs. Arthur Croft) presented to the Museum their large collection of thousand-year-old Mississippian Tradition ceramics recovered in an archaeological excavation near Diehlstaat, Missouri. The Brewer materials were joined in 1895 by a group of related objects, including a small effigy (fig. 1), also excavated at Diehlstaat,

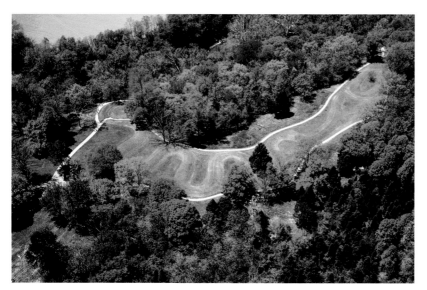

fig. 2. **Aerial view of Serpent Mound, Adams County, Ohio.**

given by Mr. and Mrs. George Washington Wales, major ceramic collectors of the period as well as Museum benefactors. This effigy, like the others that came from the Brewers and Waleses, is a modest example of the great Mississippian Tradition culture that occupied much of the American Southeast, Midwest, and adjacent territories from about 700 until the time of European contact in the sixteenth century. The mysterious mounds these ancient peoples created, such as Serpent Mound in Adams County, Ohio, nearly a quarter of a mile long, dotted the American landscape (fig. 2). Cahokia, near Saint Louis, their most monumental achievement, was a large city highlighted by the Monk's Mound, an earth pyramid that towered some twenty-eight meters (ninety-two feet) high.

The Brewers' and Waleses' objects were displayed comfortably in the Museum's original building in Copley Square. They were shown alongside ceramics from Asia (especially Japan), from the ancient Greco-Roman world, and from Europe, all of which were collecting priorities at a time when the MFA was attempting to establish itself as a major, comprehensive museum with diverse collections. As handmade objects, Native American works of art appealed to the Arts and Crafts movement's romantic fondness for preindustrial objects, and they may also have been regarded as appropriate sources of motifs and designs for industrial designers, which many museums of the period attempted to provide. For several decades, following most other institutions of the late nineteenth century, the Museum continued to collect Native American objects in this ethnographic or anthropological fashion, largely as cultural speci-

mens that nevertheless were, without question, worthy of being represented in an art museum.

These acquisitions of ancient as well as contemporary American Indian art were seemingly motivated not only by the intrinsic qualities of the objects, but also by a desire to gather historical evidence of a civilization that was perceived (with good reason) as dying in the 1870s and 1880s. By that time, centuries of official and unofficial neglect and hostility by Anglo-European settlers and their governments, exacerbated by the transmission of disease, had threatened the very existence of many nations of Native Americans, who were fighting for their lives. The Museum's Copley Square building opened its doors to the public in July 1876 only a few days after Custer's demise at the hands of the Lakota (Sioux) and Cheyenne at the Battle of Greasy Grass Creek (or the Battle of Little Bighorn). The United States Army's dreadful massacre of the Lakota at Wounded Knee, South Dakota, widely viewed as signaling the end of the Indian Wars, happened in late 1890. Ethnographers and anthropologists—many of them from Boston, some with the support of Boston philanthropists such as Mary Hemenway (1820–1894) —traveled to the Southwest in the late nineteenth century to record and preserve the customs and culture of the A:shiwi (Zuni), Hopi, and other American Indians of this vast, arid region. The extension of railroad service to New Mexico about a decade after the completion of the transcontinental railroad in 1869 facilitated access to the Southwest from the East.

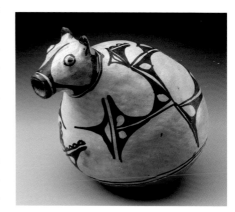

fig. 3. **Effigy pitcher, Santo Domingo** Pueblo, New Mexico, 1870s.

The first then-contemporary Indian object the Museum acquired was a clay effigy from Santo Domingo Pueblo in New Mexico (fig. 3), given in 1879 by General Charles Greely Loring (1828–1902), the Museum's curator. General Loring also used the Museum's Everett Fund to buy a collection of fifteen A:shiwi ceramics in 1887 (fig. 4) that had been amassed by Clarence Pullen (1850–1902). A railroad engineer originally from Maine, Pullen had served as the surveyor general of New Mexico in 1884–85 and amassed his collection while living there. He returned to New England and enjoyed a second career as an author and public speaker. Pullen often addressed Native American subjects in his presentations, using his collection to illustrate his articles and lectures.

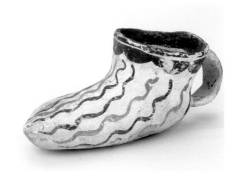

fig. 4. **Moccasin vessel, Zuni Pueblo, New** Mexico, about 1880.

These early acquisitions were joined by others, often given by collectors who are little known today. For example, bows and arrows from California Indians came from a Dr. H. L. Faxon in 1881. The Reverend Herbert Probert of Damariscotta, Maine, provided a cluster of Plains materials gathered during his stay as a Congregational missionary in Wyoming in the early 1880s, when he was posted to the First Congregational Church in Sheridan. In a memoir of his travels, Probert expressed a sentiment that may have been characteristic of the attitudes and methods of these early collectors. He noted, "I have wandered among the Indians of Wyoming and Montana, I have visited them in their 'teepees' in order to obtain interesting 'curios' from them."[2] Works from Alaska and the Northwest Coast were given by Miss Sarah M. Spooner and as a bequest from Mrs. John H. Thorndike, all gathered as "curios" from faraway exotic lands. Starting in 1898 and continuing into the early twentieth century, the omnivorous collector and Museum benefactor Denman Waldo Ross (1853–1935) provided an important body of Southwest textiles; his gift may have prompted the Museum to make a rare purchase of a "Germantown eyedazzler" Diné (Navajo) textile in 1899 (fig. 5). In that same year, Mrs. George Linder gave a significant group of sixteen baskets, mainly from California.

Such donor gifts continued to drive the Museum's acquisition of Native American art during its first half-century. For example, in 1912 John Ware Willard (great-grandson of the innovative early New England clockmaker Simon Willard) gave an outstanding group of Diné (Navajo) textiles, and then in 1916 architect George F. Meacham (1831–1917) donated a noteworthy collection of forty-three baskets. The large collection of Francis W. Galpin, a pioneering collector of historical musical instruments, included several Native American examples. William Lindsey purchased the Galpin collection and gave it to the Museum in 1917 as a memorial to his daughter and her husband, who had been killed during the German attack on the USS *Lusitania* the year before, to be known as the Leslie Lindsey Mason Collection.

But even as these gifts were being accepted, acknowledged, and lauded, American Indian objects had not yet made the transition from "specimen" to "work of art." In the early twentieth century, the MFA dispersed portions of its Native American collection. Some objects were sold, but many were given to or put on deposit (long-term loan) at other New England institutions with ethnographic collections, including the Peabody Museum at Harvard University and the predecessor of what is now part of the Peabody Essex Museum in Salem, Massachusetts. (Those that had been lent were retrieved in the 1990s.) Housekeeping may have been the motive behind some of these actions, as curators weeded out

objects they viewed as "duplicates" and as preparations were made to leave the over-crowded building in Copley Square for more spacious quarters.

Ideological reasons were also a part of this shift in emphasis. The Museum completed its packing and moved to its current site on Huntington Avenue, which opened to the public in 1909. No gallery for the Mound Builders or Native American art of any kind was included in Guy Lowell's plans for the new building. Ironically, within a few years, Cyrus Dallin's *Appeal to the Great Spirit*, a sculptural tribute to the Lakota, would be displayed in front of the Museum's entrance, where it remains today. To the attentive observer, however, its silent presence under-lined the fact that the MFA, in common with other institutions, was following a different path. Native American art was not consid-ered a significant part of the story of Ameri-can art, which was interpreted as starting with European (particularly English) colo-

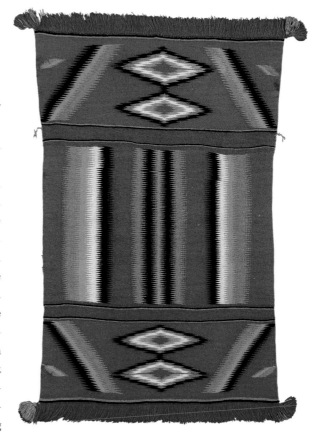

fig. 5. **Saddle blanket, Diné (Navajo), probably Arizona, about** 1895.

nization. Just as the government for much of the twentieth century attempted to erase the ethnic heritage of Native Americans and to enforce a system of assim-ilation upon them, the Museum presented a view of Western civilization in which Native Americans did not play a role; their story was relegated to natural history museums, understood as examples of "primitive" cultures outside the civilizing curve.

From the 1920s through the 1960s, the Museum acquired almost no Native American objects, aside from about a dozen textiles that entered the institution as part of the larger Elizabeth Day McCormick Collection and a few others as gifts from various donors. Native American art played no role in the new Deco-rative Arts Wing, which opened in 1928. A strong Anglo-European stance held sway in this large wing, which emphasized the glories of the art and architecture of colonial- and federal-period New England and of Europe, especially France and England. Through the display of period rooms, paintings, furniture, silver, and other objects, Museum visitors—new immigrants, schoolchildren, and oth-

ers—were exposed to the Western canon, which would help to acculturate them into the American way of life.[3]

During the 1960s, however, the American Indian Movement and associated activities forced a reassessment of the generally deplorable treatment of Native Americans and their role in society as a whole. The decade also witnessed the questioning of many long-established attitudes and boundaries in all aspects of American political, social, and cultural life and encouraged a tolerance for diversity. These transformative developments created a climate in which the Museum could again consider Native American art as a significant part of America's artistic heritage.

In 1971, as part of the celebration of the Museum's centennial, the new Department of American Decorative Arts and Sculpture was established under the curatorship of Jonathan L. Fairbanks. This new department's vigorous collecting quickly expanded the definition of "decorative arts" by focusing attention on objects made in the nineteenth and twentieth centuries (in addition to the seventeenth and eighteenth centuries), from all sections of the country (as well as from the East Coast), and in all kinds of materials (over and above the traditional strengths in furniture and silver). A renewed interest in Native American art was a part of this broader and deeper understanding of American decorative arts. In little more than its first decade, the department organized two major exhibitions in which substantial numbers of Indian objects were displayed and interpreted alongside American and Anglo-European objects of the same era.[4] In 1973–74, the Museum hosted a major exhibition entitled "The Far North: 2000 Years of American Eskimo and Indian Art," organized by the National Gallery of Art and the Amon Carter Museum, and a decade later served as a venue for "Circles of the World," a presentation of the traditional arts of the Plains Indians organized by the Denver Art Museum.

With support from an anonymous donor, Fairbanks traveled to the Southwest in 1984, and again in 1985, to research and acquire Puebloan ceramics for the Museum. These trips marked the beginning of the department's ongoing goal of collecting Southwest pottery from ancient, historic, and contemporary times, as well as the work of each pueblo, and signaled a renewal of collecting interest throughout the Museum. In 1984, the Department of Musical Instruments purchased a dozen works pertinent to its holdings and the studio potter Laura F. Andreson (1902–1999) gave twenty-eight pieces of Southwest pottery from her own collection. Andreson's example would be followed later by the metalsmith Margret Craver Withers, who over a period of several years similarly donated a substantial body of American Indian material gathered during her travels.[5] The

gifts from Andreson and Withers underscored a renewed awareness of the aesthetic qualities of Native American art by twentieth-century studio artists.

In 1988 Linda Foss Nichols joined the Museum staff and quickly became another strong advocate for Native American art, consistently supporting the acquisition of quality objects for the collection, many of which are included in this volume. In 2000 the Museum organized its first (and to date only) exhibition devoted solely to Native American art. Curated by Foss Nichols, "Voice of Mother Earth: Art of the Puebloan Peoples of the American Southwest" was shown at the MFA's sister institution in Nagoya, Japan (fig. 6).[6]

Since the early 1990s, the Museum has made an effort to push the collection beyond its focus on Southwest pottery and other objects and to represent a wider range of American Indian art. For example, in 1991 and 1992, Louise C. Carpenter donated about two dozen objects in honor of her parents, including several important examples of Plains clothing and beadwork. In 1993 the Museum was fortunate to acquire as gifts three important ledger books, including two attributed to the Kiowa artist Haungooah (Silver Horn) (fig. 7; see also pp. 148–49) and one by an as-yet-unidentified artist.

A few years later, in 1997 and 1998, the support of an anonymous donor made it possible for the Museum to acquire major works from the Northwest Coast—a chief's chest and potlatch figure—and more recently that same donor supported the purchase of a Chilkat dancing blanket (see pp. 160, 161, and 157). In 2005 Dale and Doug Anderson gave a significant cluster of Northwest Coast materials, and Museum funds were used recently to purchase a Haida button

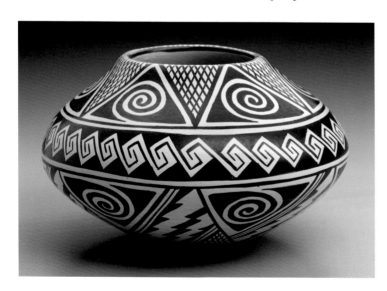

fig. 6. **Helen T. Naha**
(Hopi, 1922–1993), jar,
Polacca Village, Hopi,
Arizona, 1985.

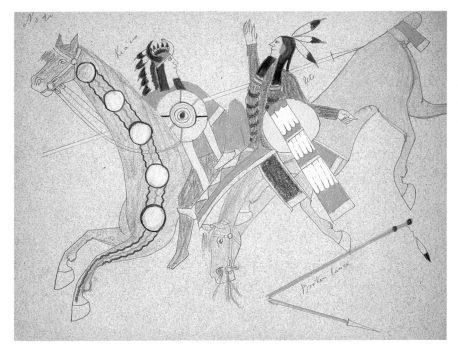

blanket (see p. 156). In 2002 the noted French anthropologist Solange Skinner gave five masks and other objects made by the Native people of Greenland that had been collected by her late husband, Governor Carlton Skinner.

The Museum has also focused on Native American art through time as well as across space. In 2003 the Andersons facilitated the acquisition of the Museum's first Native American decorative art object in a contemporary, nontraditional mode: *Raven Steals the Moon*, a glass work by Preston Singletary (see p. 41). The importance of contemporary Indian art has also been emphasized by James and the late Margie Krebs, whose gifts since 2005 of pottery (fig. 8), works on paper, and paintings by numerous Native American artists (represented only in part in this book) have continued to press the Museum to focus on this exciting and important avenue of artistic expression and all the various themes and issues that it embodies and addresses.

The collection continues to grow in new directions. In 2008 Ruth and Bert Malenka, major collectors of Southwest pottery, and their sons gave a core collection of early Diné silver jewelry, augmenting their earlier gifts of several Southwest ceramic vessels. That same year, Tim Phillips gave three important finger-woven sashes and an outstanding Lenape (Delaware) shot pouch and powder horn (see pp. 116–18). Arthur Beale (the retired head of conservation at the

Museum) and Teri Hensick, themselves significant collectors of Indian baskets, pottery, and objects of all kinds, enriched the collection through their gift of a Lataxat (Klikitat) basket, a type not previously represented in the collection, as well as a Tohono O'odham (Papago) basket (see pp. 147, 106). The generosity of donors such as these and many others will continue to shape and transform the collection, in time creating an even more balanced presentation. With the founding of the Hilsinger Janson Fund for Native American Art by Arthur R. Hilsinger and Barbara J. Janson in 2008, the first such dedicated fund in the Museum's history, the Museum no longer has to rely exclusively on gifts to expand its Native American collection and support related initiatives. An additional gift from these donors has made this book possible, and their fund will underwrite a variety of future endeavors in this field.

One scholar has observed that attitudes toward Native American art tend to "typically reflect two parallel philosophies—ethnographic description and voyeur celebration," each of which inhibits a "holistic" understanding of the material.[7] Throughout its long history, the Museum has probably been guilty, along with many other institutions, of following both philosophies. Yet an encyclopedic art museum provides an environment in which Native American art can be displayed and interpreted in a polyvalent manner, as one of many branches of material life best seen in comparison and contrast with other objects from the

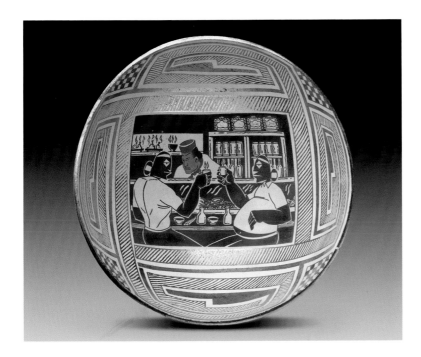

fig. 8. **Diego Romero** (Cochiti, born in 1964), *Mok a sushi* bowl, Santa Fe, New Mexico, 1999.

ancient world to contemporary times, as well as in conjunction with a wide range of material of its own specific type.

The MFA's new Art of the Americas Wing, scheduled to open in late 2010, will contain a significant gallery devoted to Native American art—its first dedicated space in more than a century. This space is adjacent to galleries in which the Museum's important collections of the art of the indigenous peoples from Central and South America will be displayed. Some contemporary works will also be on view in the Linde Family Wing for Contemporary Art. These developments will allow the arts of Native Americans in all media and from all periods to be presented to the Museum's many visitors for generations to come as a significant artistic tradition to be seen, enjoyed, and studied, both as a unique entity and in the context of other artistic expressions from across the world.

1. See Shepard Krech III and Barbara A. Hail, *Collecting Native America, 1870–1960* (Washington, DC: Smithsonian Institution Press, 1999), for case studies of the motivations and intentions of several early collectors.

2. Rev. Herbert Probert, *Life and Scenes in the Congo* (Philadelphia: American Baptist Publication Society, 1889), 165. Probert also gave to the MFA some objects he gathered during his time in the Congo.

3. As an exception that perhaps proves the rule, the Museum hosted a large show of more than six hundred Native American objects from thirty-nine public and private lenders for about two weeks in the summer of 1932. Held from May 29 to June 15, this traveling "Exposition of Indian Tribal Arts" was circulated by the College Art Association.

4. These exhibitions were "Frontier America: The Far West" (1975) and "New England Begins: The Seventeenth Century" (1982), each accompanied by a significant catalogue. "Frontier America" was accompanied by a concurrent exhibition of Diné (Navajo) rugs. "New England Begins" was particularly groundbreaking in its inclusion of Native objects alongside Anglo-American relics of the "Pilgrim century."

5. For a history of the department, see Jonathan L. Fairbanks, *Collecting American Decorative Arts and Sculpture, 1971–1991*, exh. cat. (Boston: Museum of Fine Arts, 1991), 7–19. Three display cases of American Indian ceramics were included in the exhibition accompanying this catalogue, and the department also arranged a number of small installations in its galleries and corridors in the 1990s and in the first years of the twenty-first century.

6. This exhibition, accompanied by a substantial dual-language catalogue, contained 121 objects, principally pottery from ancient times to the present, but also musical instruments, jewelry, baskets, and other Southwest objects from the Museum and two private collections.

7. Nancy Marie Mithlo, "Lost O'Keeffes/Modern Primitives: The Culture of Native American Art," in *Reservation X*, ed. Gerald McMaster (Seattle: University of Washington Press and Canadian Museum of Civilization, 1998), 57.

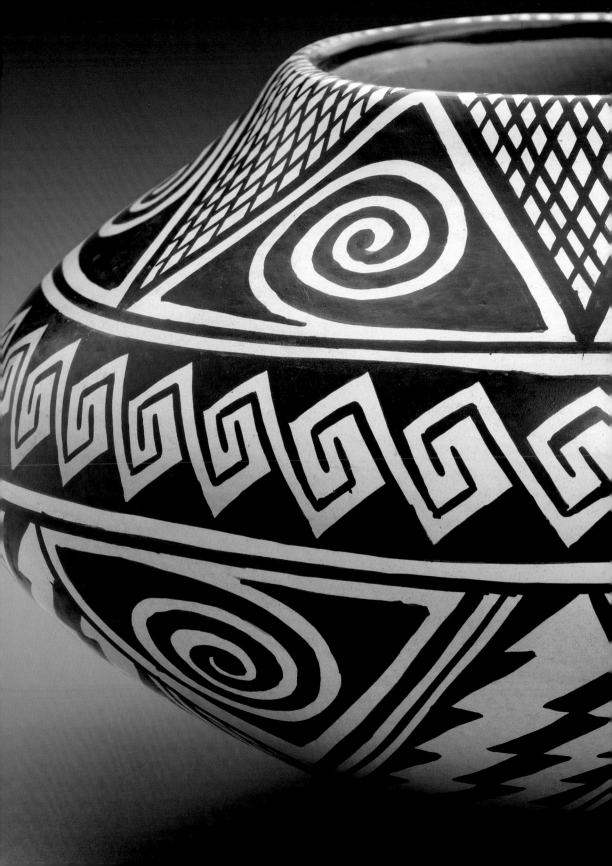

Note to the Reader

About one hundred highlights of Native North American works of art in the Museum's collection, selected from more than six hundred, are presented in this volume. The Museum, as detailed in the introduction, has acquired this material, principally as gifts, since 1877. Today it is collected and cared for by five curatorial departments: Art of the Americas; Textile and Fashion Arts; Musical Instruments; Contemporary Art; and Prints, Drawings, and Photographs. Information about all of the Museum's Native American holdings can be obtained through the collections database, available at www.mfa.org.

Throughout this book, we have used the terms "Native American," "Native," and "American Indian" interchangeably; we understand their shortcomings as labels for a very disparate body of people, but we also recognize their usefulness in a general discussion. When referring to individual nations of Native Americans and the First Peoples of Canada, we have attempted to use the name currently preferred by the specific group, followed (in parentheses) by the name that is perhaps used in more common parlance: for example, Diné (Navajo), A:shiwi (Zuni), and Wendat (Huron). For these designations and their spellings, which can be found in the literature in often bewildering variety, we have been guided by the thesaurus used for the collections database of the National Museum of the American Indian in Washington, D.C., available on their collections search page at www.nmai.si.edu. We have also used, when appropriate and known, both Native and Anglo names for individual artists and for specific objects.

The discussion of individual works of art in this book are based largely on material found in each object's data file in the relevant Museum department, with additional information derived from the sources cited in the bibliography. Direct quotations, unless noted otherwise within the text, are taken from documents housed within the object's file.

Although the works of art included here can be sorted in a variety of ways—by material or date, for example—we have elected to organize them into six the-

matic sections, each preceded by a short essay, to provide the general reader with an introduction to the richness of Native American art across both time and space, from the ancient world to the contemporary scene, and from across the North American continent. In this arrangement, the interrelatedness of objects created within a given region stands out, as well as some indication of elements of change within various cultural traditions.

Although their art is the oldest produced on the North American continent, Native Americans continue to create works of art in a variety of styles. The small group of contemporary works from the late twentieth and early twenty-first centuries that opens the book demonstrates the ongoing vitality and contributions to current American art by Native Americans, who often are regarded solely from a historical point of view. The second chapter moves back toward the beginnings of Native American art and contains ancient ceramics from the American Southwest, indicating the long presence of Native Americans on the land. Four succeeding chapters provide a survey of Native American art from different regions, principally from the nineteenth and twentieth centuries, including, on occasion, works in a traditional mode fashioned by living artists who pride themselves on carrying forward the traditions of their ancestors. These chapters, arranged by general cultural area, include a substantial selection of works from the Southwest—where connections with the ancient past are particularly strong—followed by sections devoted to objects from the peoples of the Northeastern and Southeastern Woodlands, the Plains, and the Northwest Pacific Coast. Although some of these works were made for Native use, many reflect the interaction of Native Americans with other cultures and demonstrate a mastery of new materials and techniques in weaving, silversmithing, beadwork, and other crafts. All six chapters contain many outstanding objects but provide a suggestive rather than comprehensive survey of the wide panorama of art created by Native Americans.

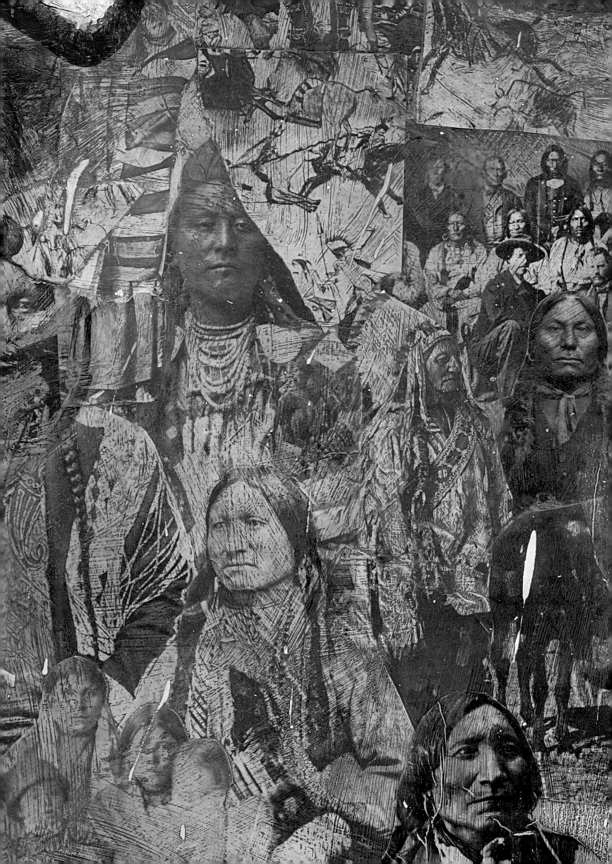

Native American Artists in the Contemporary Art World

Continuity and change are central themes in the story of Native American art. Throughout history, Native American works of art have been shaped by trade and by contact with other people—not only with the advancing waves of Anglo-Europeans but also through interactions among the numerous cultural groups gathered under the umbrella term "Native American." Most contemporary American Indian artists honor their heritage. Some, while adapting to new conditions, still largely work in what have become traditional American Indian ways; these artists are represented elsewhere in this volume. The following small group of works, however, demonstrates the varied response of Native American artists to the contemporary art movements of the late twentieth and early twenty-first centuries. These individuals, while recognizing their legacy, simultaneously strive to participate and establish themselves in the wider world of contemporary art—a new type of interaction that has affected the materials, techniques, and content of Native American art.

Historically, mechanical and artistic knowledge was transmitted among Native Americans through family lines, with techniques and skills passing from generation to generation through teaching and observation in a manner akin to the more formal bonds of indentured apprenticeships. By the early twentieth century, however, many Native Americans, in common with other aspiring artists, began to receive training in the Anglo-European canon of painting and sculpture, as well as in ceramics, metalwork, and other media, in colleges, universities, and art schools. Easel painting, for instance, was taught at the Santa Fe Indian School, starting in the early twentieth century. The Institute of American Indian Arts (IAIA), a later incarnation of the same evolving institution, has been a principal source of formal education in the arts since its founding in 1962, during the Kennedy administration. Allan Houser (1914–1994), who was among the first faculty members at the IAIA, would become perhaps the most widely recognized and acclaimed Native American sculptor and painter in the United

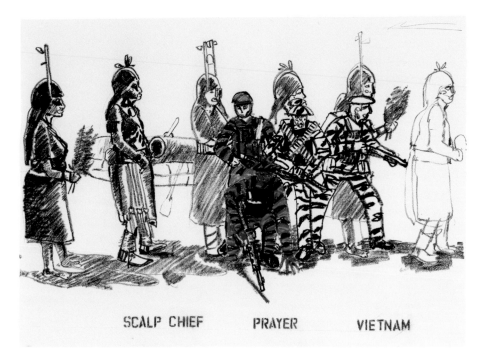

SCALP CHIEF PRAYER VIETNAM

fig. 9. **Mateo Romero** (Cochiti, born in 1966), *Scalp Chief/Prayer/Vietnam*, 1998.

States. Some four thousand students have graduated from the IAIA as of this writing, and many, including Aaron Freeland and other alumni represented in this book, have gone on to establish varied and distinguished careers in the arts.

Issues of voice, identity, and place have concerned many artists in the late twentieth and early twenty-first century but have unique resonance for Native Americans. The late 1960s and the 1970s were a crucial time in the modern history of Native Americans as a whole. The American Indian Movement (AIM), founded in 1968, aimed to reassess longstanding government policies of discrimination and inequities in the lives of Native Americans. In 1969 college students reclaimed the island prison of Alcatraz as Indian territory, and in 1972 more militant activists culminated their Trail of Broken Treaties march with the occupation of the Bureau of Indian Affairs in Washington, D.C. Members of AIM participated in the siege at the village of Wounded Knee, South Dakota, in early 1973. These protests and related events, albeit of mixed effectiveness and not supported by many Native Americans, raised awareness of Indian concerns in society at large. Much of this newfound sensibility remained tinged with romanticism, as popular literature and films such as *Dances with Wolves* (1990), for example, emphasized the deep spiritual beliefs, mysticism, and environmental sagacity of early Native Americans.

Native American artists responded individually to this rising tide of awareness of Native Americans in society as a whole. Facing difficult choices, some sought security in their ancestral identity, which increasingly emphasized a precise association as a member of a specific nation or people, as opposed to the generic label "Indian." Others hoped to enter the mainstream of contemporary art, and to be considered artists on their own merits without the qualifying adjectival tag "Native American."

Fritz Scholder, one of the most famous artists of the contemporary era, did not embrace his Native American identity as part Luiseño until his college years. Like others seeking to coexist in modern life—to find their place both inside and outside the American Indian community—Scholder created works that dismantled romantic stereotypes of Indians while employing the stylistic conventions of Pop Art and other forms of modernism. The so-called deconstruction of stereotypes through a critical examination—sometimes humorous, ironic, or satirical in tone—of superficial images of Indians has been an important focus of modern Native American artists. Mateo Romero's *Scalp Chief/Prayer/Vietnam* (fig. 9), created after the death of his father, a veteran of the Vietnam War, shows two worlds running in a parallel course, a meditation on coexistence that is also evident in much modern Native American art.

fig. 10. **Diego Romero** (Cochiti, born in 1964) and Nathan Begaye (Hopi/Diné [Navajo], born in 1969), *Death of Hector* canteen, Española, New Mexico, 2003.

The work of Indian artists, both those who were academically trained and those who learned their craft in the traditional manner, often remains closely allied to its Native American historical antecedents, as evidenced in a significant number of objects throughout this book. Some artists, however, are more adventurous than others in the iconography and forms of their works. A canteen (fig. 10) by Nathan Begaye and Diego Romero, for example, includes Romero's depiction of the death of Hector of Troy, executed in the manner of ancient Greek vase painting and applied to a traditional Southwest Indian form created by Begaye. Other artists, such as Preston Singletary, use Native American

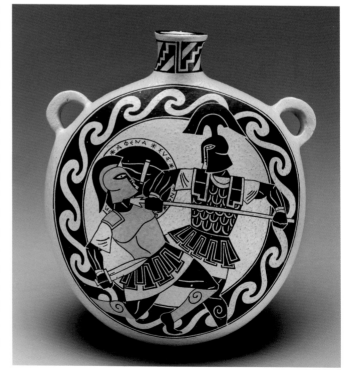

iconography with materials not normally associated with Indian art—in Single-tary's case, hand-blown glass.

Native American art—the old as well as the new—has also become a big business in the modern era, with all the attendant economic aspects of commodification, including the emergence of major dealers and galleries, regular cycles of important auctions throughout the United States and Canada, the annual sale in Santa Fe known as Indian Market, and other marketing endeavors. Inevitably, the concomitant problem of fakery has become a growing concern, as bogus imports from China, Mexico, and elsewhere have flooded the market. These incursions have prompted congressional legislation and action from the Indian Arts and Crafts Board of the Department of the Interior, which is charged with enforcing the Indian Arts and Crafts Act of 1990 and other measures designed to ensure the authenticity of Native American art. Several artists, including David Bradley, have played important roles in monitoring the marketplace and maintaining standards.

As the twenty-first century progresses, Native American artists, in common with all artists, will undoubtedly continue to encounter many challenges, each identifying a unique formula to balance the ongoing pressures of weighing continuity versus change, of seeking freedom *from* tradition as well as freedom *within* a tradition, of establishing an individual voice within or without a group identity. As the cultural critic Paul Chaat Smith (Niuam [Comanche]) notes in his recent book *Everything You Know about Indians Is Wrong* (2009), Native Americans' "true history is one of constant change, technological innovation, and intense curiosity about the world." That description of the past will no doubt serve equally well as a blueprint for the future, as Native Americans continue to make valuable, unique, and creative contributions to American art.

Jaune Quick-to-See Smith

Salish (Flathead), born in 1940

El Morro #34, 1981

Pastel on paper

Sheet: H. 76.2 cm, w. 57.2 cm (H. 30 in., w. 22½ in.)

George Peabody Gardner Fund 2003.626

El Morro #27, 1981

Pastel on paper

Sheet: H. 76.2 cm, w. 55.9 cm (H. 30 in., w. 22 in.)

Gift of James and Margie Krebs 2008.1451

A member of the Salish (Flathead) tribe, Jaune Quick-to-See Smith is of Salish, Mètis, Shoshone, and Cree descent. As a child, Smith worked as a farmhand to pay for her art lessons. She put herself through school and eventually earned a BA from Framingham (Massachusetts) State College and an MFA from the University of New Mexico. Today she is well known for work that combines Native and Western influences in a sophisticated and sometimes ironic way.

Smith's El Morro series of 1980–81 was inspired by the petroglyphs on Inscription Rock at El Morro National Monument in New Mexico. Inscription Rock is a large sandstone formation located near the historic Zuni Trail that for centuries offered a convenient sheltered camping spot to Native, Spanish, and Anglo travelers, who often carved words and pictures into the soft stone. Smith later characterized the juxtaposition of Spanish inscriptions, including simulated star charts and mapping grids, with American Indian petroglyphs of horses, canoes, people, priests, and conquistadors, as an important influence on her El Morro drawings.

Smith created these works out of earth-toned pastel, a dry and dusty medium that evokes the sandstone of Inscription Rock. Arranged across the picture surface are pictographic shapes—including jumping people, leaping horses, floating canoes, and flying arrows—that represent travel and motion. Yet, in their all-over composition and use of naïve and folk-art forms, these pastels also draw upon the work of European modernists such as Paul Klee, an artist Smith has often cited as a significant influence.

Rick Rivet
Mètis, born in 1949
String Game—2 (Kayaker), 2001

Born in the Canadian Arctic, Rick Rivet is descended from the Mètis, a distinct cultural group that grew out of the intermingling of European and Native peoples in the early days of colonization. He was raised in a family of hunters, trappers, and fishers, eventually earning his MFA from the University of Saskatchewan. As he notes, his work "aspires to the spiritual, to the recovery of the main tradition of creativity. The encounter with shamanic ideology and culture compels the contemporary artist to admit to the binding ties of a common spiritual heritage."

This is one of several paintings in which Rivet explores the forms created by string games, evoked here by the white lines in the center of the canvas. Children all over the world play string games—cat's cradle, for example—making these a nearly universal human experience. Rivet also invokes the cardinal directions with the words "North" and "South" at the top and bottom of the painting, transforming the canvas into a maplike space. At the top left, the pointed white shape suggests the form of the kayak mentioned in the title as seen from above or below.

Acrylic on canvas
H. 106.7 cm, w. 106.7 cm (H. 42 in., w. 42 in.)
Gift of James and Margie Krebs 2009.4342

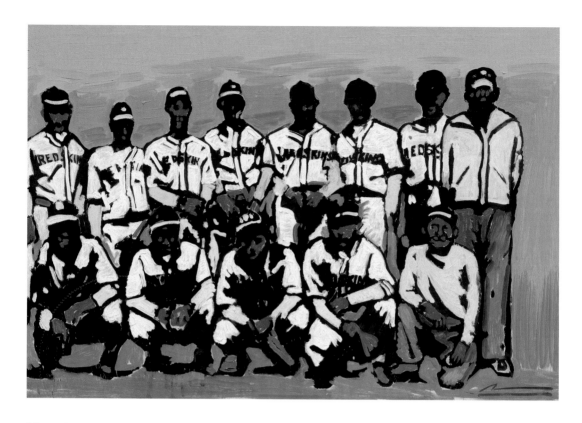

Mateo Romero
Cochiti, born in 1966
Cochiti Redskins, about 2000

Born in California, painter Mateo Romero juxtaposes images taken from contemporary American popular culture with images drawn from his Cochiti Pueblo heritage. Painting, he says, has for him a "rhythmic, hypnotic, trancelike feeling" that is connected to sacred pueblo dance.

In *Cochiti Redskins*, Romero makes a challenging statement about the use by U.S. sports teams of the word "redskins," a racist and derogatory term for Native Americans. Romero was one of seven Native American plaintiffs who in 1992 brought suit to cancel the registered trademark of the Washington Redskins National Football League team, on the grounds that slogans and images considered disparaging cannot be registered under United States trademark law.

After many years of legal wrangling, Romero and his coplaintiffs lost the case in 2008 because the appeals court found that they had waited too long after the trademark was issued (in 1967) to file suit. Here Romero reclaims and redefines the offensive word "redskin" by depicting what might be called "real" redskins, members of his native Cochiti Pueblo dressed in baseball uniforms with the word emblazoned on their chests. With a wry sense of humor, Romero has chosen to depict the figures grouped together in two rows as if arranged for a typical team photo.

Oil and asphalt on board
H. 82.6 cm, w. 121.9 cm (H. 32½ in., w. 48 in.)
Gift of James and Margie Krebs 2009.2798

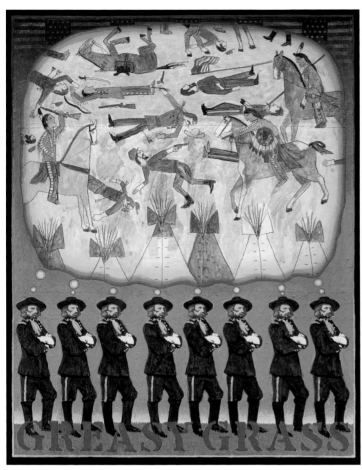

David Bradley

Ojibwa (Chippewa), born in 1954

Greasy Grass Premonition #2, 1995

A member of the White Earth Band of the Ojibwa (Chippewa), David Bradley is both a well-regarded artist and an outspoken activist. He played an important role in the movement to protect the Native American art market from fakes, which in 1990 led to the passage of a federal law criminalizing the marketing and sale of art as "Indian" unless made by an enrolled tribal member.

In *Greasy Grass Premonition* #2, Bradley combines Native American, Pop, and illustrative styles to explore the June 1876 victory of the combined forces of the Lakota (Sioux) and Northern Cheyenne tribes—commanded by Sitting Bull—over the Seventh Cavalry regiment of the United States Army, commanded by Major General George Armstrong Custer. Native Americans referred to the engagement as the Battle of Greasy Grass Creek, while the U.S. Army called it the Battle of Little Bighorn. Bradley depicts a row of Custer figures, modeled on a Civil War–era portrait photograph of the general taken by George L. Andrews (fig. 11) that was also the source for a colorful 1986 screen print by Andy Warhol. A comic book–style "thought balloon" above is filled with a Plains ledger book–style representation of Custer's premonition of the violent battle in which he would lose his life. Below, in stenciled letters that recall the work of Pop artist Jasper Johns, are the words "Greasy Grass," and above is a row of American flags. This complex mixture of styles and symbols emphasizes the clash of cultures that occurred during the battle.

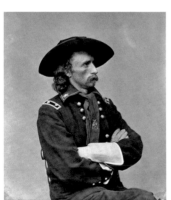

fig. 11. **Major General**

George A. Custer.

Photograph by George L.

Andrews.

Mixed media on canvas
H. 76.2 cm, w. 61 cm (H. 30 in., w. 24 in.)
Gift of James and Margie Krebs 2009.2799

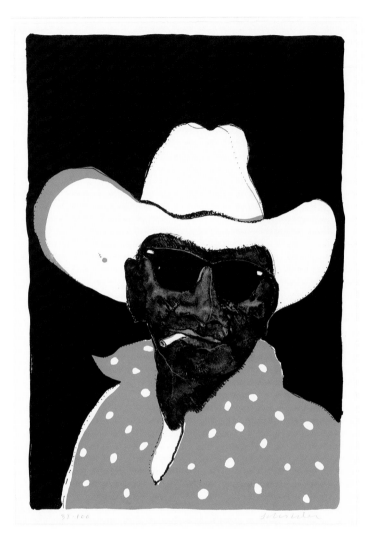

Fritz Scholder

Luiseño, 1937–2005

Cowboy Indian, 1974

Fritz Scholder was perhaps the best-known and most controversial Native American artist of the twentieth century. Although his paternal grandfather was a member of California's Luiseño tribe, Scholder did not begin to identify with Native culture until his college years. This experience of being both inside and outside the American Indian community may have motivated Scholder to deconstruct romantic stereotypes about Native Americans in his work.

With its bold color and simplified form, *Cowboy Indian* demonstrates Scholder's command of the visual conventions of Pop Art, probably gained at least in part from his studies with painter Wayne Thiebaud in the late 1950s. Yet Scholder also makes an important social point by refusing to idealize the Native American man he depicts. *Cowboy Indian* presents two identities traditionally at odds with each other, the cowboy and the Indian, and shows that in reality the two can be one.

Color lithograph
Sheet: H. 61 cm, w. 43.2 cm (H. 24 in., w. 17 in.)
Lee M. Friedman Fund 2003.624

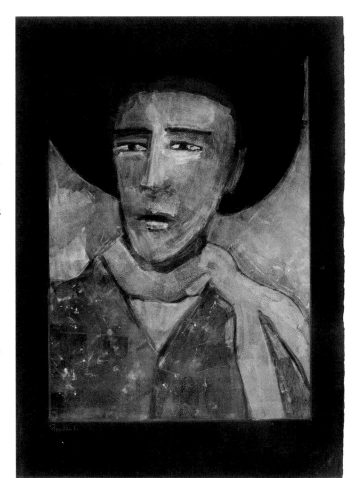

Aaron Leonard Freeland
Diné (Navajo), born in 1956
My Mother's Uncle When He Was
Young, 2004

Aaron Freeland is one of many noted
graduates of Santa Fe's innovative and
influential school for Native American
artists, the Institute of American Indian
Arts. Freeland, a Diné (Navajo) artist,
produces monotypes—one-of-a-kind
prints created by manipulating pigment
on a flat printing plate and pressing a
sheet of paper into the inked surface.
In many works, Freeland then adds lay-
ers of paint or pastel by hand. Here, it
appears that he has lightly rubbed the
colored areas of the print with wide
sticks of pastel chalk, leaving a loose
network of angular marks. This process
creates an image of great depth and
richness.

The title of *My Mother's Uncle*
When He Was Young both conveys
information about the identity of the
sitter and evokes a sense of nostalgia
for his lost youth. In the image itself,
Freeland refuses to idealize or glamor-
ize his great-uncle, instead creating an
enigmatic, even masklike visage. This
portrait presents a somber young man
who perhaps is facing an uncertain or
difficult future.

Monotype
Platemark: H. 60.5 cm, w. 45 cm
(H. 23¹³⁄₁₆ in., w. 17¹¹⁄₁₆ in.)
Sheet: H. 76.5 cm, w. 56.5 cm
(H. 30⅛ in., w. 22¼ in.)
Museum purchase with funds donated by
James N. and Margie M. Krebs 2005.107

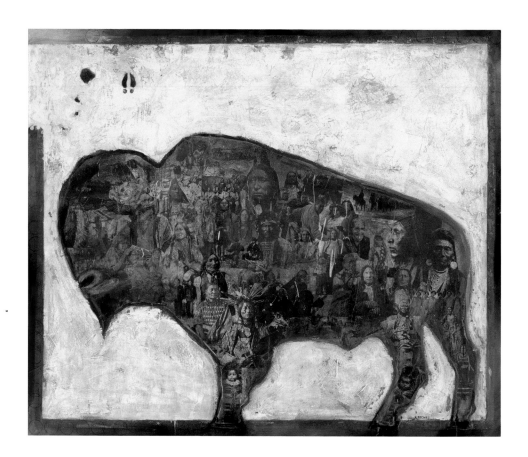

Natchez

Shoshone/Paiute, born in 1954

White Buffalo—We the People, 1997

The buffalo has important symbolic resonance for many contemporary Native American artists, both because of its significance in traditional Plains Indian culture and because, more recently, the species has begun to flourish after its near extinction. Here Natchez, by descent a Shoshone and Paiute, creates an explicit relationship between the buffalo's body and the historical images of Native people collaged within it. In this way, Natchez suggests that Native Americans, like the buffalo, continue to thrive and prosper after great hardship, suffering, and loss.

In the painting's title Natchez refers to the white buffalo, an extremely rare animal (occurring in approximately one out of every ten million births) considered sacred by many Plains Indian cultures. The title also evokes the figure of the White Buffalo Woman, highly significant to several Plains peoples, who is said to have taught the Lakota (Sioux) to pray. During an appearance on earth, White Buffalo Woman also showed the people how to use the buffalo to sustain them; as she was departing, she promised to reappear one day and restore the earth to harmony. Combined with the phrase "We the People" in the title, the work suggests a hopeful vision of growth and renewal for Native Americans.

Acrylic and collage on canvas
H. 121.9 cm, w. 147.3 cm (H. 48 in., w. 58 in.)
Gift of James and Margie Krebs 2006.1925

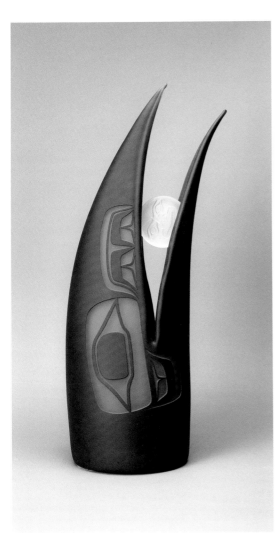

Preston Singletary
Tlingit, born in 1963
Raven Steals the Moon
Seattle, Washington, 2002

Seattle artist Preston Singletary has been working
with glass since the early 1980s, when he first met
the Italian glass virtuoso Lino Tagliapietra, who
made Seattle's glass community his second home.
Study at the nearby Pilchuck Studios, run by Dale
Chihuly, honed Singletary's skills as he fashioned
glassworks that followed trends established by vari-
ous American and European artists. Today, Singletary
is a leading Native American artist working in glass,
a medium that is not part of traditional Native Ameri-
can artistry but that has attracted a small group of
American Indian practitioners.

In recent years, Singletary has turned to his Tlingit
heritage to produce a body of work that is strongly
reminiscent of carved totemic forms. In particular, he
has employed Tlingit crest symbols on blown glass to
great effect. *Raven Steals the Moon* embodies a well-
known Tlingit myth that relates how Raven stole the
moon from a heavenly chief who kept both the sun
and the moon in a padlocked box. Here Raven holds
in his open beak a sandblasted, clear-glass disk
depicting the face of the moon. In stories, Raven
was often portrayed as a trickster, a troublesome
and wily creature who accomplished good despite
his shortcomings.

Blown red glass; black overlay with sandblasted design
H. 49.5 cm, diam. 15.2 cm (H. 19½ in., diam. 6 in.)
Gift of Dale and Doug Anderson and Preston Singletary
2003.350

Nathan Begaye
Hopi/Diné (Navajo), born in 1969
Squash Maiden
Santa Fe, New Mexico, 2002

Nathan Begaye, one of the most innovative and free-wheeling contemporary Native American potters, was born in Arizona to a Diné (Navajo) father and a Hopi mother. After a rather conservative family upbringing near the Hopi Third Mesa in Arizona, he studied pottery at the Institute of American Indian Arts in Santa Fe and then in the distinguished ceramics program at Alfred University in upstate New York, where he worked with the studio potter Wayne Higby.

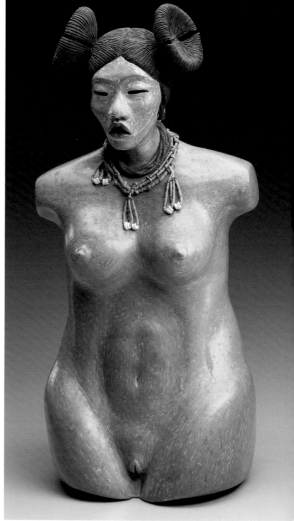

Begaye's extraordinary pottery is noted for its eclecticism; he draws upon the full range of Native American motifs and designs to create a wide variety of objects that almost always have an air of humor and wit about them. He is as interested in sculptural form—including the human form—as he is in the more typical Native American manner of painting geometric, abstract, and other designs on vessels.

As Begaye developed this *Squash Maiden* vessel (fig. 12), he selected a subject from his Hopi background, a young maiden adorned with bead necklaces and with her hair coiled in the "squash blossom" or "butterfly" style that Hopi girls of marriageable age typically adopted. Her state of undress, however, is

anything but maidenly. An air of sensuality or eroticism—not uncommon in Begaye's pottery—is one element that sets Begaye, and also Diego Romero, apart from many modern Native American potters.

Earthenware with slip paint, beads
H. 35.9 cm, w. 14.6 cm, d. 14 cm
(H. 14⅛ in., w. 5¾ in., d. 5½ in.)
Gift of James and Margie Krebs 2006.1911

fig. 12. **Nathan Begaye at work.**

Diego Romero
Cochiti, born in 1964
Burning Airplanes
Española, New Mexico, 2002–3

Diego Romero was born and raised in Berkeley, California, the home of his European American mother, Nellie Guth, but spent summers at Cochiti Pueblo in New Mexico, his father's ancestral home.

Romero's pottery often combines traditional patterns derived from prehistoric Anasazi and Mimbres pots with designs drawn from ancient Greek black-figure vase painting. Much of his pottery and prints, as here, features the exploits of the Chongo brothers (a *chongo* is a Southwestern Native man who wears his hair in a traditional bun), who encounter and interact with various aspects of popular American culture, often in a humorous and satirical way. Here, however, the mood is somber, as each Chongo brother, depicted on two sides of the vessel, sits in an automobile and gazes at burning airplanes descending over different landscapes, a haunting vision in the wake of 9/11.

Romero, who studied pottery making with Nathan Begaye as a young man, attended several schools be-

fore receiving his MFA from the University of California, Los Angeles, in 1993 and now lives in New Mexico. His brother, Mateo Romero, is a painter (see p. 36).

Earthenware with painted decoration
H. 27.9 cm, diam. 25.4 cm (H. 11 in., diam. 10 in.)
Gift of James and Margie Krebs 2006.1907

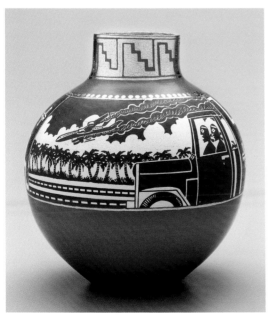

Edna Romero
Santa Clara, born in 1936
Water jar
Taos Pueblo, New Mexico, 2001

Although the Museum has a strong collection of Native American pottery from the Southwest, the holdings include only a few examples made of the glittering micaceous clay favored by the potters of several northern New Mexico pueblos. Edna Romero, originally from Santa Clara, is a member by marriage of the extended Naranjo pottery-making family of Taos, which has some of its roots in Santa Clara.

 This water jar is a thinly walled, beautifully formed vessel distinguished by its carefully modulated surface and elegant shape. It was acquired directly from the artist by the donors at Indian Market in Santa Fe in August 2001. Indian Market, organized by the Southwestern Association for Indian Arts and held each year since 1922, provides an important opportunity for many Native American artists to market their wares to collectors and to receive recognition for their work. Romero's pottery has received awards at numerous Indian Markets and other Southwest art fairs.

Micaceous clay
H. 31.8 cm, diam. lip 22.2 cm
(H. 12½ in., diam. lip 8¾ in.)
Gift of the Bardar Collection in honor of
Ruth S. Malenka 2001.822

Christine Nofchissey McHorse
Diné (Navajo), born in 1948
Vessel
Santa Fe, New Mexico, about 1985–90

Christine Nofchissey McHorse is perhaps New Mexico's most widely recognized living Diné (Navajo) potter. Educated at the Institute of American Indian Arts in Santa Fe, she married Joel McHorse, a silversmith of Taos Pueblo, in 1969; one of their sons, also named Joel, is a distinguished potter represented in this chapter. McHorse learned pottery making from her husband's family. Her work is thus rooted in the Taos manner, but it also reflects a blend of Anglo and Diné characteristics that in combination create her unique approach.

This vessel is a large coiled pot, probably pit-fired, in a nontraditional form featuring a scalloped, molded border. It is made of mica-flecked clay, mined near Taos, and coated with resinous piñon pine pitch, a material typically used by the Diné on the exterior of vessels. The undulating surface of the pot is enlivened by incised and painted glyphs, echoing shapes and forms found in petroglyphs in the Southwest. The surface is further enhanced by the smoke or fire clouds that occur in the firing process and that are also a significant aspect of her son Joel's vessel (see p. 46).

Micaceous clay with piñon pine pitch
H. 26.7 cm, diam. 45.7 cm (H. 10½ in., diam. 18 in.)
Museum purchase with funds donated by Ruth S. Malenka
from a bequest by Barbara F. Swartz 2008.110

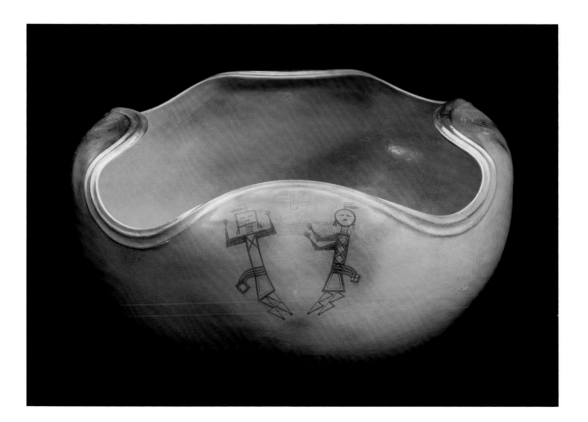

Joel C. McHorse

Diné (Navajo)/Taos, born in 1969

Storage jar

Santa Fe, New Mexico, 1996

This storage jar is both an homage to tradition and a monumental work of contemporary art. Joel McHorse conceived "this large corrugated piece . . . [as] a tribute [to] and exploration of the ancient pottery made by Native American potters long ago." Using skills learned from his mother, Christine Nofchissey McHorse, Joel modeled the neck of his coiled vessel upon examples of Anasazi corrugated ware. By manipulating the amount of oxygen that reached the vessel during the firing process as well as the temperature, he was able to achieve a precise location for the dark so-called smoke or fire clouds that enrich the body of the vessel and give it a distinctly contemporary feeling. The local clay from the family's pit near Taos Pueblo, rich in natural mica, gives the vessel its sparkling surface.

Micaceous earthenware with micaceous slip
H. 43.2 cm, diam. 48.9 cm (H. 17 in., diam. 19¼ in.)
Museum purchase with funds donated by
John S. Montgomery 1997.176

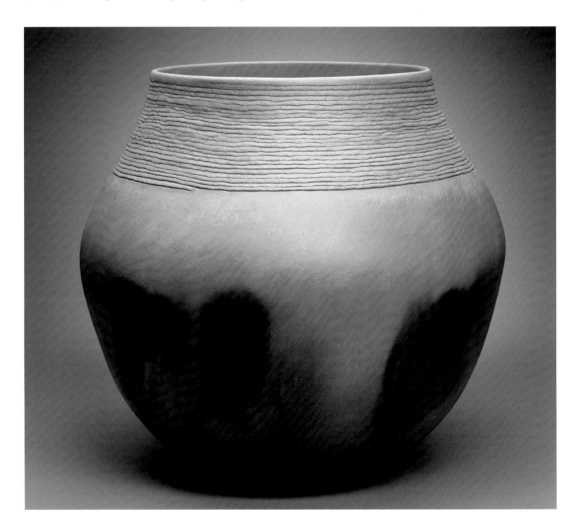

Jacquie Stevens

Ho-Chunk (Winnebago), born in 1949

Vessel

Santa Fe, New Mexico, 1987

Jacquie Stevens, a Ho-Chunk (Winnebago), grew up in Nebraska and was attracted to clay at an early age. She learned pottery making at the Institute of American Indian Arts in Santa Fe, where she studied with Otellie Loloma (1922–1993), a Hopi potter, in the late 1970s. She later graduated from the College of Santa Fe.

Stevens's pottery gained recognition in the 1980s for its strong organic, asymmetrical forms and frequent use, as here, of a single color in a minimalist fashion, which achieves aesthetic success without explicit narrative content. This large, sculptural vessel was constructed using the traditional method of hand coiling: the vessel was shaped with many coils of clay that were then smoothed and scraped to create the thin-walled form. The exterior was given its dimpled impressions by a small blunt stick, stamped repeatedly around nearly the entire body of the object, with only the area near the undulating neck left in reserve. Stevens covered the white clay body with a layer of slip consisting of a fine mica and white clay mixture that was then rag-polished before firing. The result is a luminous white vessel, clearly contemporary in form and color but also evocative of ancient Southwestern corrugated ware (fig. 13).

Earthenware with slip and mica powder
H. 47 cm, diam. 45.7 cm (H. 18½ in., diam. 18 in.)
Gift of Stephen and Betty Jane Andrus 1993.545

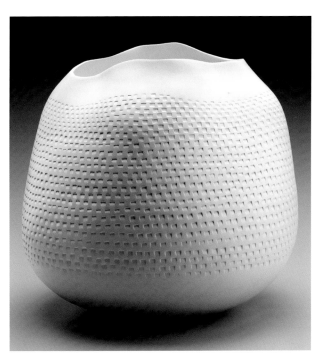

fig. 13 Jar, Anasazi, Northeastern Arizona and northwestern New Mexico, 900–1100.

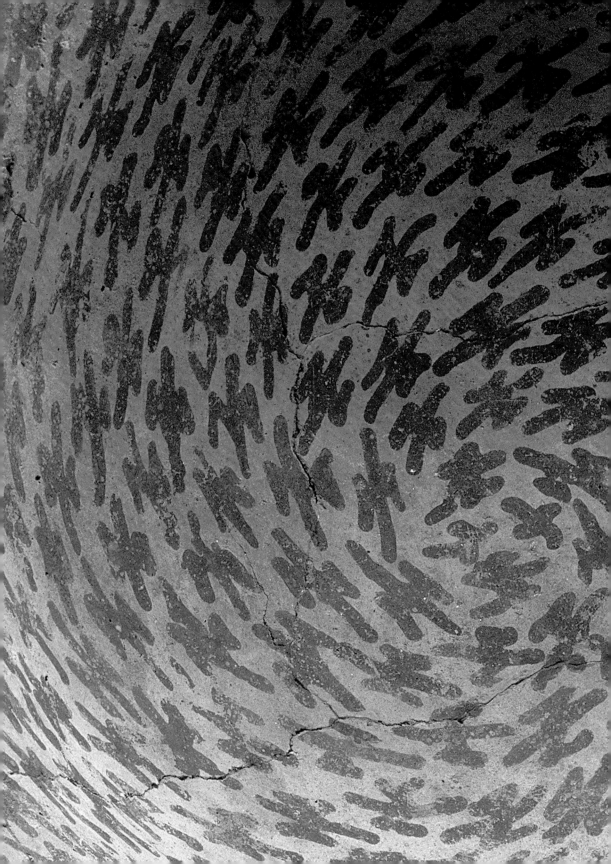

Beginnings: The Ancient Southwest

Where does the story of Native Americans in North America begin? This seemingly simple question does not have a simple answer. Various Native American creation stories and traditions provide rich, evocative descriptions of the people's emergence on their land. Other explanations, offered by generations of historians and archaeologists, have been based on theories of migration: from Asia, via a land bridge across the Bering Strait during the last Ice Age; via boat, from Asia or Polynesia; or moving northward from Central and South America. Whatever the case, the evidence is incontrovertible that there has been a Native American presence on the land for thousands of years, in almost every part of the continent from the Arctic through the Great Plains and the Eastern Woodlands. The archaeological record stretches back to initial settlements of about 12,000 B.C., although some research suggests an even earlier date. The size of the Native American population before European contact in the late fifteenth century, the nature of their society, and their impact on the environment remain subjects for lively debate.

Our understanding of the vast and disparate ancient history of Native Americans is based almost entirely on the work of archaeologists, who have described the gradual changes in Native American life in each part of the continent from the earliest evidence forward into the historic era (when writing was introduced). Cultures in each region developed individually, depending on the local landscape and the bounty that it provided, from the earliest hunter-gatherer peoples of California to the bison hunters of the Plains or the early Arctic cultures that relied on resources from the land and sea.

The only prehistoric Native American culture represented in any depth in the Museum's collection is that of the ancient Southwest, as evidenced in this section by pottery made by the Hohokam, the Mogollon (including the Mimbres), and the Anasazi, who lived in various parts of what is now New Mexico, Arizona, and southern Colorado and Utah. The ceramics in the collection date from, roughly,

between 700 and 1300. After that time, the Southwest peoples dispersed for reasons that are unclear, although a prolonged drought may have been a factor. Present-day members of the various pueblos in New Mexico and Arizona are their descendants.

The distinguishing characteristics of ancient Native American life in the Southwest, as distinct from ancient American Indian cultures in other areas, included the use of agriculture, especially the cultivation of squashes, beans, and corn, ground with simple stone tools (see figs. 14–15), and adaptation to a demanding environment in which water was especially scarce and precious. The Southwest peoples also developed communities known for their size and stunning architecture, such as the so-called Cliff Palace in Mesa Verde in Colorado (fig. 16), major sites at Pueblo Bonito and in Chaco Canyon, the White Horse Ruin in Canyon de Chelly, and the Hohokam Snaketown site in Arizona.

Archaeological evidence suggests that pottery making in the Southwest developed about 200–250. Although there were many variations in clays, technique, and firing, vessels were produced following a basic formula. Made without the use of a potter's wheel, they were assembled from coils of clay arranged by hand and then smoothed and polished into shape, also by hand or with the use of a wooden shaping device. After being covered in a thin layer of slip (a mixture of water and clay that provides a smooth surface), vessels were painted with various pigments in both figural and abstract designs before being fired outdoors.

Although much ancient Southwest pottery was utilitarian, the examples in this section are embellished with figural and abstract images that reflect a refined sense of design and great command of the brush. Both modern archaeologists and Pueblo potters have interpreted many of these designs as references

fig. 14. **Grinding stone and hand stone, probably northern Arizona, 700–1400.**

fig. 15. **Mortar and pestle, probably northern Arizona, 700–1400.**

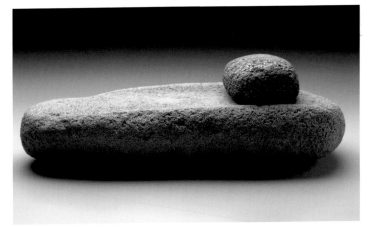

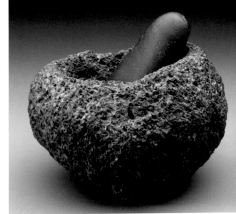

to rain, fertility, and the developing *kachina* (ancestral spirit being) rituals, dances, and beliefs that remain significant today in Puebloan spiritual life. These ancient wares—excavated throughout the Southwest in archaeological sites but also found in the form of potsherds near ancient sites—have provided many modern Pueblo artists with inspiration for their own work as the long tradition of constancy amid change has evolved in the Southwest.

fig. 16. *Cliff Palace, Mesa Verde National Park, Colorado*, 1941. Photograph by Ansel Adams.

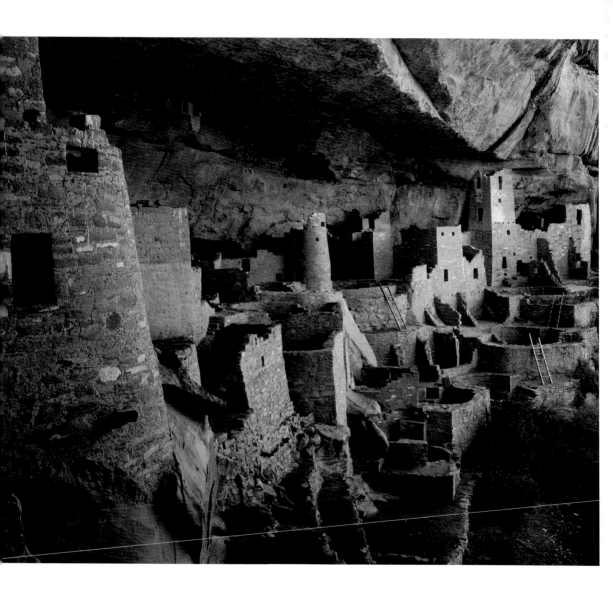

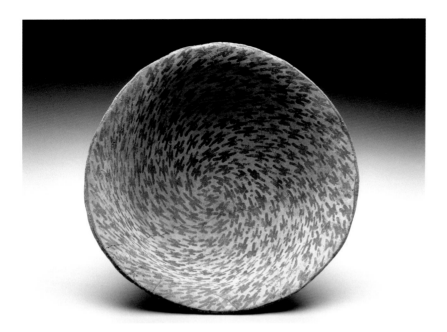

Bowl

Hohokam

Gila and Salt River region, southern Arizona, 850–950

The Hohokam flourished in the dry, southern sections of what is now Arizona, along the Salt, Gila, and Verde rivers, for more than a millennium. Living in small villages consisting of individual houses, they were farmers who have become known for the elaborate irrigation systems they constructed in the flat river valleys. The Hohokam interacted with their neighbors, including Native people to the south in what is now Mexico, the Anasazi to the north, the Mogollon to the east, and peoples along the Pacific Ocean and Gulf of California to the west. They began making pottery as early as 200–250, some six or seven centuries before this bowl was fashioned. Archaeological evidence suggests, however, that by about 1300, their culture was in decline, and a century later their villages were burned and abandoned for reasons as yet unknown.

Hohokam potters constructed vessels like this large bowl by placing coils of clay over a stone form, and then paddling them into the desired form and thickness. This buff- or tan-colored bowl is painted with a vigorous pattern of what has been interpreted as a spiral, whirling design of numerous birds in flight, perhaps linked to a Southwestern creation story. Such a creative, free-flowing design is characteristic of much Hohokam pottery.

Earthenware with slip paint; Santa Cruz red-on-buff style
H. 9.5 cm, diam. 26.7 cm (H. 3¾ in., diam. 10½ in.)
Museum purchase with funds donated by Mr. and Mrs. Peter S. Lynch, Anne and Joseph P. Pellegrino, an anonymous donor, and Frank B. Bemis Fund 1989.235

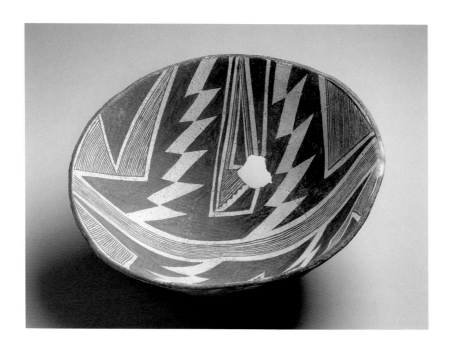

Bowl

Mimbres

Mimbres River Valley, southwestern New Mexico, 850–1000

The Mimbres flourished along the river of the same name in what is now southwestern New Mexico. They are especially known for their pottery containing animal and human images, but most of the surviving Mimbres pottery more closely resembles this example, notable for its asymmetrical composition featuring bold geometric shapes, elegant fine lines, and zigzag designs suggesting rain and lightning. These ancient motifs have continued to be important to modern Southwest potters, who have drawn on them repeatedly, as is the case with a tall jar made by Carmel Lewis of Acoma (fig. 17).

Many Mimbres objects have emerged from burials, unearthed either archaeologically or at the hands of looters. The Mimbres inverted these vessels and placed them upon the face of the deceased, ceremonially puncturing the bowl with a so-called kill hole (visible here), possibly in accordance with a belief that this opening would release the spirit of the vessel into the next world. The painted designs within the bowl provided a panorama for the deceased to contemplate for all eternity.

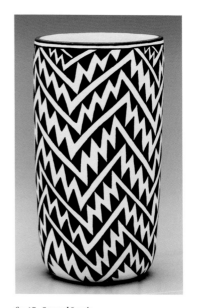

fig. 17. **Carmel Lewis**
(Acoma, born in 1947),
jar, Acoma Pueblo, New
Mexico, about 2000–2002.

Earthenware with slip paint; Black-on-white, Style II
H. 11.4 cm, diam. 27.9 cm (H. 4½ in., diam. 11 in.)
Museum purchase with funds donated by Mr. and Mrs. Peter S. Lynch, Anne and Joseph P. Pellegrino, an anonymous donor, and Frank B. Bemis Fund 1989.231

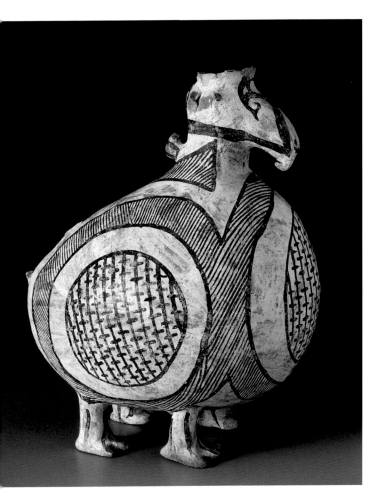

Avian effigy

Mogollon

Quermado and Reserve area, west-central
New Mexico, 1000–1175

For more than a thousand years, the
Mogollon people, flanked to the west by
the Hohokam and to the north by the
Anasazi, lived in what are now large parts
of central and southern New Mexico and
Arizona. This large avian effigy, dating
from the eleventh or twelfth century, is
a product of their late historical and
artistic phase. Such effigies of birds and
birdlike creatures are not uncommon in
prehistoric Southwest pottery, although
this is an exceptionally large and well-
preserved example.

The scholar Linda Foss Nichols has
linked this effigy with more modern com-
ponents of A:shiwi (Zuni) mythology;
Zuni Pueblo is located near the historic
Mogollon territory. Part of the A:shiwi
creation story involves the emergence of
life through four stages of an underworld
to the middle world, in which humans
take their current form, as well as four
stages of an ascending overworld extend-
ing into the sky. A birdlike effigy such as
this—with eyes, ducklike curved bill, four
webbed feet, and painted feathers on
each side—may represent a creature that
could successfully navigate these various
worlds of water and sky.

Earthenware with slip paint; Cibola White ware,
Gallup Black-on-white style
H. 25.4 cm, w. 19 cm, d. 15.9 cm
(H. 10 in., w. 7 ½ in., d. 6 ¼ in.)
Museum purchase with funds donated by a Friend
of the Department of American Decorative Arts
and Sculpture and Harriet Otis Cruft Fund
1989.316

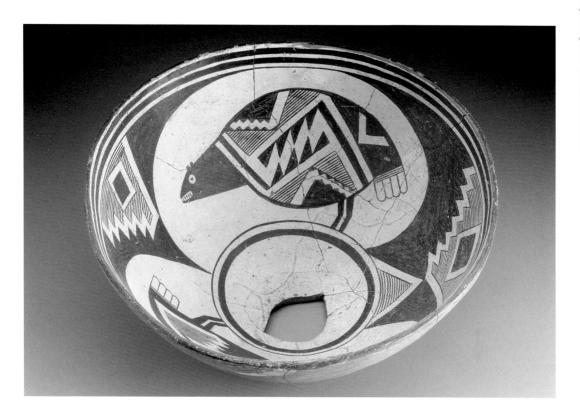

Bowl

Mimbres

Mimbres River Valley, southwestern New Mexico,
1000–1150

Only about one-fifth of surviving painted Mimbres
pottery is decorated with images of animals, birds,
insects, or humans; this example features two ani-
mals circling the bowl from right to left around the
puncture known as the kill hole. These figures have
bearlike heads and birdlike bodies; they resemble fat
quails, complete with tail feathers. Many of the ani-
mals on Mimbres pots are mythical beasts or com-
bine the features of more than one species, making
precise identification difficult, although other
painted vessels clearly depict rabbits, turkeys, and
other readily recognizable subjects.

The wide variety of creatures represented on
Mimbres work suggests that the Mimbres traveled
and traded far afield from their native land along
the Mimbres River in what is now southwestern New
Mexico. For example, sea creatures native to the
Gulf of California 970 kilometers (600 miles) away
have been identified on Mimbres vessels. Beautifully
painted, Mimbres pottery has great aesthetic appeal
to modern eyes and has been popular with collectors
for nearly a century. The pottery also clearly embodies
the worldview and philosophy of its vanished cre-
ators, although the Mimbres culture remains frustrat-
ingly mysterious to us, due to the absence of written
records and the fact that many Mimbres vessels lack
any archaeological context.

Earthenware with slip paint; Classic Black-on-white, Style III
H. 12.1 cm, diam. 28.6 cm (H. 4¾ in., diam. 11¼ in.)
Museum purchase with funds donated by the Seth K. Sweetser
Fund and Supporters of the Department of American Decorative
Arts and Sculpture 1990.248

Water jar

Mogollon

East-central Arizona and adjacent New Mexico,
about 1050–1200

This capacious jar is designed to hold water and to be
carried atop its owner's head. To facilitate this func-
tion, the maker impressed thumb- or fingerholds on
the lower part of the vessel's body, to be used both in
picking up the vessel and in balancing its substantial
weight while walking. This useful modification is
rarely encountered in prehistoric vessels.

The painted black-and-white designs on the jar
cover about two-thirds of its large ovoid body. Con-
sisting of fretwork, parallel lines, stepped passages,
and white zigzag shapes, they all symbolize rain, a
reference to the contents of the vessel and a recogni-
tion of water's importance in the arid climate of the
Southwest.

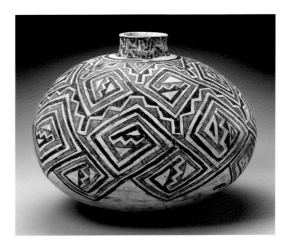

Earthenware with slip paint; Cibola White ware,
Tularosa Black-on-white style
H. 29.2 cm, diam. 38.1 cm (H. 11½ in., diam. 15 in.)
Museum purchase with funds donated by Mr. and Mrs. Peter S.
Lynch, Anne and Joseph P. Pellegrino, an anonymous donor,
and Frank B. Bemis Fund 1989.232

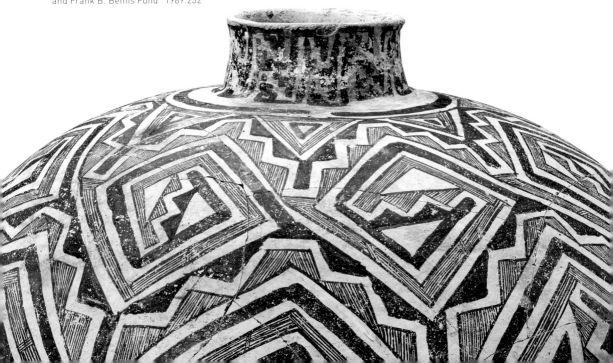

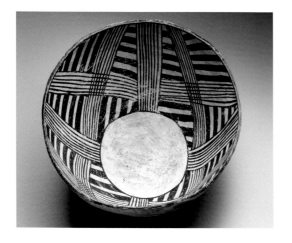

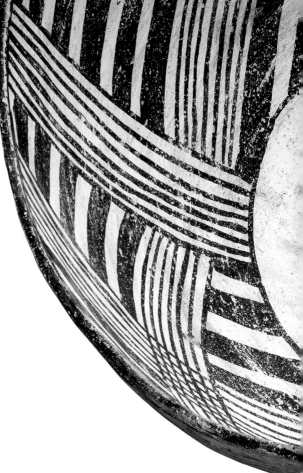

Bowl
Mogollon
Puerco River Valley to Reserve region,
west-central New Mexico, 1050–1200

The design of this bowl is a linear composition that both delights the eye and probably reflects the cosmological view of its maker. Four bands of thin parallel lines emanate from the large central oval, effectively quartering the composition. These lines are then intersected by both vertical and horizontal bands, overlapping and intertwining to replicate a weaving pattern such as those found on textiles or basketry of the period. Each large quadrant of the bowl's interior is thus dominated by an X-shaped design; the interstices are also filled with broader bands of dark and white lines.

In many Puebloan cultures, the number four is of considerable significance, representing the four horizontal directions of their universe (which do not always directly correspond to the cardinal points of the compass). Two other elements, the zenith and the underworld, typically complete the six directions of the Puebloan cosmos; sometimes a middle place, where living people reside, is also recognized. Here the visual division of the painted scheme into four elements could represent the horizontal directions, while the open circle at the center might stand for the zenith and underworld, and perhaps the middle place as well.

Earthenware with slip paint; Cibola White ware, Reserve Black-on-white style
H. 14 cm, diam. 28.6 cm (H. 5½ in., diam. 11¼ in.)
Museum purchase with funds donated by Mr. and Mrs. Peter S. Lynch, Anne and Joseph P. Pellegrino,
an anonymous donor, and Frank B. Bemis Fund 1989.239

Bowl

Anasazi

Borderlands from Puerco River south to the headwaters of the Salt River, Arizona and New Mexico, 1175–1280

Ancient pottery from the Southwest with a red slip ground, such as the bowl seen here, is known today as White Mountain Red ware and is among the most frequently encountered types of ceramics. The interior of this bowl is defined by a large six-pointed star with terraced and fretwork designs on its outer edges, with the center left in reserve.

The principal distinguishing characteristic of this vessel, however, is a pair of birds with long, curved necks and bifurcated tails, possibly parrots or, specifically, scarlet macaws, which are depicted facing each other on the exterior of the bowl. The scarlet macaw, one of the world's most colorful birds and now an endangered species, is native to Central and South America. Traders from Mexico may have introduced specimens to the Puebloan peoples of Arizona and New Mexico as early as 1100; scarlet macaw feathers and skeletons have been found at various archaeological sites in Chaco Canyon.

Earthenware with slip paint; White Mountain Red ware, St. Johns Polychrome style
H. 9.2 cm, diam. 24.8 cm (H. 3⅝ in., diam. 9¾ in.)
Museum purchase with funds donated by The Seminarians 1993.666

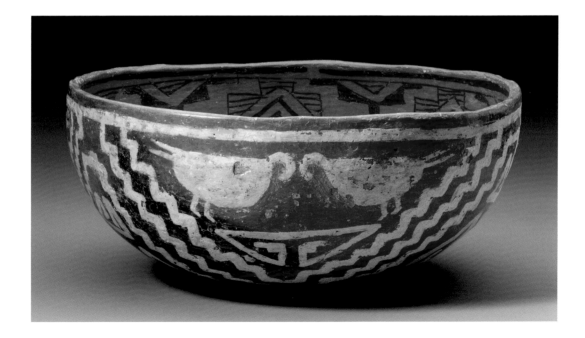

Bowl

Arizona or New Mexico, 1200–1500

Although its precise origin is unknown, this
bowl speaks eloquently of the abilities of
the prehistoric Southwest potter and painter
who decorated it with a variety of images,
which allow for much speculation as to their
meaning. The bowl's design features two
pairs of painted figures facing each other,
probably engaged in a dance or religious
ritual. Each is depicted with minute but
carefully delineated facial features and has
raised arms bent at the elbow, with the
hands in an open-palm position. One pair—
the figures with torsos containing a checker-
board pattern, symbolic of water—is posed
in a birthing position, with knees bent and
legs akimbo, evocative of fertility. The other
two figures seemingly relate to the same
concerns: they sport horns on their heads,
associated with fertility, and are painted
with double triangles above and below a
central motif, again referencing water. The
exterior of the bowl (not visible here) is pain-
ted with square spirals (or interlocking fret-
work), which were associated with Ho-bo-bo,
the Keeper of Wind, according to an explana-
tion Hopi priests offered to ethnographer
Alexander Stephen before 1890.

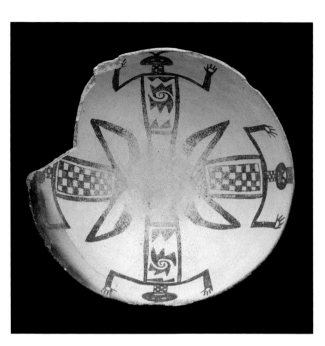

Earthenware with slip paint
H. 9.5 cm, diam. 22.9 cm (H. 3¾ in., diam. 9 in.)
Museum purchase with funds donated by Mr. and
Mrs. Peter S. Lynch, Anne and Joseph P. Pellegrino,
an anonymous donor, and Frank B. Bemis Fund
1989.236

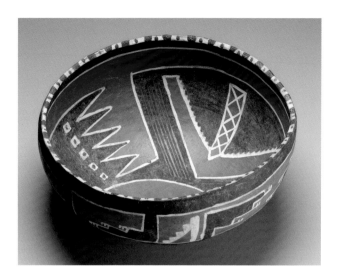

Bowl

Anasazi

East-central Arizona or New Mexico, about 1325–1400

This bowl is painted in what has become known as the Fourmile Polychrome style, a dramatic mode of decoration that emerged in the fourteenth century. It is named for Four-Mile Ruin, a large ancient pueblo in east-central Arizona on Pinedale Creek, near the Little Colorado River, where numerous examples have been excavated.

Typically, bowls in this style, as here, have a bright red slip, decorated with black nonfigural designs in glaze or matte glaze paint outlined in white, and are painted on both the interior and the exterior. The abstract designs are sometimes interpreted as representing birdlike elements. These motifs on Fourmile Polychrome wares have led some scholars to see the style as one of the predecessors of historic pottery from Hopi and A:shiwi (Zuni), which often features bird imagery. This stylistic continuity is one of the threads that demonstrate the long trajectory of Southwest pottery.

Earthenware with slip paint; White Mountain Red ware, Fourmile Polychrome style
H. 8.9 cm, diam. 20.3 cm (H. 3 ½ in., diam. 8 in.)
Museum purchase with funds donated by Mr. and Mrs. Peter S. Lynch, Anne and Joseph P. Pellegrino, an anonymous donor, and Frank B. Bemis Fund 1989.238

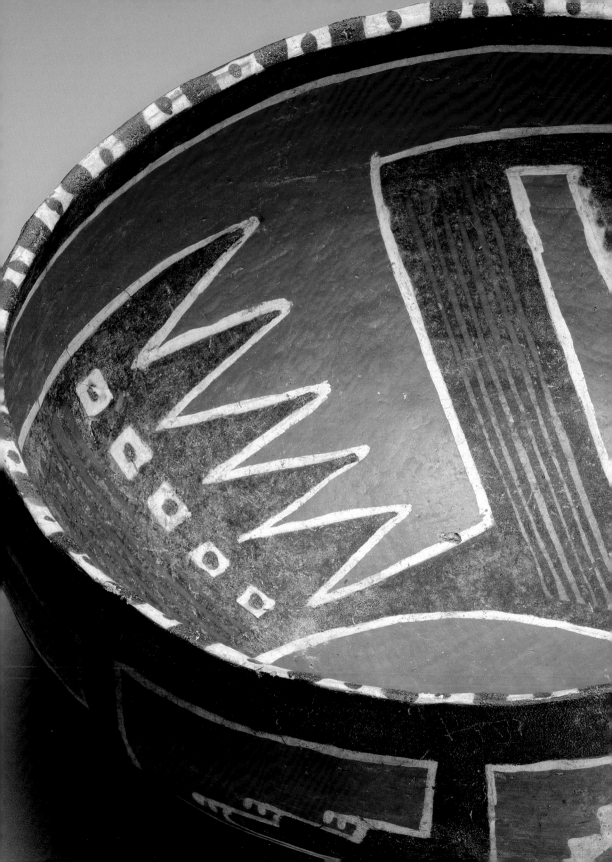

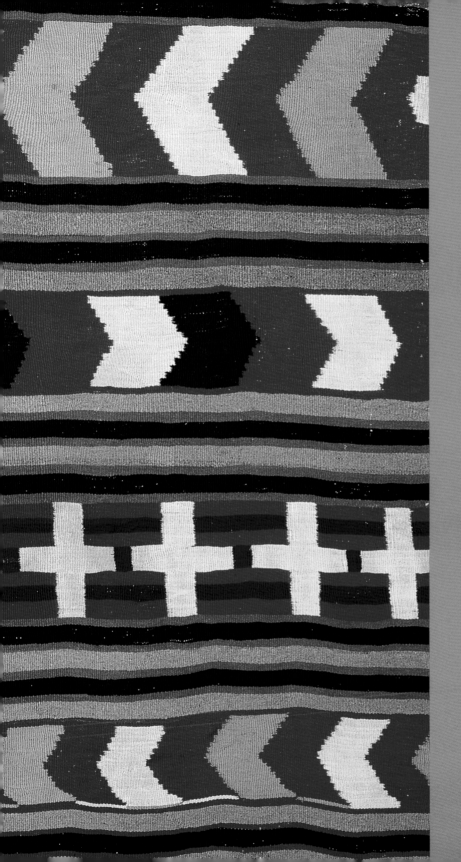

The Southwest and Far West

The Southwest is a vast geographic territory that includes New Mexico, Arizona, and the southern sections of Colorado, Utah, and Nevada and extends into the northern Mexican states of Sonora and Chihuahua. The area is especially noted for its dramatic, towering red rock formations, epitomized by those found in Monument Valley, and for its vertiginous canyon lands, including the world-famous Grand Canyon. This arid region is nevertheless a mixed environment of deserts, plateaus (or mesas), and mountains and is the habitat for many distinctive types of flora and fauna, such as the speedy roadrunner and the large, tree-like saguaro cactus. This enormous area, as well as the lands even farther west comprising much of the present state of California, has long been home to a diverse body of Native Americans: numerous Puebloan peoples; the Southern Athapaskan tribes known as the Diné (Navajo) and Apache; the River Yuman, Plateau Yuman, O'odham, and others; and numerous California peoples.

When Spanish colonists entered the Southwest in the sixteenth century searching for gold and converts, they encountered many Native Americans living in numerous small communities they called *pueblos* (fig. 18). This Spanish word for "village," still in use today, means "people." The Spanish used the term to identify people who lived in flat-roofed homes made of adobe or stone, sometimes two or three stories high, clustered around plazas. Puebloan religious life centered on a structure—often partly underground—known as a *kiva*, and featured numerous *kachinas*—supernatural beings who served as intermediaries between living people and the gods. Kachinas were personified by Indians through masks and costumes worn in dances and ceremonies, and small kachina dolls were fashioned to teach young children the differences between the many different spirits.

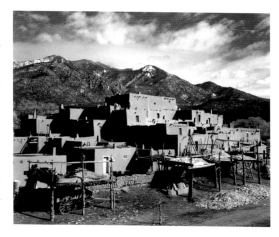

fig. 18. *Taos Pueblo, New Mexico,* 1941. Photograph by Ansel Adams.

Today nineteen pueblos are located in New Mexico, and the several Hopi villages are in Arizona. Although they share much in common in terms of religion and cultural belief, the Puebloan people speak six different languages: Keres, Tewa, Tiwa, Towa, Hopi, and A:shiwi (Zuni). Each community is a separate entity with its own rules, regulations, customs, taboos, and traditions.

Central to the material culture of the Puebloan people is the art of pottery making. Ancient pottery from the Southwest, featured in chapter 2 of this book, was often a source of inspiration for modern artists who feel a kinship with their ancestors. Each potter—historically a woman, although men were also involved (now they are liable to be of either gender)—has a distinctive hand, but potters of a given pueblo largely work within the conventions of their community and thus produce objects that fall into identifiable groups in terms of their materials and designs. Initially, these vessels played significant roles as functional objects for eating, drinking, storage, and other purposes, but their production as trade goods, especially after the introduction of the railroad to the Southwest in 1880, has been an important part of Puebloan economic life for more than a century. Today the art of pottery making is alive and well in many pueblos, with artists in each community producing work that honors historic traditions. Each vessel has great meaning for its maker, who respects the earth of which it is made, the continuation of tradition that it represents, and the symbolism—often referencing life-giving rain—that it embodies.

Jewelry is another artistic endeavor that continues to thrive in the pueblos, along with the creation of baskets, headdresses, musical instruments, and other objects. The jewelry made in Santo Domingo, Zuni, and elsewhere, often featuring mosaic work executed in shell and turquoise, animal carvings generally known as fetish figures carved in stone, or combinations of silver and turquoise, also draws on ancient prototypes.

fig. 19. **Concha belt, Diné** (Navajo), Arizona, about 1875–1900.

Unlike the Puebloan peoples, whose ancestors had occupied the land for millennia, the Diné and Apache arrived later from the Canadian north, perhaps about 1400. They lived in a widespread, noncentralized manner reflective of their hunting traditions and led a pastoral existence very different from the settled, agriculturally based life of the Puebloan Indians. Using horses, they hunted antelope, rabbits, and occa-

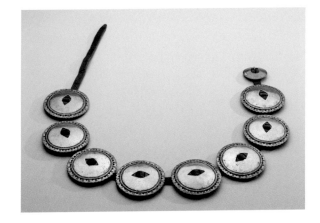

sionally buffalo. The Diné and Apache often engaged in warfare with the Pueblo Indians and the Spanish.

Today the Diné—the largest body of Native Americans in the country—live in the vast Navajo Nation in parts of New Mexico, Arizona, and Utah. Historically, they resided in hogans, small round dwellings, and many of them raised sheep, goats, and horses. The Diné are especially known for their weaving, which they learned from the Puebloan people, and for silversmithing, a craft in which they also excelled. They adopted the vertical loom, first weaving cotton and later using the wool that they began to raise about 1600. For centuries, as they developed their own geometric design vocabulary for blankets and, later, rugs, there has been a great market for Diné weaving. Their silver jewelry—concha belts (fig. 19), bracelets, squash-blossom necklaces, horse bridles, *ketohs* (wrist guards), and other forms, often embellished with turquoise—initially was based on techniques they learned from Mexican silversmiths in the 1860s.

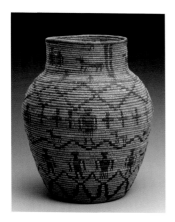
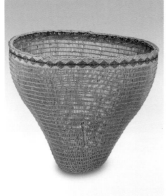

fig. 20. Jar, Western Apache, Southeastern Arizona (San Carlos or White Mountain Reserve), about 1880–90.

fig. 21. Gathering basket, Karuk (Karok), Northern California, 1880–1900.

The Apache are particularly known as great basket makers (fig. 20), initially fashioning them as functional objects and later for trade. Numerous Far West Native American tribes, particularly in California, are also extraordinary basket makers (fig. 21), although their work is not yet well represented in the Museum's collection. Using plant fibers in every aspect of their lives, they produced baskets not only of great utility but also of high aesthetic quality.

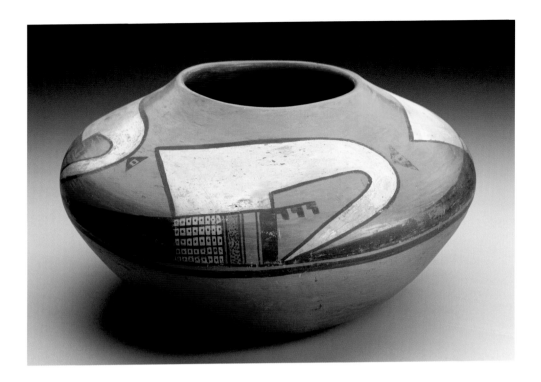

Nampeyo (Sand Snake)
Hopi-Tewa, 1860–1942
Seed jar
Hano village, First Mesa, Hopi, Arizona, 1904–10

Nampeyo of Hano—along with Maria Martinez of San Ildefonso and Lucy Lewis of Acoma—is one of the few Native American potters to gain relatively wide recognition by name, and she was undoubtedly the first. In the 1890s Nampeyo began making pottery based on ancient potsherds found near her home on First Mesa in Hopi, many of them in a style now known as Sikyatki Polychrome, which was made from about 1400 to 1625. This pottery, crafted from a yellow clay, featured black designs enhanced with red. Using those shards as a springboard, Nampeyo developed what has become known as the Sikyatki revival style. Her pottery was recognized for its high quality at an early date and has remained popular with collectors ever since.

Nampeyo's biographer Barbara Kramer has noted that large-diameter, low-profile jars of this type were one of Nampeyo's signature objects. According to one of Nampeyo's descendants, the distinguished potter Dextra Quotskuyva Nampeyo, the prominent white shape painted on this vessel represents the head of the bald eagle. The eagle continues to be an important sacred bird in Hopi religion; its plumes and feathers are thought to carry prayers to the gods of nature.

Earthenware with slip paint
H. 16.5 cm, diam. 32.4 cm (H. 6½ in., diam. 12¾ in.)
Museum purchase with funds donated by Independence Investment Associates, Inc. 1995.101

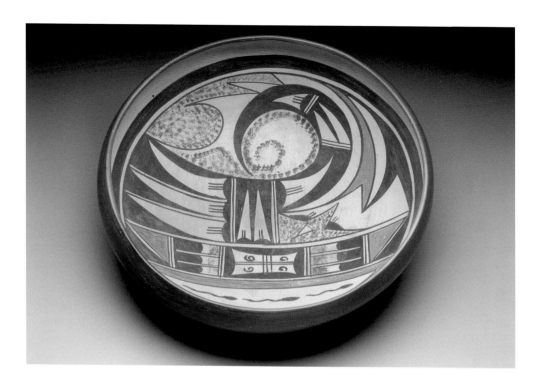

Attributed to **Tewanginema**

Hopi-Tewa, active 1900–1940

Bowl

Sichomovi village, First Mesa, Hopi, Arizona, 1920–40

Located in northeastern Arizona, the Hopi lands contain a number of villages situated atop or just below three principal mesas. This shallow, wide bowl probably was used for *piki*, a type of corn bread, although it has also been described as a fruit bowl. It was created in Sichomovi, a small village on First Mesa that, along with Walpi and Hano, is a Tewa-speaking community. First Mesa has been the center of pottery making in Hopi for many years.

This unsigned bowl is closely related in its details to several bowls and jars, now in the collection of the Museum of Northern Arizona, that were made by the Hopi-Tewa potter Tewanginema, who was active in the early twentieth century. The tripartite composition here contains a band of three tadpoles swimming in line; a narrow so-called sky band; and a large rendition of a mythical bird figure replete with feathers and scrolls.

Earthenware with red and black slip paint

H. 10.2 cm, diam. 34.3 cm (H. 4 in., diam. 13½ in.)

Gift of Laura F. Andreson 1984.626

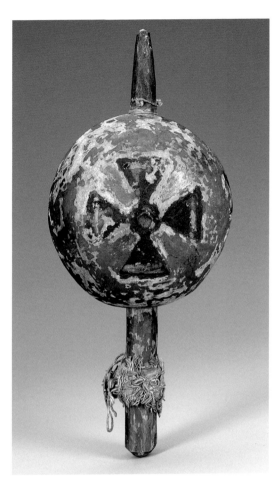

Rattle
Probably Hopi
Arizona, 19th century

Central to both sacred and secular music in the Southwest, rattles are found in multiple shapes and sizes, as varied as the species of gourds from which they are principally constructed. Rattles were often assigned very deliberate uses within musical settings that were typically known only to the practitioner. This rattle (*aaya*) was probably made for and used by the Hopi.

Dried and hollowed, this gourd is pierced by two holes, allowing a wooden handle to pass entirely through the center. The handle is secured by friction and a small wooden peg inserted at the top of the gourd. Several shades of green pigment cover the surface. The cross shape is symbolic of the four directions from which the winds and spirit beings come. This symbol—often misunderstood to be the Maltese cross of Christian traditions—is widespread in American Indian spirituality.

Gourd, wood, pigment
L. 28.7 cm, diam. 12.8 cm, d. 8.5 cm
(L. 11⅚ in., diam. 5⅛ in., d. 3⅜ in.)
Leslie Lindsey Mason Collection 17.2235

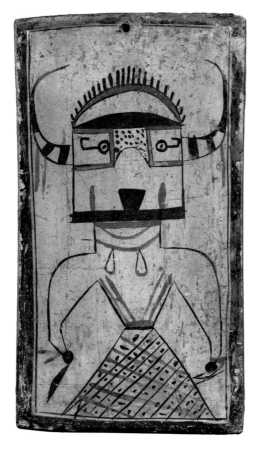

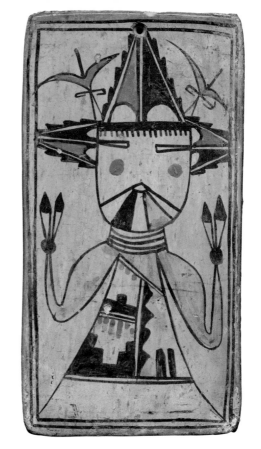

Tile with a warrior or guard kachina
Tile with Palhikwmana kachina
Hopi
Hopi Pueblo, Arizona, about 1892–99

These tiles represent a blend of American Indian pottery-making skills with Anglo marketing concepts. Thomas Varker Keam, an Arizona trader, and his partner Alexander M. Stephen are generally credited with developing the idea in the 1880s of commissioning Hopi potters to produce small tiles—a form not normally made by Native potters—in various shapes for sale to tourists. This scheme proved to be remarkably fruitful, and the tile business flourished in Hopi and nearby pueblos into the 1920s until the Great Depression.

These early examples from the 1890s depict kachinas (ancestral spirit beings), as do most such tiles, although images of birds, plants, and other subjects are also known. The two kachinas represented here are among the more than five hundred who interact with humans as part of Puebloan religion, especially as practiced among the Hopi and A:shiwi (Zuni). Whereas the tile on the left bears an image that is probably that of a warrior or guard kachina, the example on the right has a more readily identifiable image of Palhikwmana Moisture Drink Maiden, or Poliimana or Butterfly Maiden in various versions. To facilitate hanging in late-Victorian interiors, a hole was made in the top of each tile, created by inserting a small round stick into the formed clay, which would burn away during firing.

Earthenware with slip paint
1998.5: H. 18.1 cm, w. 9.8 cm, d. 1.3 cm
(H. 7⅛ in., w. 3⅞ in., d. ½ in.)
1998.6: H. 18.4 cm, w. 10.5 cm, d. 1.3 cm
(H. 7¼ in., w. 4⅛ in., d. ½ in.)
Seth K. Sweetser Fund 1998.5–6

Water jar

Acoma

Acoma Pueblo, New Mexico, 1880–1900

Perched high atop a towering mesa in central New Mexico, Acoma, also colloquially known as Sky City, is one of the most magnificently sited villages in the world. Inhabited for at least a thousand years, the village is also one of the oldest continually occupied communities in the United States. Its geographical and physical isolation provided inhabitants with a degree of independence that allowed them to retain a largely preindustrial, traditional way of life—which early visitors often noted and romanticized (fig. 22)—well into the twentieth century.

Acoma pottery, such as this late-nineteenth-century example, has been made for centuries from a deposit of locally dug clay. The inherent plasticity of this natural material permits the potter to fashion lightweight vessels with thin, hard-fired walls that can accommodate a precise painting style.

A water jar such as this example was used to collect water from rivers, wells, and cisterns and to transfer it back to the pueblo. Many were fashioned with a concave base to facilitate transport on one's head. Evidence of Native use on this serviceable jar, such as the wear around the rim, indicates that it was employed in this manner before it was collected in the late nineteenth or early twentieth century.

Earthenware with black and red slip paint
H. 29.8 cm, diam. 26.7 cm (H. 11¾ in., diam. 10½ in.)
Museum purchase with funds donated by Anne and Joseph P. Pellegrino 1988.290

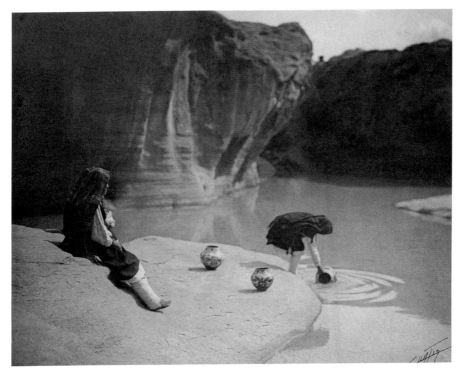

fig. 22. Edward S. Curtis (1868–1952), *At the Old Well of Acoma*, 1904.

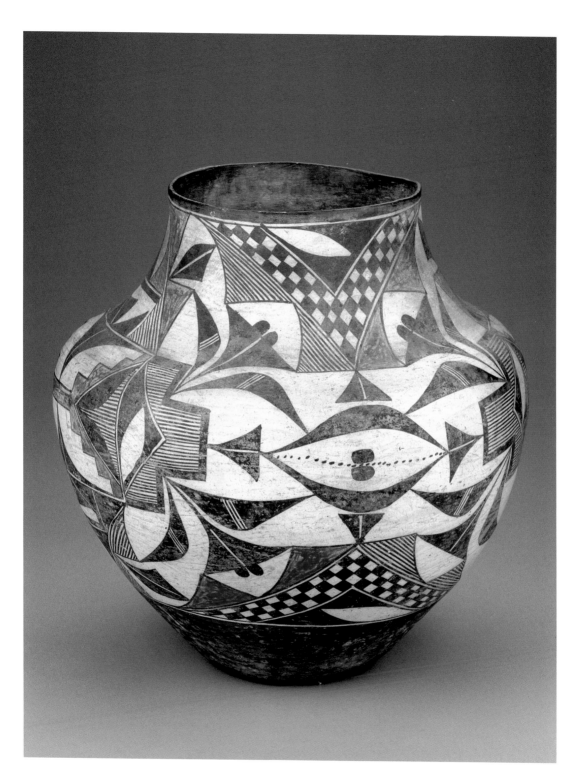

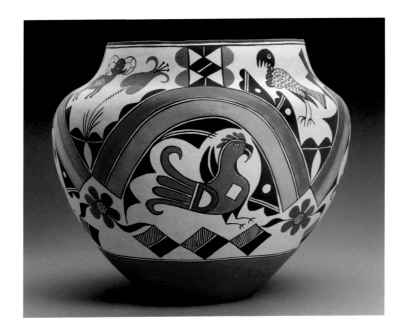

Frances Torivio (Sra-ma-tyai, or Singing Child)

Acoma, 1905–2001

Storage jar

Acoma Pueblo, New Mexico, 1987

Notable for its large size and elaborate iconography, this storage jar is perhaps the masterwork of Frances Torivio, one of Acoma's most accomplished artists, who made it when she was about eighty-two years old. She envisaged it as the representation of a hunting scene, with lively images of bighorn sheep and turkeys around the rim, as well as with floral and other landscape elements. She also included a parrot—a common Acoma motif since the mid-nineteenth century—prominently at front and center. Parrots are revered in Acoma for a variety of reasons: with their bright and varied colors, they are associated with rainbows and hence rain; they are also thought to serve, along with other types of birds, as spirit messengers to the gods.

Thinly walled and painted with great expression and painstaking precision, Torivio's jar is the embodiment of the qualities that define Acoma pottery and that have made it prized by collectors and museums. Three of Torivio's daughters are potters, including Maria Lilly Salvador, whose pottery also represents the finest in modern Acoma work (fig. 23).

Earthenware with slip paint
H. 31.1 cm, diam. 36.8 cm (H. 12¼ in., diam. 14½ in.)
Museum purchase with funds donated by Daniel and
Jesse Lie Farber 1987.223

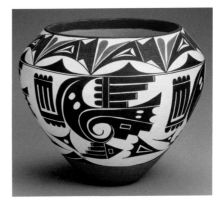

fig. 23. Maria Lilly Salvador (Acoma, born in 1944), water jar, Acoma Pueblo, New Mexico, 1984.

Velma Chino (Tsninahzite)

Acoma, born in 1931

Jar

Acoma Pueblo, New Mexico, 1993

The so-called fine-line painting on this pot by Velma Chino is an excellent representative of a characteristic type of Acoma pottery decoration. Prehistoric in origin, this style of precise painting was revived in the 1940s and 1950s at Acoma, and it quickly became closely associated with the work of Lucy Lewis (1900–1992), perhaps the most famous twentieth-century potter from Sky City, as well as Marie Z. Chino (1907–1982) and Jesse Garcia (about 1910–1990). Fine-line pottery remains one of the most popular types of Acoma wares.

Chino probably applied her pigment in the Acoma tradition, using a brush prepared from the leaves of the yucca plant. Typically, yucca leaves are first removed from the plant, and the fibers of individual leaves are softened by chewing until they separate into strands resembling bristles. These strands are then gathered together in an appropriate width (the more strands there are, the wider the brush), tied together, and trimmed to an even length. Skilled painters such as Chino are able to achieve great precision with these simple brushes. Here she has used variations on a single pattern, painted repeatedly to cover the entire surface of the narrow-necked vessel.

Earthenware with slip paint
H. 19.1 cm, diam. 22.9 cm (H. 7½ in., diam. 9 in.)
Museum purchase with funds donated by Mr. J. Richard Klein and Dr. and Mrs. Gerald Entine 1993.673

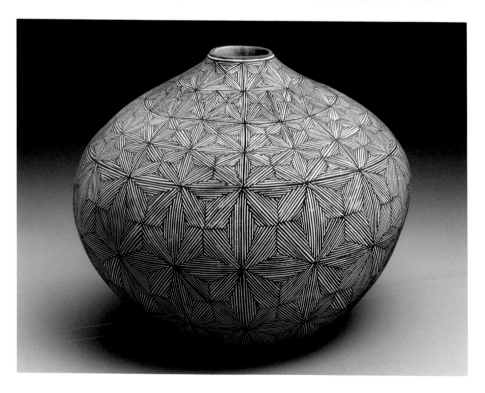

Evelyn Cheromiah (Sru tsi rai)

Laguna, born 1928

Water jar

Laguna Pueblo, New Mexico, 1993

Laguna is one of the more recent pueblos, founded officially on July 4, 1699. Initially it was settled by Indians from many other villages seeking refuge after the 1690s Spanish reconquest following the Pueblo Revolt of 1680. Historically, pottery making in Laguna has been of a modest scale; the objects are closely related, in terms of style and materials, to those produced in much larger quantities at Acoma, twenty-five kilometers (sixteen miles) to the southwest.

This exquisitely painted water jar by Evelyn Cheromiah is an outstanding example of Laguna pottery by one of its twentieth-century masters. Here Cheromiah has used a large central motif with triangles to represent butterflies (at left and right) and flowers (in the figure eight at top and bottom). These symbols represent significant elements of the landscape in which deer, revered by the Laguna people, live. Cheromiah explains that "the deer's house is beautiful outside, with flowers and butterflies." Repetitions of this motif are separated by cross-hatched designs signifying all-important rain descending from black clouds.

Along with Gladys Paquin and others, Cheromiah revived Laguna pottery making in the early 1970s; today her daughter Lee Ann is among those who maintain the tradition. Cheromiah, commenting on her work in 1993, noted the importance of continuing "our traditions as did our ancestors." "[T]he higher power & mother earth give me the talent & strength to do traditional pottery. I talk to the clay woman & spirits of long ago to work with me, when doing pottery, & it comes much ... easier." Such veneration of "mother earth" and the "clay woman" or "clay mother" is common among Southwest potters.

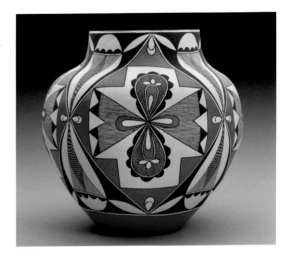

Earthenware with slip paint
H. 23.2 cm, diam. 24.1 cm (H. 9⅛ in., diam. 9½ in.)
Museum purchase with funds donated by The Seminarians
1993.671

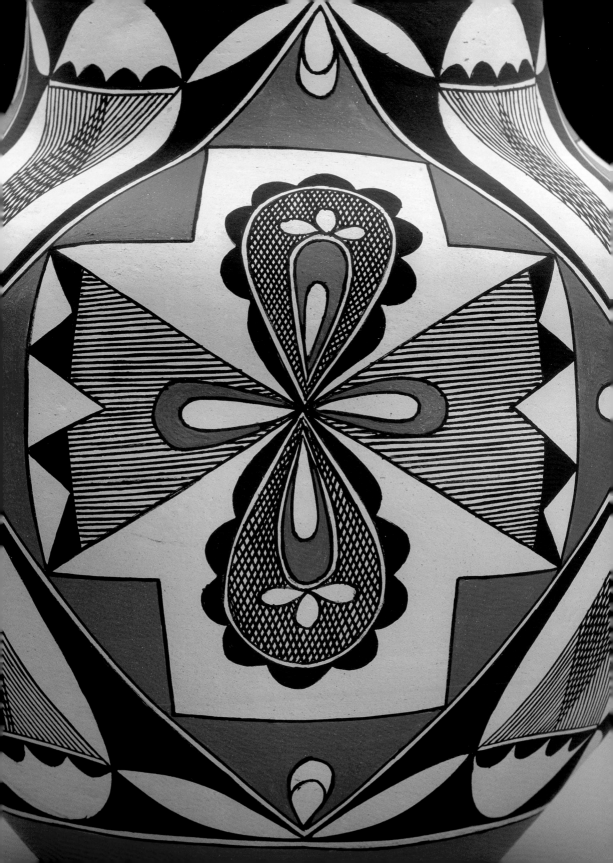

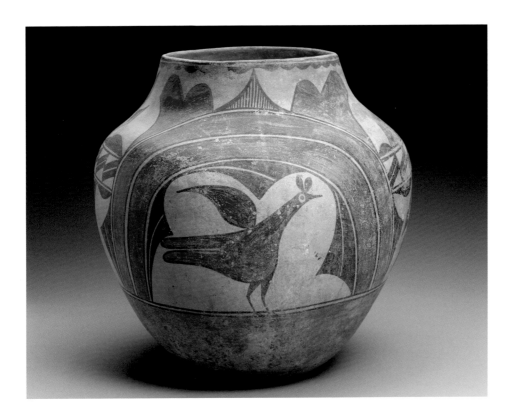

Jar

Zia

Zia Pueblo, New Mexico, about 1920

Beginning about 1820 and continuing into the twentieth century, much of the pottery made at Zia Pueblo was decorated with images of birds. The bird seen here—sometimes referred to as a roadrunner (now the state bird of New Mexico) but often simply called a Zia bird by potters and scholars alike—is characteristic of those found on Zia pots made roughly between 1880 and 1930, although there are many variations in detail. Here it is framed within rainbow arcs, another motif found on many Zia vessels.

Although it flourished in the sixteenth and seventeenth centuries, Zia was virtually destroyed by the Spanish in the Pueblo Revolt of 1680. It was eventually rebuilt, but Zia remains a small pueblo. Pottery has always been one of its principal products, both for internal use and subsequently for commercial trade. Zia pottery is tempered with locally obtained ground basalt, giving it a pronounced hardness.

Earthenware with slip paint
H. 31.8 cm, diam. 33 cm (H. 12½ in., diam. 13 in.)
Museum purchase with funds donated by The Seminarians and an anonymous donor in honor of Bertram J. Malenka
1993.665

Eusebia Toribio Shije (Kirani')
Zia, born in 1936
Water jar
Zia Pueblo, New Mexico, 1985

Recent scholarship has identified more
than forty potters active in Zia in the
twentieth century, and others undoubt-
edly remain unidentified. The most promi-
nent member of the older generation was
Trinidad Medina (1883/84–1969), who was
taken by the trader Wick Miller on a tour
of department stores across the United
States in the 1930s and 1940s. Her travels
also included a demonstration of pottery
making at the Century of Progress Expo-
sition held in Chicago in 1933, which
helped to bring Southwest Native Ameri-
can pottery to a wider audience.

Featuring many of the same motifs as
the older Zia jar opposite, this example by
Eusebia Shije demonstrates the strong
elements of continuity in Zia pottery as
well as her own sprightly painting style,
especially evident in the lively stance of
her Zia bird. Shije began making pottery
in the 1950s, and this large example of her
mature work was awarded a prize at the
sixty-fourth annual Indian Market in
Santa Fe in 1985.

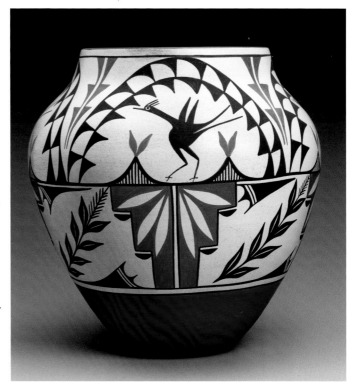

Earthenware with slip paint
H. 26 cm, diam. 26 cm
(H. 10¼ in., diam. 10½ in.)
Museum purchase with funds donated by
a Friend of the Department of American
Decorative Arts and Sculpture 1985.454

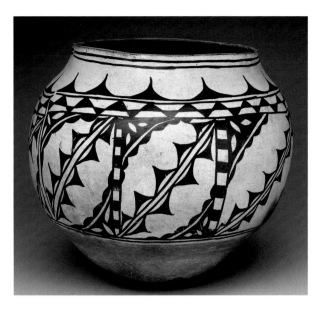

Storage jar

Cochiti or Santo Domingo

Cochiti or Santo Domingo Pueblo, New Mexico, 1860–1870s

The pueblos of Cochiti and Santo Domingo share the Keres language and are located only a few miles apart, one on each side of the Rio Grande in northern New Mexico. Historically, their pottery has been influenced by that produced at the adjacent Tewa-speaking pueblos to the north, such as San Ildefonso, Santa Clara, and Tesuque. The geometric, black-on-cream painting on this jar is in a style known today as Kiua Polychrome and has been made in both Cochiti and Santo Domingo. The survival of this large vessel in good condition is probably due to its use in a Native home in a little-used storage area, where it avoided damage from frequent handling.

Earthenware with slip paint
H. 45.7 cm, diam. 52.7 cm (H. 18 in., diam. 20¾ in.)
Museum purchase with funds donated by Independence
Investment Associates, Inc. 1997.175

Storage jar

Santo Domingo

Santo Domingo Pueblo, New Mexico, 1920–30

Santo Domingo, one of the most culturally conservative pueblos, is known for its turquoise jewelry (see pp. 96–97) and pottery in traditional modes. This large bulbous jar is painted in the bold manner characteristic of Santo Domingo pottery; its black-and-cream-colored design features a band of large circles above a lower repeat of leaves that alternate direction, creating a zigzag pattern. It was probably made for the storage of grain or bread.

The vessel is girdled with a framework of rawhide binding that, while perhaps not original, has been in place for some time. Such rawhide support was usually added to pots to strengthen them after they had cracked; here, however, the object remains in good condition. It is possible that the rawhide was applied to make it easier for the user to grip and lift such a bulky object.

Earthenware with slip paint, rawhide
H. 35.6 cm, diam. 48.9 cm (H. 14 in., diam. 19¼ in.)
Otis Norcross Fund 1998.4

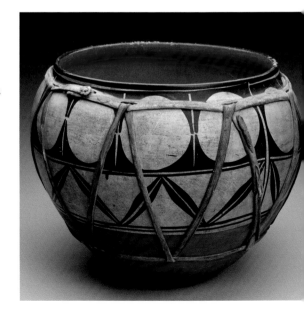

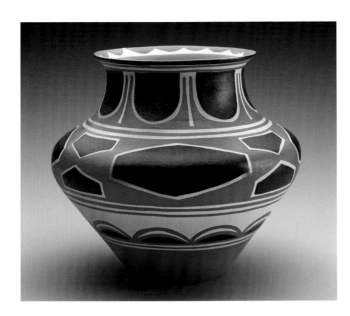

Robert Tenorio
Santo Domingo, born in 1950
Water jar
Santo Domingo Pueblo, New Mexico, about 1993

An acknowledged master potter and teacher in his family, Robert Tenorio was first exposed to pottery making during his years as a student at the Institute of American Indian Arts in Santa Fe from 1969 to 1971. Although he learned more-modern techniques there, throughout his long career he has preferred to work in traditional ways, honoring his Santo Domingan heritage while retaining a love for experimentation and a willingness to draw upon a variety of design sources.

In this instance, the geometric design of this water jar—in red and black paint with a cream ground barely visible as a demarcation between the shapes—is a his-

torical reference to a type of Santo Domingo pottery. Known as the Aguilar style, the design was developed about 1900 by three female potters named Cate (one of whom was married to a man named Aguilar). Tenorio's jar is based on an example of the Cates' work in the collection of the School of American Research in Santa Fe, one of the great repositories of Southwest Native American art.

Earthenware with slip paint
H. 24.1 cm, diam. 24.1 cm (H. 9½ in., diam. 9½ in.)
Museum purchase with funds donated by
Mr. and Mrs. Daniel Morley 1993.672

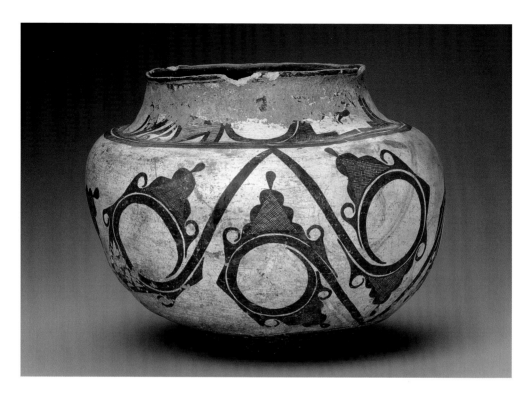

Water jar
A:shiwi (Zuni)
Zuni Pueblo, New Mexico, 1820–40

The A:shiwi (Zuni) Pueblo, located near the Arizona border, is the westernmost New Mexican pueblo. The A:shiwi people have occupied Zuni Pueblo lands for more than a millennium and speak their own distinct language. By the mid-sixteenth century, when they first encountered the Spanish, the A:shiwi lived in six or seven small villages, which the Spanish hoped were the legendary Seven Cities of Cibola, reputedly rich in gold and treasure. Much later, in the late nineteenth century, Zuni Pueblo became the focus of intense study by early anthropologists and ethnographers who sought to understand its religion, customs, and material life before it vanished.

Dating from the early to mid-nineteenth century, this jar was collected during the period of late Victorian fascination with A:shiwi life. For its visual success, it relies upon the rhythmic repetition of a capped spiral design around its circumference, an element of an A:shiwi style known as Kiapkwa Polychrome. This highly abstract motif consists of a circular spiral with a long tapering tail, with crosshatched triangular caps on each side flanked by scrolls. These spirals are an early version of the rainbird motif, which became a standard part of the A:shiwi decorative vocabulary about 1870 (see p. 86). The rim, damaged from Native use, is also painted with images of small birds, probably a reference to the significant role birds played in Zuni religion and cosmology. Although the form of this vessel suggests it was a water jar when new, scientific testing has determined that it was used to hold indigo dye later.

Earthenware with white and black slip paint
H. 27.9 cm, diam. 34.5 cm (H. 11 in., diam. 13⁹/₁₆ in.)
Gift of Mrs. George A. Goddard 02.850

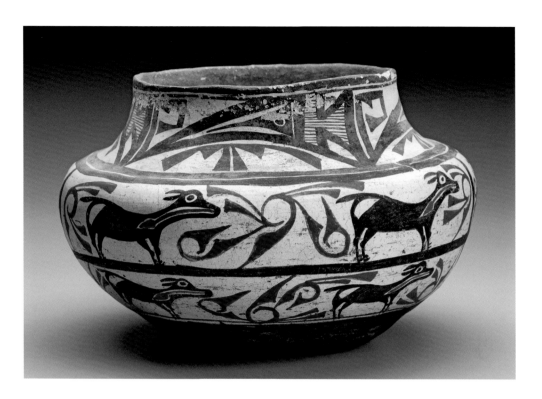

Water jar

A:shiwi (Zuni)

Zuni Pueblo, New Mexico, about 1860–80

The animal motif on this vessel, usually described as a deer but which might also represent an elk or antelope, began to be used on A:shiwi (Zuni) pottery at about the time this example was made, in the 1860s or 1870s; it remains in much use today. Such animals also began to be shown at this time with the so-called heart-line motif, very popular in A:shiwi but also used on Hopi, Acoma, and Laguna pottery, in which a painted line, usually red, extends from the mouth of the deer and terminates in a heart-shaped arrow planted deep in the animal's chest. The feet of the animals are also painted here in a characteristic A:shiwi manner, with one hoof above the other on each leg; each animal is shown with an open area at its rump, another convention typical of this design.

The heart-line motif may be a reverent allusion to the sacred breath of life of the animal depicted. Frank Hamilton Cushing recorded an A:shiwi legend in which a young hunter who has shot his prey with an arrow is provided with instructions to follow: "should he fall, quickly go to him, throw your arms around him, put your lips close to his, breathe in his breath, and say, 'Thanks, my father, this day I have drunken your sacred wind of life.'"

Earthenware with red, black, and brown slip paint
H. 16.5 cm, diam. 25.4 cm (H. 6½ in., diam. 10 in.)
Gift of Charles Greely Loring 93.8

Water jar
A:shiwi (Zuni)
Zuni Pueblo, New Mexico, about 1880

This polychrome jar represents many of the distinguishing characteristics of A:shiwi (Zuni) pottery as it had evolved by the second half of the nineteenth century. Made of a whitish clay, the pot is brightly painted in red, brown, and black against a ground of white slip. It bears a fine rendition of the A:shiwi rainbird symbol, the highly abstract motif that dominates its body and that was used repeatedly in this conventionalized form on A:shiwi pottery by the late nineteenth century. (An earlier version is seen on the vessel on p. 84.) Ancient in origin, the elements of the rainbird motif, including the coil (sometimes containing a small dot or circle suggesting a bird's eye), fretwork, and stepped designs, may initially have served as a form of symbolism referencing birds, feathers, clouds, and rain, as well as ceremonial bows, feathers, drumsticks, and other objects.

As with most of the New Mexico pueblos, pottery making suffered a decline in Zuni before being revived in the mid- and late twentieth century by Daisy Hooee Nampeyo, Jennie Laate, Milford and Joseph Nahohai, and others. In addition to being known for their pottery, A:shiwi artisans are renowned for their silver and turquoise jewelry, featuring "embroidery" techniques, and for carved-stone animal fetishes.

Earthenware with red, brown, and black slip paint
H. 27.9 cm, diam. 33 cm (H. 11 in., diam. 13 in.)
Everett Fund 87.25

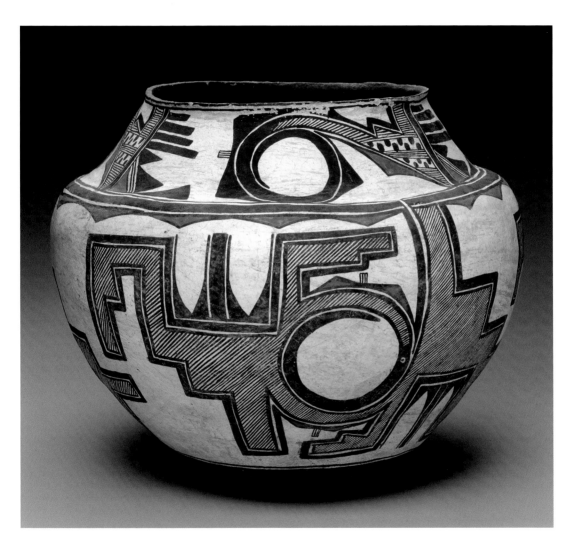

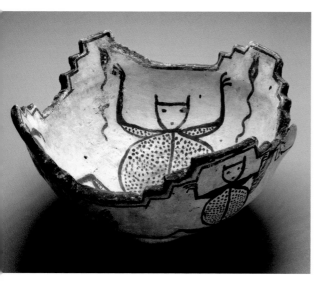

In common with many other examples of the form, this bowl has an angular stepped rim, suggesting clouds; some other examples are also fitted with an arched handle to create a basket, and others have a wavy, rather than terraced, rim. The bowl is painted inside and out with images of a large frog and smaller tadpoles and dragonflies, which are associated with water and fertility. This iconography is distinctive to these bowls in A:shiwi pottery, and differentiates them from other bowls and jars made for daily household use.

Earthenware with black and white slip paint
H. 8.9 cm, diam. 19.1 cm (H. 3 ½ in., diam. 7 ½ in.)
Everett Fund 87.30

Corn or prayer-meal bowl
A:shiwi (Zuni)
Zuni Pueblo, New Mexico, about 1880

According to the early anthropologist James Stevenson, in a field report compiled for the Smithsonian's Bureau of Ethnology, the A:shiwi used bowls with terraced rims, such as this small example, "only in their sacred and ceremonial dances." This vessel may have served as a prayer-meal bowl for an individual or a family, as opposed to larger examples the community used in the *kiva* (the community's spiritual center). Finely ground dry cornmeal, or a mixture of cornmeal and turquoise, would be placed in the center, and during certain ceremonies or blessings, a pinch of the meal would be taken and symbolically cast on various sacred objects or on the heads of people leading the ceremonies.

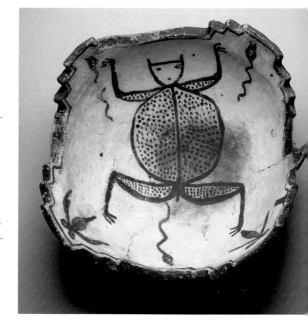

Owl effigy

A:shiwi (Zuni)

Zuni Pueblo, New Mexico, about 1880–92

In common with many cultures, the A:shiwi (Zuni) people regarded the owl as a symbol of wisdom, and owls figure in their creation stories. Representations of owls such as this example have long been eagerly sought as souvenirs by tourists visiting the Southwest. Although A:shiwi clay owls were especially popular in the first quarter of the twentieth century, this earlier figure was acquired in the late nineteenth century, when it caught the eye of General Charles G. Loring, then the MFA's curator, who subsequently gave it to the Museum in 1893 (see also p. 15).

Owls, along with storyteller figures and other figural works, continue to be a significant part of the stock-in-trade for Southwest potters. For example, Quanita Kalestewa, a contemporary A:shiwi potter, makes a specialty of owls, finding them quicker and easier to make than larger bowls. She has observed that although the origins of the popularity of the owl in Zuni Pueblo have become obscure, "our grandfather used to tell us that owls helped us fight in the wars a long time ago. The owl would warn people that something is out there and they should be alert. The owl is a symbol of luck for us, but for the Navajos and Apaches, the ones that used to raid the Zunis, for them it was a symbol of death. I didn't think that the owl was associated with anything bad in Zuni."

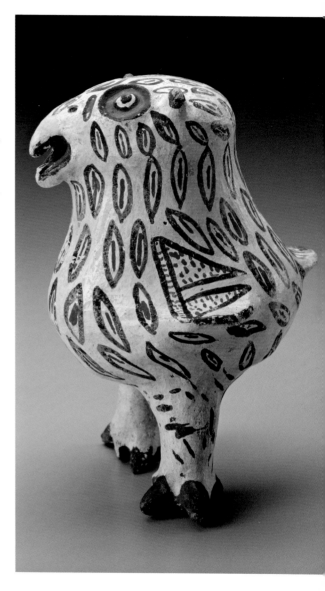

Earthenware with white, brown, and red slip paint
H. 18.4 cm, w. 12.7 cm, d. 12.7 cm (H. 7¼ in., w. 5 in., d. 5 in.)
Gift of Charles Greely Loring 93.1499

Attributed to **SaraFina Gutierrez Tafoya (Ka-saweh, or Autumn Leaf)**

Santa Clara, about 1863–1949

Water jar

Santa Clara Pueblo, New Mexico, about 1890

Earthenware with polished slip

H. 25.4 cm, diam. 29.8 cm (H. 10 in., diam. 11¾ in.)

Gift of Laura F. Andreson 1984.632

Made by **Margaret Tafoya (Kohn Powi, or Corn Blossom)**

Santa Clara, 1904–2001

Carved by **Alcario Tafoya**

Santa Clara, 1900–1995

Water jar

Santa Clara Pueblo, New Mexico, about 1963

Earthenware with polished and unpolished slip

H. 43.8 cm, diam. 33 cm (H. 17¼ in., diam. 13 in.)

Museum purchase with funds donated by John S. Montgomery

1996.334

Toni Roller (**Ka-Tsawe, or Green Leaves**)

Santa Clara, born in 1935

Jar

Santa Clara Pueblo, New Mexico, 1999

Earthenware with polished and unpolished slip

H. 25.7 cm, diam. 22.2 cm (H. 10⅛ in., diam. 8¾ in.)

Museum purchase with funds donated by John S. Montgomery

1999.448

In Puebloan society up to the late twentieth century, pottery making was a woman's occupation, and techniques were passed from one generation to the next through the maternal line. The work of the mother, daughter, and granddaughter of one pottery-making family from Santa Clara Pueblo exemplifies that tradition.

Santa Clara pottery is best known for its black or red glazes and the bear-paw print, both of which are represented here by the elegant early water jar by SaraFina Gutierrez Tafoya (top left). According to members of her family, several generations of potters preceded SaraFina, who was born in the 1860s.

Her daughter Margaret Tafoya learned pottery while playing at her mother's knee, and in time she became one of the most distinguished Native American potters. Her water jar (top right) features an image of Avanyu, the important rain-bringing serpent, carved by Alcario Tafoya, her husband.

Avanyu is also depicted in slightly different fashion encircling the tall water jar (bottom) of Margaret's daughter, Toni Roller, who, along with several of her sisters, trained with her mother. Three of Roller's children and two of her grandchildren are also potters, continuing a line of potters than now spans more than eight generations.

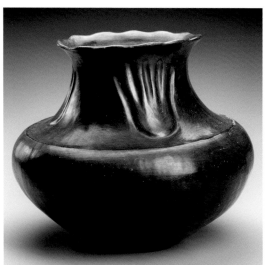

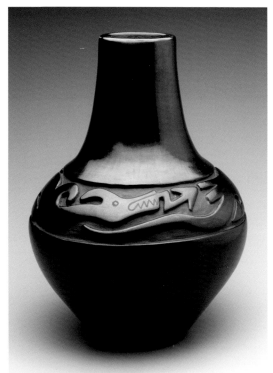

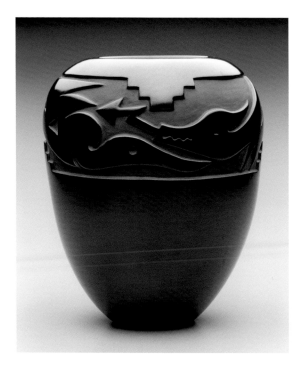

Attributed to **SaraFina Gutierrez Tafoya**
(Ka-saweh, or Autumn Leaf)
Santa Clara, about 1863–1949
Wedding jar
Santa Clara Pueblo, New Mexico, about 1890

Popularly called a wedding vase today, double-spouted jars of this type were and are created by potters in several of the northern New Mexico pueblos, perhaps most prominently in Santa Clara. Such wedding vases, made by the family of the groom, are used in nuptial ceremonies, in which the man drinks from one side and the bride from the other. The dual spouts represent the two individuals entering into marriage, and the arched piece that connects the spouts represents the bond formed by their union.

Although unsigned, details of ornament and workmanship—the series of thumb-print indentations circling the vase above its midpoint, the flaring double spout, and the arched handle—allow the contemporary Santa Clara potter Toni Roller to identify this vase as the work of her grandmother, SaraFina Gutierrez Tafoya. Here slip was not applied to the lower half of the vessel, and the slip of the upper half emerged from firing a deep red.

Earthenware with polished slip
H. 31.8 cm, diam. 27.9 cm (H. 12½ in., diam. 11 in.)
Gift of Professor Emeritus F. H. Norton and the Department of Metallurgy and Materials Science at the Massachusetts Institute of Technology 1971.567

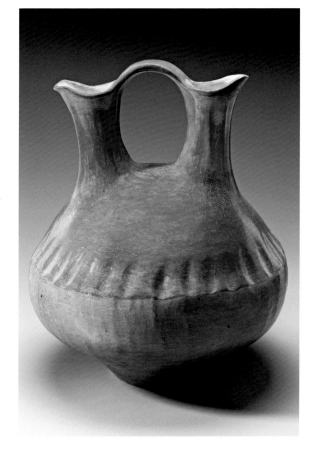

Helen Shupla (Kahtséh, or Yellow Leaf)

Santa Clara, 1916–1985

Melon jar

Santa Clara Pueblo, New Mexico, 1985

Earthenware with polished slip

H. 10.2 cm, diam. 13 cm (H. 4 in., diam. 5⅛ in.)

Museum purchase with funds donated by a Friend of the Department
of American Decorative Arts and Sculpture 1985.452

Melon jar

Santa Clara Pueblo, New Mexico, 1984

Earthenware with polished slip

H. 20.3 cm, diam. 23.2 cm (H. 8 in., diam. 9⅛ in.)

Alice M. Bartlett Fund 1986.259

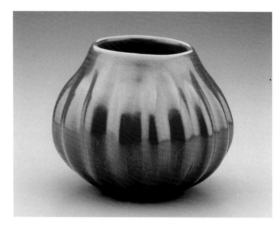

Helen Shupla, the maker of these two vessels,
achieved their remarkable luster through vigorous
stone polishing. Each pot was essentially crafted in
the same fashion, until the firing stage. Although the
two vary considerably in size, each is fashioned
from coiled layers of clay, smoothed and shaped by
hand and with small tools to achieve the ribbed, gour-
dlike shape. Shupla then applied several layers of a
thick clay slip with a brush. The slip was polished
with stones until it became smooth and shiny; then
the pot was ready for firing.

By controlling the way the fire burns during firing,
potters can affect the final color of objects. If the fire
is smothered with dry, pulverized horse manure, the
oxygen supply will be cut off, and the pot will turn
black. Such burnished black wares were and remain
a specialty of Santa Clara potters. If the fire is left to
burn without smothering, the pot will emerge red in
color, as seen here on the smaller vessel.

Although it may be based on ancient prototypes, the
form of these melon jars gained great popularity in the
late nineteenth and early twentieth centuries, when it
struck a resonant chord with the growing number of
collectors and tourists visiting the Southwest.

Made by **Maria Montoya Martinez (Poveka, or Water Pond Lily)**

San Ildefonso, 1887–1980

Painted by **Julian Martinez (Po'kanu, or Animal Kingdom)**

San Ildefonso, 1885–1943

Bowl

San Ildefonso Pueblo, New Mexico, 1919–20

Maria Martinez (often known simply as Maria) of San Ildefonso Pueblo was one of the foremost Pueblo potters of the twentieth century. Her development and eventual mastery of black-on-black burnished wares made that style virtually synonymous with San Ildefonso and brought her (and many of her fellow Native Americans) widespread acclaim throughout the United States and the world. Maria made the pottery, and her husband Julian, an accomplished artist, decorated it. After Julian's death, Maria collaborated with her daughter-in-law Santana and son Popovi Da as her long career continued.

This important, early experimental bowl reflects a crucial moment in the development of the techniques needed to make black-on-black pottery. Already an established potter within her family and community, Maria was encouraged in the early twentieth century by Edgar Lee Hewett and Kenneth Chapman of the Museum of New Mexico to investigate a modern interpretation of prehistoric black pottery. Here, Julian painted the Avanyu (water serpent) design on the bowl, and then Maria carefully polished around the painted design prior to firing. This made polishing a slow and delicate task, and even then the matte-black painted design needed to be touched up after polishing.

Later Maria and Julian realized that it was more efficient to reverse the process, by polishing the entire vessel first and then painting out the images that were meant to appear matte in the final product. Oxygen deprivation during firing transformed the color of the iron-rich clay to black. This revised method became the regular practice for Maria and other San Ildefonso potters and is now the pueblo's signature style.

Earthenware with polished and unpolished slip
H. 21.6 cm, diam. 33 cm (H. 8½ in., diam. 13 in.)
Museum purchase with funds donated by Independence Investment Associates, Inc. 1996.241

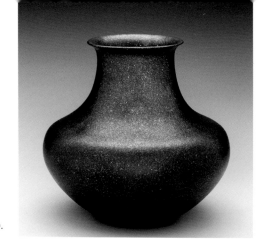

Myrtle Cata
San Felipe/San Juan, born in 1953
Water jar
San Juan Pueblo, New Mexico, 1991

Born in San Felipe Pueblo, Myrtle Cata moved to San Juan at the time of her marriage in 1977. She continued her independent study of pottery making in that northern Tewa village, adopting the San Juan style and materials, and began selling her work about 1980. She obtains her clay from the mountains near La Madera and prepares her vessels in the traditional manner. This water jar was selected for the Museum from among the pots displayed in the back of Cata's pickup truck at the San Felipe Corn Dance in 1991, an event, like many other similar gatherings, at which the marketing of a wide variety of wares took place in conjunction with the ceremony.

Cata's water jar is an extraordinary example of a Native American potter's ability to create a stunning work of art through the deceptively simple use of materials and form. The coiled vessel, wider than it is tall, has a boldly curved, vase-shaped profile. Cata takes advantage of the glistening flecks of mica in her clay and the temper it was mixed with, and through the extra step of stone polishing brings out a subtle tonality of shades and colors in the characteristically undecorated jar.

Micaceous earthenware with polished slip
H. 21.6 cm, diam. 29.8 cm (H. 8½ in., diam. 11¾ in.)
Museum purchase with funds donated by The Seminarians in honor of Jonathan L. Fairbanks 1991.472

Lonnie Vigil
Nambe, born in 1949
Water jar
Nambe Pueblo, New Mexico, about 1995

One of eight northern pueblos in New Mexico, the small village of Nambe, in common with many of its neighbors, is noted for its cooking and storage earthenware vessels fashioned from local clays rich in mica. Lonnie Vigil has been in the forefront of Nambe pottery since the early 1980s, when he returned home after a career in business and finance in New Mexico and Washington, D.C.

On March 4, 1982, while in Washington, Vigil attended a stage and art show at the Kennedy Center for the Performing Arts entitled "Night of the First Americans," a performance written by Phil Lucas, a Choctaw filmmaker. Although this show was controversial at the time (it included performances and works by people who falsely claimed to be Native Americans), it served as an epiphany for Vigil. He was inspired to return to his roots, where his sense of a deep cultural affinity with his great-grandmother and great-aunts, who had been potters before his time, guided his work. Vigil continues to feel that he "is responsible for making sure that the Clay Mother stays alive in my village."

Micaceous earthenware with micaceous slip
H. 24.1 cm, diam. 25.4 cm (H. 9½ in., diam. 10 in.)
Gift of James and Margie Krebs 2006.1912

Tony Aguilar
Santo Domingo, 1919–1999
Ernestine Aguilar
Santo Domingo, 1932–1996
Necklace
Santo Domingo Pueblo, New Mexico, about 1990

Angelita (Angie) Reano Owen
Santo Domingo, born in 1946
Bracelet
Santo Domingo Pueblo, New Mexico, 1995

Santo Domingo, located near the venerable Cerrillos turquoise mine, is well known among the New Mexico pueblos as a center of jewelry making. Turquoise is an essential element in Santo Domingo jewelry, and artists there also excel at *heishi* (shell beadwork) and mosaic jewelry.

This massive necklace by Tony and Ernestine Aguilar, a husband-and-wife team of Santo Domingo, is unusual for its combination of turquoise with cylinders and other elements made of stamped brass, a combination that the Aguilars employed with great success from the mid-1960s into the 1990s. Their use of brass has been linked to Tony's training in silver-smithing by Wilfred Jones, a Diné (Navajo) silversmith, at the Santa Fe Indian School (later the Institute of American Indian Arts) from 1939 to 1942. After this, Tony joined the war effort and was stationed in Iran, where he was exposed to local metalworking tech-niques and materials. He continued his study of vari-ous types of jewelry after his return to the Southwest.

Here, the Aguilars have used many disks of hand-rolled turquoise separated by five brass elements with stamped decoration, including a central rectan-gular unit set with turquoise on all four sides, flanked by bands on each side, and terminating in the neck clasp, which consists of brass cones that also bear the Aguilars' maker's mark.

Turquoise, brass
L. 76.2 cm, diam. 3.8 cm (L. 30 in., diam. 1½ in.)
Gift of Mrs. Morgan K. Smith 1992.280

"My bracelets," says Angelita Owen, "actually start with a large shell. I shape it into a bracelet and then I clean it so the epoxy sticks. When I'm picking the stones for the top I decide if I want colors in it or if I want it plain." Here the bracelet core is tiger cowrie shell, and the mosaic work consists of turquoise, spiny oyster (orange and purple pieces), mother-of-pearl (iridescent white), and jet (black). The pieces are held in place with epoxy, which Owen colors black to provide definition to the composition. It takes Owen three or four days to select the stones, and then she decides on the pattern, in this case a herringbone that she is noted for creating.

Owen's jewelry is a modern interpretation of prehis-toric mosaics produced in the Southwest. Although mosaic work had been revived at Santo Domingo Pueblo in the early twentieth century, by the 1960s it had fallen out of fashion. Owen, encouraged by her parents, both of whom were jewelers who worked in turquoise and shell, began studying ancient Hoho-kam and other mosaics in 1969, and in the 1970s she revived the genre. She made her first tiger cowrie piece in 1982. In a pattern common to many families in the Southwest, her siblings, many of her in-laws, and her grandchildren and grandnephews are also jewelers.

Tiger cowrie shell, turquoise, spiny oyster,
mother-of-pearl, jet, black epoxy
H. 5.4 cm, diam. 7.3 cm (H. 2⅛ in., diam. 2⅞ in.)
Museum purchase with funds donated by Lois and
Stephen Kunian and The Seminarians 1998.57

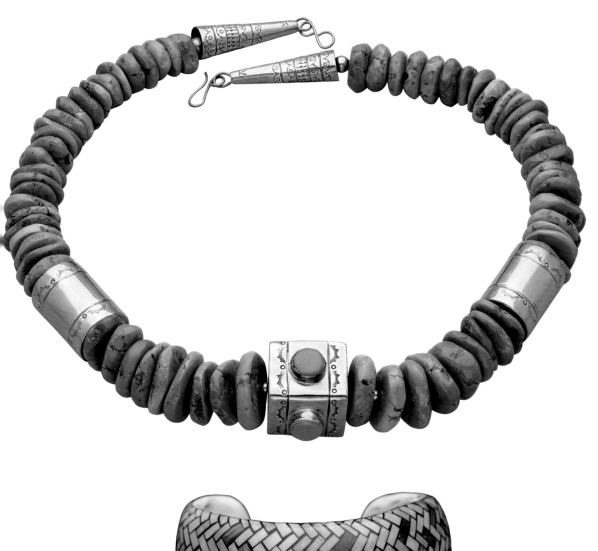
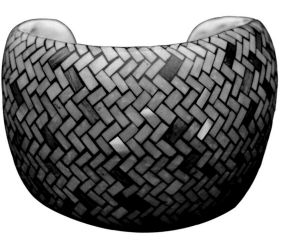

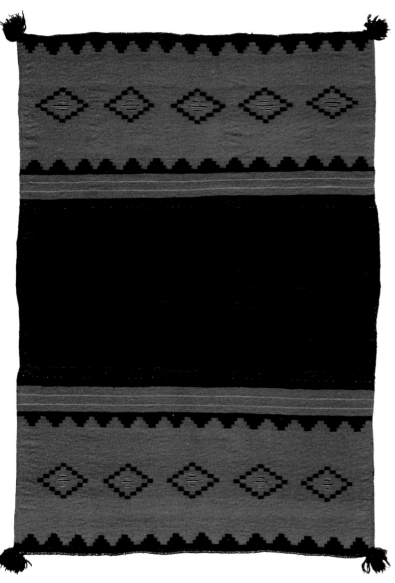

Panel from a woman's dress
Diné (Navajo)
Arizona or New Mexico, about 1850–70

Diné (Navajo) women wore dresses composed of two narrow panels stitched together at the neck and sides and worn with a belt. This panel would have formed one side of a dress, and an identical panel, the other. (The Museum also owns the second panel, but the two panels have now been detached from each other.)

Women's dresses were woven for personal use and not for trade, unlike the sarapes and rug included in this chapter. The dark background with red sections and designs along each end is a typical pattern for women's dresses of this type. Diné women stopped wearing this style of garment, except for ceremonial use and on some social occasions, in 1868, when they adopted the velvet blouse and skirt as their traditional dress. This change occurred when the Diné were allowed to leave the Bosque Redondo Reservation in southeastern New Mexico, where they had been confined by the United States Army following the tragic Long Walk in 1864. They then returned to their ancestral homeland, the Dinétah, in the Four Corners area, where present-day Utah, Colorado, New Mexico, and Arizona intersect.

Wool interlocked tapestry
H. 130.8 cm, w. 96.5 cm
(H. 51½ in., w. 38 in.)
Denman Waldo Ross Collection 00.676

Sarape
Diné (Navajo)
Arizona or New Mexico, about 1860–65

Adelaide Ludlam Waters traveled from Philadelphia to Fort Wingate, Arizona Territory, in 1866 as a new bride. When she returned to Pennsylvania in the 1870s, the new Mrs. Waters brought back this sarape (blanket). The sarape must have been woven when Adelaide lived at the fort. This was a time of great change in the lives of the Diné (Navajo). Between 1862 and 1868, they were interned at Fort Sumner and the Bosque Redondo. As their traditional lifestyle changed, so too did their weavings: they introduced new materials, such as yarns produced in Germantown, Pennsylvania, and developed new designs, taking advantage of the broad color palette of the Germantown yarns. The bands of crosses and chevrons of this example are typical of this emerging new style. Some of the blue, gray, white, green, pink, and dark red yarns are from Germantown, and others are hand spun, as was traditional, or raveled from imported cloth.

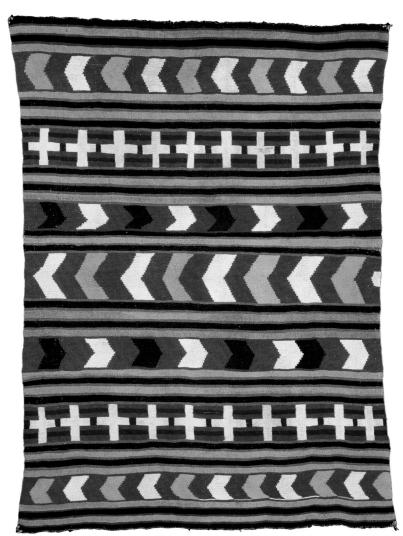

Wool interlocked tapestry
H. 141.6 cm, w. 184.2 cm (H. 55¾ in., w. 72½ in.)
Gift of Mrs. Harold D. Walker and Miss Eleanor W. Brooks
in memory of their mother Mrs. N. B. K. Brooks 52.1369

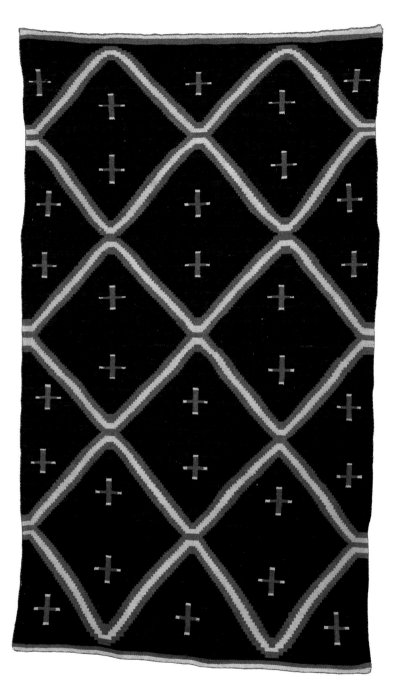

Sarape

Diné (Navajo)

Arizona or New Mexico, about 1885

Diné (Navajo) sarapes (blankets) with blue and brown stripes in the background are known as Moqui (or Moki) blankets. The term *Moqui* comes from the Spanish word for the Hopi people from whom the Diné probably learned to weave in the seventeenth century; persecution of the more sedentary Hopi Pueblo by the Spanish at this time often forced the Hopi to live with the nomadic Diné, and intermarriages occurred. The sarape—which is vertical in orientation, rather than horizontal like the wearing blanket—was a popular trade item with Hispanic, Puebloan, and Plains peoples, as well as Anglo-Europeans. This striped pattern is one of the older designs used by the Diné and can be traced back through archaeological remains to the mid-eighteenth century. The Puebloan peoples, including the A:shiwi (Zuni), also wove this style of blanket. Ironically, no Hopi examples have been found.

Wool interlocked and dovetailed tapestry
H. 209.6 cm, w. 123.2 cm
(H. 82½ in., w. 48½ in.)
Gift of John Ware Willard 12.1084

Chinle revival-style rug
Diné (Navajo)
Chinle, Arizona, 1925–40

During the twentieth century, many entrepreneurs opened trading posts throughout Diné (Navajo) territory to sell Indian products to the tourists who visited the area in increasing numbers. In 1923 Camilo Garcia, Leon H. "Cozy" McSparron, and Hartley T. Seymour acquired three trading posts in Chinle, Arizona. They began working with local weavers to produce new rugs in the style of early Diné examples dating from the so-called classic period—roughly from the mid-seventeenth century to 1868—which were characterized by simple stripes and bands. The weavers used wools provided by the trading posts and experimented with vegetable and some chemical dyes. Although the color palette and banded layout of this rug are typical of these revival-style rugs, the large hexagonal forms are not. Chinle revival and other revival styles proved popular with consumers in the 1920s and 1930s; their simple patterns and color schemes blended well with modern interiors of the time, and their affordable prices made them accessible to a wider audience.

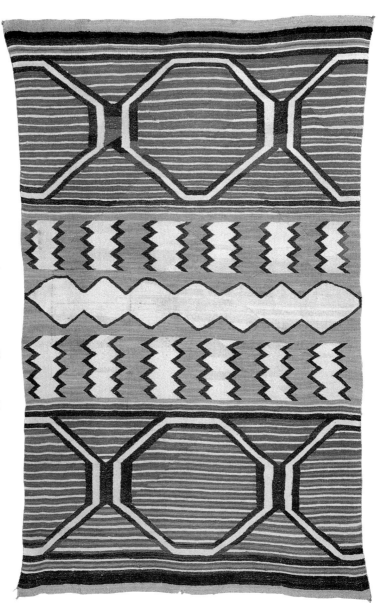

Wool dovetailed tapestry
H. 133.4 cm, w. 202 cm
(H. 52½ in., w. 79½ in.)
Gift of James and Margie Krebs 2008.1453

Necklace
Diné (Navajo)
Arizona or New Mexico, about 1890–1910

A few years after silversmithing was introduced to the Diné (Navajo) in the mid-nineteenth century, the craft developed swiftly, and a number of individuals achieved reputations as distinguished craftsmen. Atsidi Chon (Ugly Smith), for example, one of the most important early silversmiths, was active in the region as early as the 1870s. Beshthlagai-ithline-athlsosigi (Slender Maker of Silver) became well known in the late nineteenth and early twentieth centuries for his innovative designs and technical competence; the *ketoh* (wrist or bow guard) shown here (fig. 24) has such precise hammered and stamped decoration that it may have been made by him.

This necklace, commonly called a squash-blossom necklace, is also a product of these first few decades of Diné silver. Although seemingly simple in form, its creation required considerable effort and skill on the silversmith's part. The necklace derives its common name from its twelve so-called squash-blossom flowers, a stylized interpretation of the young pomegranate, a Spanish-Mexican motif frequently used as trim on men's clothing and often carved in churches. Each four-pronged floral element has at its opposite end a rectangular section, notched on its edges, that is pierced to accept the string. There are fifty-six spherical beads in total, each made of two halves soldered together. The necklace terminates in a double *naja*, an inverted crescent-shaped form. This Moorish symbol was brought to the Southwest by the Spanish and also used by the Diné on horse headstalls as well as necklaces.

As time passed, the squash-blossom necklace proved to be a popular item for Natives, collectors, and tourists alike. Later versions are often more elaborate, containing, for example, double or triple strands of beads rather than single and often inset with turquoise and coral.

Silver
L. 43.2 cm (L. 17 in.)
Gift of Ruth S. and Bertram J. Malenka and their sons, David J. and Robert C. Malenka 2008.2006

fig. 24. **Possibly by Beshthlagai-ithline-athlsosigi (Diné [Navajo], died in 1916), *ketoh* (wrist or bow guard), Arizona, about 1890–1910.**

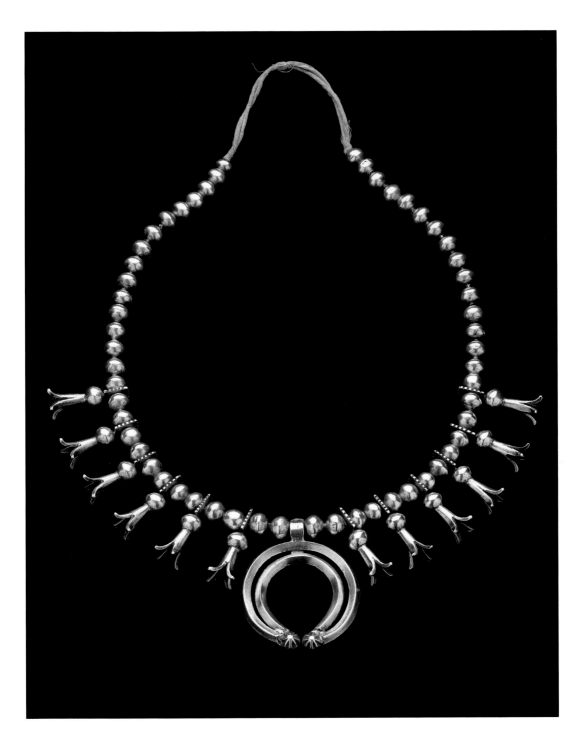

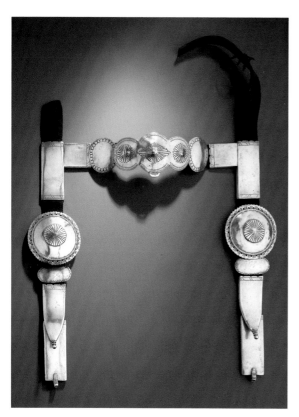

a melting pot; turquoise elements were often used as highlights on their silver products.

This horse's headstall is one of the characteristic Diné forms made in the late nineteenth and early twentieth centuries, along with concha belts (see fig. 19, p. 68), *ketoh*s (wrist or bow guards designed to protect the wrist from the snap of the bowstring), squash-blossom necklaces, bracelets, rings, and a few other types. Fashioned from commercial leather, the side pieces of the bridle are sheathed in part in silver, including a concha (a round, shell-shaped ornament) with stamped decoration, and have silver strap ends that curve upward. The so-called cloud-shaped brow or crosspiece has both stamped decoration and rocker-engraved detail (in which the design is created with the use of an awl) on its plaques. An ornament, probably a crescent-shaped *naja* related to the example on the necklace illustrated on p. 103, was originally suspended from the loop located on the browpiece at its center.

Silver, leather
H. 64.8 cm, w. 44.5 cm, d. 5.1 cm
(H. 25½ in., w. 17½ in., d. 2 in.)
Gift of Ruth S. and Bertram J. Malenka and their sons,
David J. and Robert C. Malenka 2008.2003

Horse's headstall
Diné (Navajo)
Arizona, about 1875–1900

Unlike the indigenous peoples of Central and South America, the early Natives of North America did not have ready access to precious metals from their own mines. Not until Europeans introduced silver into North America did the Native tribes begin fashioning it into jewelry and other forms. Although the Diné (Navajo) were not necessarily the first Native Americans to work in silver, they have been among the most creative artists in this medium. They first learned silversmithing from Mexican *plateros* (silversmiths) working in the Southwest during the second half of the nineteenth century, probably in the late 1860s or 1870s. The raw material for their craft was usually obtained by casting Mexican and American coins into

Jereme Delgarito
Diné (Navajo), born in 1974
Bracelet
Smith Lake, New Mexico, about 2000

Bracelets have long been a staple of the Diné (Navajo) silversmiths, produced in a wide variety of forms ranging from simple silver bands to large elaborate cuffs inset with turquoise and stones. That tradition is kept alive today by many modern artists, including Jereme Delgarito, the maker of this outstanding bracelet. Delgarito, who uses an initial and surname

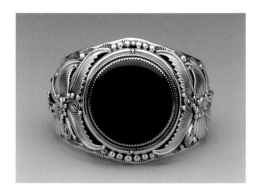

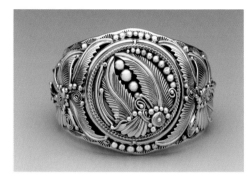

Fiddle
White Mountain Apache
Southeastern Arizona, 19th century

Small tubular fiddles such as this one are the only known stringed instruments made by the Native peoples of North America, although it is unclear how far back their use extends. Most likely their invention was influenced by observation of stringed instruments used by Spanish settlers in the early sixteenth century. They are found only in the Southwest region among the Apache and in portions of Southern California. In the Apache language, the instrument's onomatopoeic name, *kízh kízh díhí*, means "buzz buzz sound," which relates to the soft, pinched tone produced by its single string, made from strands of horsehair. An alternative name is *tsii' edo' ái*, which means "wood singing."

Constructed from the stalk of an agave or mescal plant, the body of the fiddle may be hollowed out after first splitting the stalk lengthwise, or the pith may be removed through a large sound hole cut into the side. This type of fiddle is always played by itself and usually for personal pleasure; however, it has also been documented in ceremonial use. This particular example is covered with detailed painted geometric motifs representing aspects of the natural world, such as insects (the bow-tie shapes and the large black diagonal lines) and clouds, waves, or ripples (the curvilinear forms at each end of the body).

Agave stalk, horsehair, pigment
L. 31.5 cm, diam. 4.3 cm (L. 12⅜ in., diam. 1¹¹/₁₆ in.)
Leslie Lindsey Mason Collection 17.2239a–b

mark above a feather and the word "Sterling" in script as his maker's mark, is part of a family of silversmiths that includes several brothers and a nephew. He resides on the Navajo Reservation in Smith Lake, New Mexico, not far from Gallup.

Fashioned with elaborate foliate forms and scrolls, this substantial silver bracelet is notable for its superb craftsmanship. The design features a central pivoting section, which rotates to reveal a silver disk on one side, ornamented to match the arcs of the bracelet, and a black onyx on the reverse. Although contemporary in feeling, the bracelet recalls historical precedents such as the modern Danish jewelry of Georg Jensen as well as Diné prototypes.

Silver, black onyx
H. 5.1 cm, w. 7.6 cm, d. 6 cm
(H. 2 in., w. 3 in., d. 2⅜ in.)
Gift of Chaya and David Saity 2004.2220

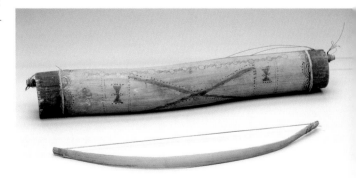

Storage container

Tohono O'odham (Papago)

Southern Arizona, about 1890–1920

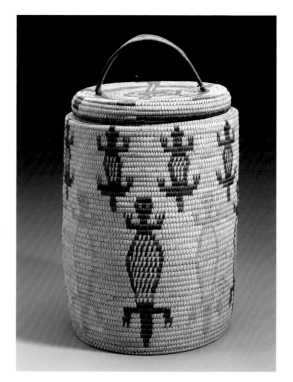

The Tohono O'odham (Papago) have long resided in south-central Arizona and adjacent parts of northern Mexico. Along with a neighboring related people, the Akimel O'odham (Pima), they are often considered to be the modern descendants of the ancient Hohokam (see p. 54). Seminomadic farmers—the name *Papago* translates as "bean people"—the Tohono O'odham (or "desert people") share much in common with the Akimel O'odham (river people), including a reputation as prolific makers of beautiful baskets fashioned in a variety of sizes, forms, and designs (fig. 25).

This finely coiled storage container is fitted with a removable lid and loop handle. It is notable for its design of sixteen lizards, depicted in two colors and in two sizes, each with its eyes articulated. Larger lizards are arrayed around the main body of the vessel in alternating colors, while the smaller lizards, all in brown, are arranged near the top. These smaller examples lack heads; one head, however, appears on the edge of the lid and can be matched up with a body on the main section of the container. Lizards and many other animal and human forms are often found on Tohono O'odham baskets.

Given the striated design on the back of the container's lizards, it is likely that they are a representation of the Gila monster, a large, colorful, and venomous lizard whose habitat in the Sonoran Desert largely coincides with the Tohono O'odham territory. Both the Tohono O'odham and the Akimel O'odham believe, according to some sources, that the Gila monster has mystical powers that can cause sickness, a cautionary belief perhaps rooted in the fact that its venom, although delivered in a smaller dose, is as toxic as that of a diamondback rattlesnake.

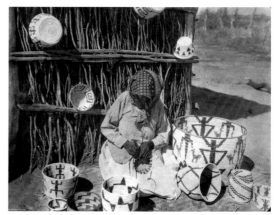

fig. 25. Tohono O'odham (Papago) basket maker at work, Arizona, 1916. Photograph by H.T. Cory.

Coiled yucca, bear grass
H. 44.5 cm, diam. 25.4 cm (H. 17½ in., diam. 10 in.)
Gift of Arthur Beale and Teri Hensick 2009.4626

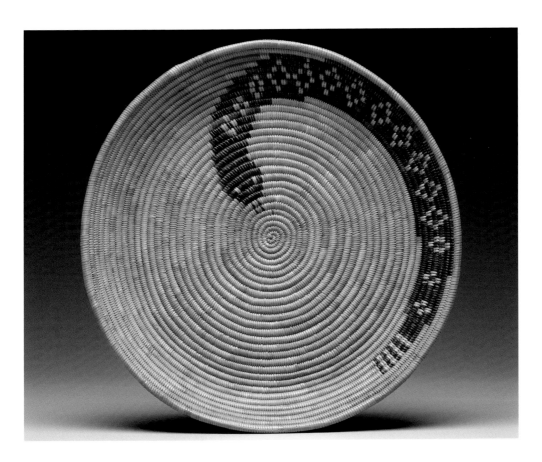

Attributed to Guadalupe Arenas

Cauhilla, active about 1900–1920

Tray

Possibly Palm Springs, California, about 1900

The basket makers of California, including the Mission people of the southern part of the state, are especially noted for the high quality of their art and craft. This shallow tray, decorated with a diamondback rattlesnake icon showing the serpent's split tongue, is similar to examples attributed to Guadalupe (or Lupe) Arenas of the Cauhilla, who was born in Alamo, California, but lived and worked in Palm Springs in the early twentieth century. Snakes were a popular motif on Mission baskets, along with lizards, turtles, deer, goats, sheep, horses, and humans. Snakes, in the Native American worldview, inhabited the spiritual

and physical worlds, and also symbolized power— used for both good and evil. Usually, the snake coils from the earthly center toward the spiritual outer rim, but here the image is rendered in reverse, with the snake winding around from the rim toward the middle.

Snakes were an important part of the Mission people's iconography, but their presence on a basket added a frisson of excitement and exoticism that also appealed to many tourists. This example was purchased by a family in the lumber business about 1900, who built a collection by exchanging timber for baskets.

Coiled grass stems, juncus grass, sumac
H. 3.5 cm, diam. 29.2 cm (H. 1⅜ in., diam. 11½ in.)
John Wheelock Elliot and John Morse Elliot Fund 1992.197

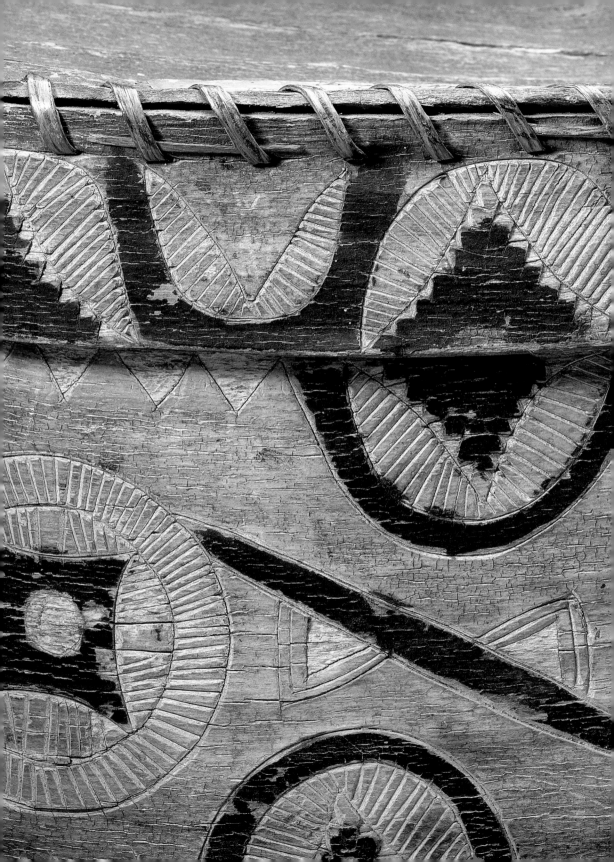

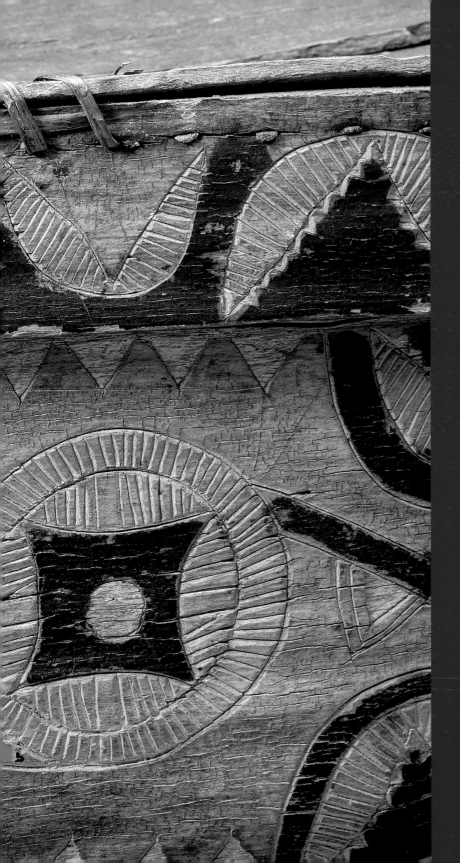

Northeastern and Southeastern Woodlands

The Northeastern and Southeastern Woodlands peoples occupied most of the eastern third of the North American continent and have been named for the enormous forests—consisting of white pine, birch, elm, oak, hickory, southern yellow pine, ash, and many other species—that historically covered much of the area. The Northeastern and Great Lakes tribes were located in New England and in adjacent areas of southern Canada, extending to the western shores of the Great Lakes and to the river valleys of Ohio, Indiana, and Illinois. The Southeastern Woodlands groups lived in most of the American South, pushing northward into Virginia and westward to Arkansas, Louisiana, and parts of Texas. Over time, the presence of Woodlands people in their ancestral homelands diminished dramatically through disease, assimilation, migration, and forced evictions westward, although some strong communities remain throughout the region.

The northern area was dominated by the many tribes speaking Algonquin (Algonkin) and by the Iroquois Confederacy (including the Mohawk, Oneida, Seneca, Onondaga, and Cayuga, joined later by the Tuscarora), which was located in New York State. The equally diverse southern territory was home principally to Muskogean-speaking Indians—Cherokee, Muskogee (Creek), Choctaw, Seminole, Chickasaw, and many others. Many of these peoples in the South were forcibly relocated by the United States government to Oklahoma in 1830 under the Indian Removal Act of the same year.

Both in the North and the South, the Woodlands people were the descendants of ancient civilizations. They managed the forests that covered their territories and put the abundant natural materials the forests provided to good use, using wood and bark to fashion wigwams and longhouses, canoes, eating utensils, war clubs, lacrosse sticks, and many other implements, as well as ceremonial objects, including masks and rattles.

Because of their proximity to the Atlantic, from the sixteenth and seventeenth centuries onward the Woodlands people had close contact with Europeans

through the fur trade. Later, the substantial influx of French and English immigrants encroached upon their territory, and many Woodlands peoples became involved in the various colonial wars of the eighteenth century. In time, this contact, which was often disastrous to the Natives due to the introduction of disease and the loss of their lands, included a concomitant exchange of goods that would affect Native production of objects.

Most of the objects in this chapter reflect this ongoing cross-cultural exchange, principally as it occurred in the nineteenth and early twentieth centuries. New materials, such as various European textiles and glass beads, were adopted in place of or in combination with traditional Native materials such as moose hair and porcupine quills, a transition seen in the production of three finger-woven sashes (see p. 116). New techniques, such as splint basketmaking, were also introduced by Europeans in the eighteenth century and then adopted by Natives, particularly among those living in New England, who fashioned baskets for trade and later, in the nineteenth and twentieth centuries, for the tourist market. Boxes and other forms using porcupine quillwork (fig. 26) and objects with incised designs on birchbark (fig. 27) were common items of production, especially among the Passamaquoddy and Penobscot in Maine and the Maliseet and Mi'kmaq (Micmac) in the Canadian Maritime provinces. Eventually, glass-bead work became ubiquitous throughout the region on bandolier bags, smaller pouches, moccasins, and various other articles of clothing.

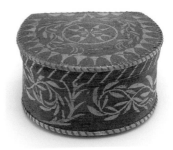

In the southern area, basketmaking was a highly developed craft, particularly among the Chitimacha people of Louisiana, known for their cane baskets and mats. Although important historically, pottery has not been as significant in the modern Southeast as other goods. The craft is still maintained by some artists, however, including Anna Belle Sixkiller Mitchell of the Western Band Cherokee, whose bowl (fig. 28), with its all-over design of stamped spirals, is a recognition of the deep roots of her ancestry. Her ornamental motif, which she calls Complicated Stamp, evokes the ancient forms and ornaments, anywhere from five hundred to a thousand years old, employed by the Mississippian culture of prehistoric times; the stamp is also a reference to a symbol used by the Cherokee during the last few centuries.

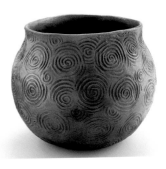

fig. 26. **Basket, Mi'kmaq (Micmac), Maine or Nova Scotia, Canada, about** 1875.

fig. 27. **Container, Penobscot or Passamaquoddy, Maine,** 1930–1950s.

fig. 28. **Anna Belle Sixkiller Mitchell (Cherokee, born in** 1926), **bowl, Vinita, Oklahoma,** 1993.

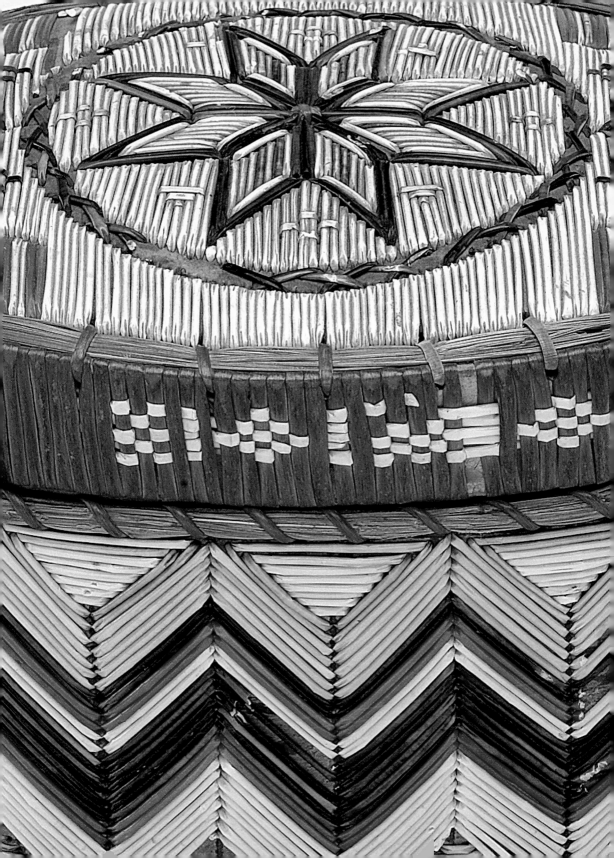

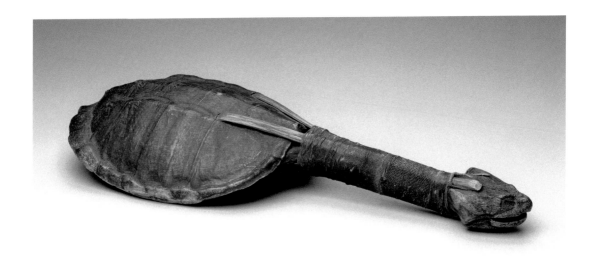

Rattle

Seneca

New York State, 19th century

In the oral traditions of the people of the Iroquois Confederacy (which includes the Seneca), the earth rests on the back of a giant turtle. Depictions of turtles are pervasive throughout Seneca culture, and the *kanyáhte' ká'nowa'* (snapping turtle rattle) is no exception. The rattle is constructed from the body of the common snapping turtle. The turtle's stretched-out neck forms the handle, which is supported by a wooden core and several splints attached to the shell. Traditionally, chokecherry pips are placed inside the shell to produce the rattling sound. Although some rattles are adorned with paint and feathers—in accordance with the owner's personal taste—this more typical example is devoid of any adornment. The patina is probably the result of age and wear (notice the fractures on the edge of the shell), but it survives largely undamaged.

These rattles are the most important ritual instruments in Iroquoian culture and are used in healing ceremonies by members of the False Face Society, a group known for its intricately carved wooden masks. The False Face Society exists to eliminate sickness, disease, and evil spirits in Iroquoian communities. In ceremonies, singers sit astride wooden benches in the middle of a longhouse dwelling, vigorously striking the tops of the benches with the rattles to mark the dance rhythm.

Turtle shell, elm wood, chokecherry pips
L. 43.3 cm, w. 17.5 cm, d. 6.5 cm
(L. 17⅟₁₆ in., w. 6⅞ in., d. 2⁹⁄₁₆ in.)
Leslie Lindsey Mason Collection 17.2233

Moccasins

Probably Wendat (Huron)
Eastern Great Lakes region, late 18th–early
19th century

These rare early examples are part of the tradition of making decorative moccasins for trade, which Northeastern Native Americans had engaged in since at least the early eighteenth century. Desired by non-Natives for their beauty and portability, moccasins today are one of the best-represented categories of Native American art in museum collections. Although British officers acquired many earlier moccasins for their curiosity cabinets, this pair probably was purchased in 1828 by Caira Robbins (1794–1881) of Lexington, Massachusetts, on her grand tour of the Northeast, which took her across New York State via the Erie Canal (which opened in 1825). Whether acquired on this trip or earlier by her father, a fur dresser and store owner, these moccasins reflect changes in taste and trade.

Made by women, moccasins such as these were traditionally constructed from a single piece of leather (usually smoked moose- or deerskin), which was sewn down the instep with panels of dyed and woven porcu-pine quills over the instep seam and around the ankle flaps. In this pair, the quills were woven with thread probably made from milkweed or nettle plants, although sinew was also used. Dyed deer- or moose-hair fringe with metal cones is typical of Wendat (Huron) moccasins; however, on this pair, a single stitch holds each tuft to a wool backing. Ribbon edging is also common, but here the openings are appliquéd with a line of twisted white quills. In the late 1820s, artists began favoring dense floral patterns of appliquéd dyed moose hair on more deeply flared ankle flaps, dispensing with fringe and quillwork panels. This maker stayed close to the eighteenth-century form while freely incorporating imported textiles, which continued to be used more extensively. By choosing black wool and silk, she highlighted her skilled quillwork—a waning tradition—and added to the beauty of the moccasins.

Leather, woven and appliquéd porcupine quills, moose or deer hair, silk, wool, tinned sheet iron, bast fiber thread
H. 6.5 cm, w. 10.5 cm, d. 23.5 cm
(H. 2⁹⁄₁₆ in., w. 4⅛ in., d. 9¼ in.)
Gift of Miss Ellen A. Stone 98.1006–1007

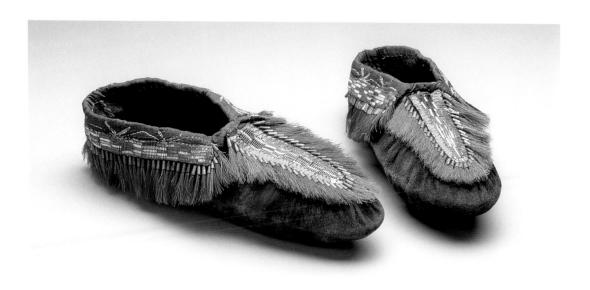

Sash

Eastern Woodlands

Eastern Great Lakes region, mid- to late 18th century

Plaited (finger-woven) wool with porcupine quills

L. 208.3 cm (L. 82 in.)

Gift of Timothy Phillips 2008.1456

Sash

Possibly Wendat (Huron)

Eastern Great Lakes region, early 19th century

Plaited (finger-woven) wool with glass beads

L. 284.5 cm, w. 20.3 cm (L. 112 in., w. 8 in.)

Gift of Timothy Phillips 2008.1455

Sash (*ceinture flêchée*)

Mètis

L'Assomption, Canada, mid- to late 19th century

Plaited (finger-woven) wool

L. 381 cm, w. 31.8 cm (L. 150 in., w. 12½ in.)

Gift of Timothy Phillips 2008.1458

Native Americans fashioned hand-plaited, or finger-woven, narrow sashes (or belts) that were used to bundle cradleboards, tow sleds, and toboggans or to hold up their garments. Before the arrival of the Europeans, the materials they used were found locally and included the inner bark of basswood, cedar, and elm; fiber from plants such as milkweed and dogbane; and strips of moose hide. Finger-woven fragments made of white and brown spun dog hair have been excavated in the desert caves of the Southwest, which were once home to the Anasazi. On the East Coast, the Penobscot used the inner fibers of basswood and colored them with mineral dyes of black, red-brown, yellow, or blue. The finest finger weaving could be further embellished with dyed porcupine quills or moose hair.

Native Americans quickly adapted trade goods for finger weaving. Yarns unraveled from blankets and cloth replaced the local bast fibers (strong woody fibers derived from plants), and white glass beads replaced the porcupine quills and moose hair. The openwork sash (left) is a rare early form and still includes porcupine-quill decoration. The Museum's Wendat (Huron) red sash with arrow shapes outlined in white trade beads (center) is the predecessor of the *ceinture flêchée* (right), finger-woven belts adopted by the Mètis. The Hudson Bay Company employed Native weavers from L'Assomption, Canada, and developed a local industry by the mid-nineteenth century.

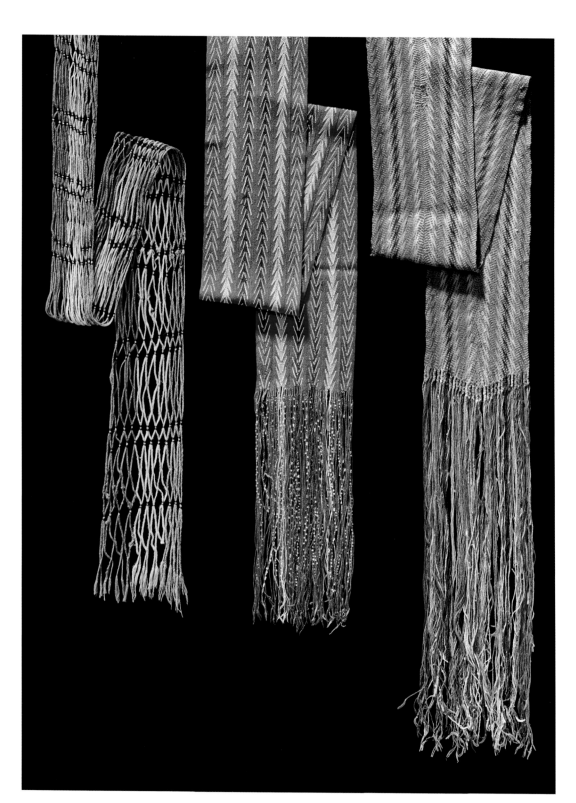

Powder horn and shot pouch

Possibly Lenape (Delaware)
Eastern United States, early 19th
century

Native Americans traditionally used
a range of bags. When Europeans
brought guns to the New World, the
shot pouch and powder horn were
introduced. On the East Coast, this
occurred almost as soon as the Dutch
and English arrived in the first half
of the seventeenth century.

Lavishly decorated shot bags were
probably made as gifts and not for
everyday use. The provenance of this
bag suggests that this is the case here.
According to family history, a Lenape
hunting guide gave the shot pouch
and powder horn to Nathaniel Hurd, a
merchant of Frederick, Maryland, who
often hunted in the Allegheny Moun-
tains with him. The materials and dec-
oration of the shot pouch support the
provenance: the use of wool trade
cloth and the decoration of fine white
beads with a picot or lacelike edging
appear to be consistent with Lenape
practices at the time. Several Lenape
women's leggings collected in the
nineteenth century by Erastus Tefft
and donated to the American Museum
of Natural History in New York are
similar in execution and style, further
supporting the attribution of this shot
pouch and powder horn to the Lenape.

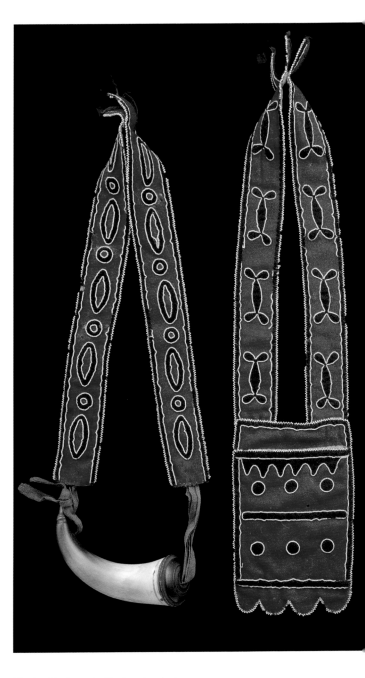

Wool twill trimmed with glass beads, horn
2008.1459.1 (powder horn): L. 71.1 cm, w. 19.1 cm (L. 28 in., w. 7½ in.)
2008.1459.2 (shot pouch): L. 73.7 cm, w. 16.5 cm (L. 29 in., w. 6½ in.)
Gift of Timothy Phillips 2008.1459.1–2

Container

Probably Wolastoqiyik (Maliseet) or Passamaquoddy
Southern New Brunswick, Canada; or northeastern
Maine, about 1800

This oval box is a rare surviving example of a fragile
tree-bark container associated with the Wolastoqiyik
(Maliseet) and Passamaquoddy peoples of New Bruns-
wick and Maine. The incised patterns typically found
on such containers have been highlighted here with
black pigment to give richness and three-dimensional
character to the design. The top of the fitted lid was
apparently left unadorned. From the earliest times,
Indians of the Northeastern Woodlands used the bark
of many kinds of trees, such as white birch, ash, bass-
wood, chestnut, fir, spruce, and cedar, as well as the
elm seen here, for many different purposes, including
the covering of lodges. The bark for these containers
was stripped from the trees in the spring, when it
could be removed most easily, often in wide sheets,
through the use of simple stone or wooden tools.

When acquired by Nina Fletcher Little, a noted col-
lector of early Americana, this box contained a hand-
written note from the mid-nineteenth century stating
the following: "This box was left / behind by the Indi-
ans when / they burnt the town of Medfield / Feb 21
1675. Mass / But one house left standing." Although
this note raises the exciting possibility that the con-
tainer dates from the seventeenth century, the box
was probably made about 1800, long after the Med-
field episode in King Philip's War (which actually
occurred in 1676).

Elm bark, split root, black dye
H. 19.1 cm, w. 21.6 cm, d. 40 cm
(H. 7½ in., w. 8½ in., d. 15¾ in.)
Museum purchase with funds donated by a Friend of the
Department of American Decorative Arts and Sculpture in
honor of Nina Fletcher and Bertram K. Little 1994.20a–b

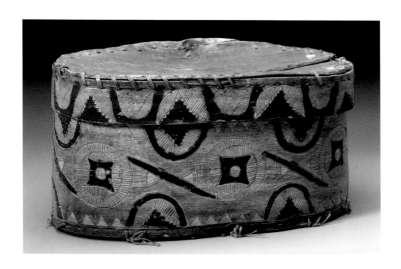

Set of twelve baskets
Possibly southern Innu (Montagnais)
Quebec, Canada, 1860–1900

Although quillwork boxes, cradles, and other forms were commonly produced by many peoples of the North-eastern Woodlands, such sets of round stacking baskets are rare today. Only two others are known: a set of thirty baskets collected in the first half of the eighteenth century (British Museum, London) and another of eleven examples dating from about 1848 (Thaw Collection, Fenimore Art Museum, Cooperstown, New York). Those two sets, closely related to this nest in both construction and decoration, are linked to the southern Innu (Montagnais) peoples of the northern Quebec area, providing the basis for the attribution of the Museum's later example.

Each birchbark basket in this nest of twelve has an octagonal base, sewn together with spruce root. The sides are embellished with porcupine quillwork in a pattern of flowers and leaves; the wooden rims also have quillwork, arrayed to form a striped and checkerboard pattern. The dozen baskets, carefully graduated in size to nest together snugly, range in diameter from 13 to 17.8 centimeters (5⅛ to 7 inches), and in height from 4.5 to 5.1 centimeters (1¾ to 2 inches).

The southern Innu, named Montagnais (mountaineers) by the French in recognition of the mountainous region in which they live, reside along the forested northern shores of the Gulf of Saint Lawrence in Canada. (The northern Innu, or Naskapi, occupy the even more rugged Labrador plateau.) The Montagnais created high-quality quilled birchbark vessels and containers of various sorts for trade for many years. The floral motifs seen here, an element of a design vocabulary introduced over time through contact with European goods, appealed to late-nineteenth-century Anglo-European consumer taste and notions of femininity. Simultaneously, the flowers may also have retained a variant meaning for the Native makers, for whom plants were a locus of medicinal power.

Birchbark, porcupine quills, spruce root
Overall: H. 13.3 cm, diam. 17.8 cm (H. 5¼ in., diam. 7 in.)
Gift of Judith C. Herdeg in memory of her grandparents, United States Senator
Marcus A. and Mrs. Ethel Warren Coolidge 1991.1019a–l

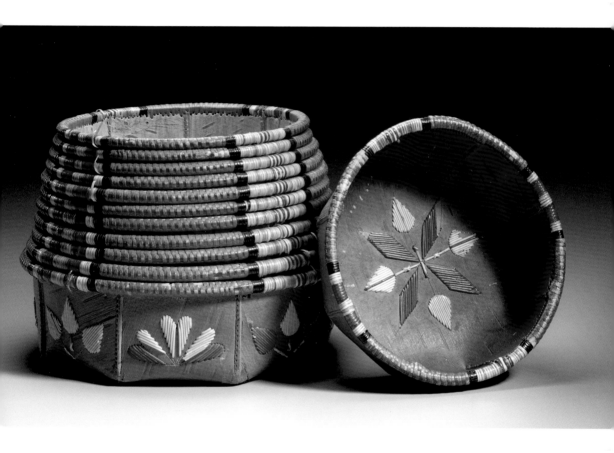

Basket
Probably Mohegan-Pequot
Southeastern New England, 1830–1900

In 1674 the English traveler Daniel Gookin took note of the baskets made by the Native peoples of New England: "From the trees where the bark grows, they make severall sorts of baskets, great and small. Some will hold four bushels or more: and downward, to a pint. In their baskets they put their provisions. Some of their baskets are made of rushes; some of bents; others of maize husks; others, of a kind of wild hemp: and some of barks of trees: any of them very neat and artificial with the portraitures of birds, beasts, fishes, and flowers upon them in colours." Gookin's observations were later published in his *Historical Collections of the Indians in New England* (1792 and later editions).

 This woven basket was probably made by the Mohegan-Pequot of southeastern New England for an Anglo customer. The abundant hand-painted motifs of clouds, stars, faces, intertwined vines, hearts, and tulips are characteristic of Mohegan-Pequot baskets and seem to suggest layers of meaning that are not readily apparent today. The colors are achieved through laundry bluing (a dye that when used on splints ages to green) and so-called Mohegan pink (a mixture of red lead and white lead). An unknown person, probably the original owner rather than the maker, used a steel pen to inscribe the name Smith on the lid in a type of script in common use for much of the nineteenth century.

Probably ash, laundry bluing, Mohegan pink
H. 33 cm, diam. 31.1 cm
(H. 13 in., diam. 12¼ in.)
Harriet Otis Cruft Fund 1989.80a–b

material commonly used by the Cherokee, the pattern is created through the use of the customary colors of red and black. Here, however, the red is a modern synthetic aniline dye instead of the historic color obtained from the puccoon or bloodroot (*Sanguinaria canadensis*). The black was probably derived from boiled black-walnut root. Cherokee baskets, collected by institutions and individuals since at least the 1880s, have been produced in quantity for the tourist market.

River cane, vegetal and aniline dye
H. 32.7 cm, diam. 29.2 cm (H. 12⅞ in., diam. 11½ in.)
Museum purchase with funds donated by
the Barra Foundation, Inc. 1992.525

Basket
Cherokee
Probably North Carolina, about
1935–50

This mid-twentieth-century basket is part of a long-standing history of Cherokee basketry, practiced by the people first in their ancestral homeland in the American Southeast and later in Oklahoma, after many Cherokee were forcibly removed there by the United States government in the 1830s. Traditional Cherokee stories refer to baskets being used by the first humans, and Cherokee have made baskets continuously for thousands of years as part of an evolving form of material expression.

Although the shape of this flat-bottomed basket is traditional, its diamond-and-cross weave pattern, known as the Chief's Daughter, is a modern addition to the Cherokee design vocabulary. Woven of river cane, a local

Basket

Nipmuc

Probably central Massachusetts, about 1830–40

This large rectangular basket is constructed of wide checker plaiting, with three rows of narrower wicker plaiting on the top and bottom edges and a single wrapped rim. The basket is embellished with red and blue painted symbols throughout, all characteristic of Nipmuc (or Nipmuck) decoration from the 1830s, which form a complex pattern. The front and back are decorated with a star-shaped medallion, which is surrounded by triangles and situated at the center of a large X formed by crossed lines with leaflike terminals, all traced with dotted lines. Curls and crescent shapes create a stockade border on the top and sides, and stripes and dots mark off the bottom border. The sides bear three repeated medallions composed of domes around a center space: two on the top row and one centered below. As is often the case with such baskets, newspaper was used to line the inside, and some fragments remain; however, there are no dates or place-names that would allow the basket to be dated and its place of manufacture to be located more precisely.

The Nipmuc, who spoke Algonquin (Algonkin), lived in the interior of New England, in the central part of Massachusetts and in adjacent areas of Connecticut and Rhode Island. By about 1850, warfare with other American Indians and disease had reduced their population to around five hundred, and their long tradition of basketmaking largely came to an end.

Ash, laundry bluing, Mohegan pink

H. 31.1 cm, w. 53.3 cm, d. 43.2 cm (H. 12¼ in., w. 21 in., d. 17 in.)

Museum purchase with funds donated by Mr. and Mrs. William White Howells 1994.187

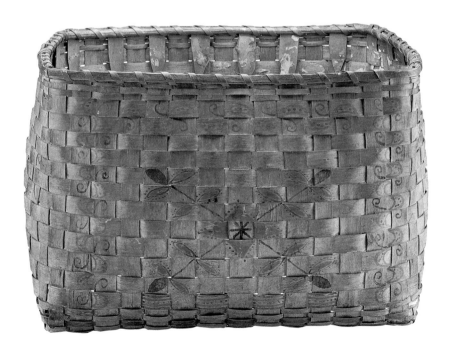

Side chair with quillwork panels
Chair: Nova Scotia, Canada; or possibly Maine, 1860–80
Quillwork: Mi'kmaq (Micmac), Nova Scotia, Canada, 1850–70

This Renaissance revival–style side chair synthesizes two distinct traditions to create a new and exciting vision. The chair is a good example of a form made in many shops in America and Canada during the late nineteenth century. Its columns and carved elements are painted black in imitation of ebony and are highlighted with gold to enrich the surface. Porcelain casters, patented and marked by their maker (the firm of Clarke and Timmons), make the chair easily movable.

The most significant feature of the chair, however, and the element that raises it above the ordinary, is the incorporation of two panels of porcupine quillwork as the flat seat and back panel of the chair. Beginning in the mid-nineteenth century, such panels were made by women of the Mi'kmaq (Micmac) for use in seating furniture produced in chair-making shops in the Maritime provinces of Canada; some panels were exported to England and America for the same purpose. Due to the fragility of the material, surviving examples are rare.

In this chair, the quillwork is fashioned in geometric patterns and colored with six types of vegetal dye in muted tones of brown and beige.

Ebonized mahogany; porcupine quillwork with vegetable dyes on birchbark with spruce root; porcelain, iron, and brass casters
H. 109.2 cm, w. 47 cm, d. 47.8 cm
(H. 42 in., w. 18½ in., d. 18¾ in.)
Museum purchase with funds by exchange from a Gift of the Estate of Jeannette Calvin Hewett in memory of her husband Roger Sherman Hewett, Bequest of Greenville Howland Norcross, Bequest of George Nixon Black, and Bequest of Mrs. Stephen S. FitzGerald 1992.521

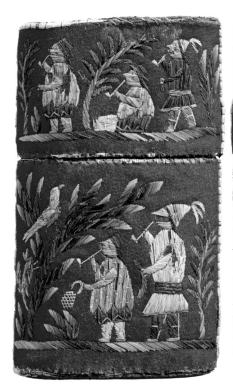
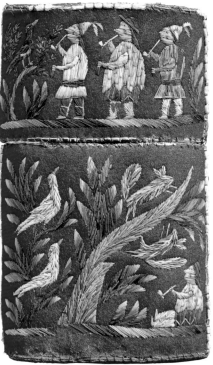

Cigar case

Wendat (Huron)

Probably Lorette, Quebec, Canada, mid-19th century

The Great Lakes region was a popular tourist destination during the nineteenth century. Niagara Falls was one of the highlights of the trip, but a visit to a Native American village also featured prominently on the agenda. One popular stop was the town of Lorette outside Quebec City. The Wendat (Huron) people who lived in the town would perform Native dances to entertain the visitors, who then often concluded their visit by shopping for curios. To satisfy this market, the women of Lorette produced moose hair–embroidered birchbark souvenirs such as cigar cases, boxes, trays, and needle and letter cases. These objects often depicted nature and daily life, such as the scene on this cigar case of men smoking their pipes.

Bark and wool trade cloth embroidered with dyed moose hair
H. 16 cm, w. 9.5 cm, d. 4.5 cm (H. 6⅕₆ in., w. 3¾ in., d. 1¾ in.)
Gift of Miss Aimée and Miss Rosamond Lamb 63.289

Envelope case
Wendat (Huron)
Eastern Great Lakes region, mid-19th century

Among the first French immigrants to settle in Canada during the seventeenth century were the Catholic Ursuline nuns who established convents to educate and convert Native American girls. To help support themselves, the nuns produced food products, artificial flowers, and fine embroideries. When the British conquered Canada in 1759, the nuns lost the financial support of the French and increased their production of souvenir items, creating Indian dolls and canoes as well as moose hair–embroidered European-style bark boxes and workbaskets. These items became popular with the British soldiers and their wives living and traveling in Canada.

By the end of the eighteenth century, the Ursulines had stopped making embroidered bark curios, but the growing number of American travelers along the Saint Lawrence River could now find their souvenirs produced by Native American women. Women of the Mi'kmaq (Micmac) and Wolastoqiyik (Maliseet), as well as the Wendat (Huron) people of Lorette, produced curios in the manner of the Ursulines. The floral design of this envelope case looks back to the elaborate ecclesiastical embroideries produced by the Ursulines throughout the eighteenth century.

Bark embroidered with moose hair
and lined with silk plain weave
H. 23 cm, w. 40 cm, d. 1.5 cm
(H. 9⅟₁₆ in., w. 15¾ in., d. ⅚₁₆ in.)
Gift of Miss Aimée and Miss
Rosamond Lamb 61.1104

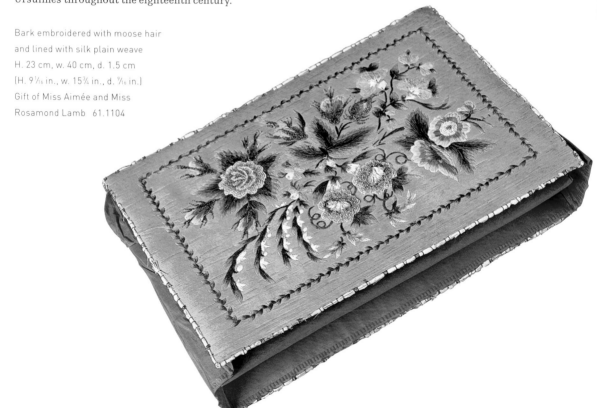

Peter B. Jones

Onondaga/Seneca, born in 1947

Effigy pot

Seneca (Cattaraugus Reservation), New York, 1993

Earthenware, grapevine twigs

H. 18.1 cm, diam. 13.3 cm (H. 7⅛ in., diam. 5¼ in.)

Museum purchase with funds donated by
the Fraser Family Foundation 1993.176a–b

Tammy Tarbell-Boehning

Mohawk, born in 1950

Vessel

Syracuse, New York, 1983–84

Earthenware

H. 10.8 cm, diam. 9.5 cm (H. 4¼ in., diam. 3¾ in.)

Gift of Barbara McLean Ward in memory of
Suzanne Greeley McLean 1993.219

Peter B. Jones is a mature, recognized Iroquois potter whose work demonstrates his commitment to traditional concepts and forms. The son of an Onondaga mother and a Seneca father, Jones represents two of the six nations of the Iroquois Confederacy. Although by birth he is a member of the Beaver Clan of the Onondaga Nation (clan association follows matrilineal lines), Jones has chosen to follow the tradition of living and working within his wife's Seneca Cattaraugus Reservation. At age fourteen, he studied at the Institute of American Indian Arts in Santa Fe. The most important influence on his creative development there was the teaching of well-known Hopi potter Otellie Loloma (Loloma also taught Jacquie Stevens; see p. 47). His early work was selected for the institute's Honors Collection (his first representation in a prominent collection), and subsequently his pieces have been collected and exhibited by a number of museums. Jones's effigy pot is named for the small faces placed at the points of the four cardinal directions around its rim. The faces recall human images carved in the pipe bowls of Northeastern Woodlands people. The pot's form and its castellated rim with incised decoration echo traditional Iroquois vessels.

Native American pottery traditions can also be recognized in the smaller vessel by Tammy Tarbell-Boehning. A Mohawk by birth, Tarbell-Boehning grew up near the Onondaga Indian Reservation in upstate New York and studied ceramics at Syracuse University. This vessel, made early in her career, recalls in its form and castellated rim with a matte finish the ancient vessels of Northeastern Woodlands people, but the lustrous black surface of the lower portion reflects Tarbell-Boehning's interest in Southwestern methods of firing and stone burnishing, as evidenced by the pottery of Maria Martinez and others from San Ildefonso Pueblo (see p. 94).

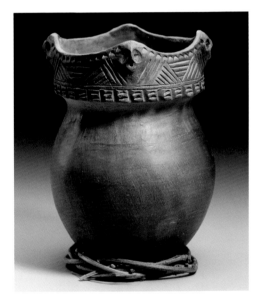

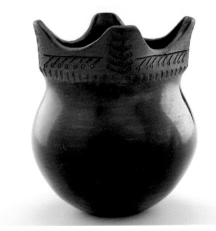

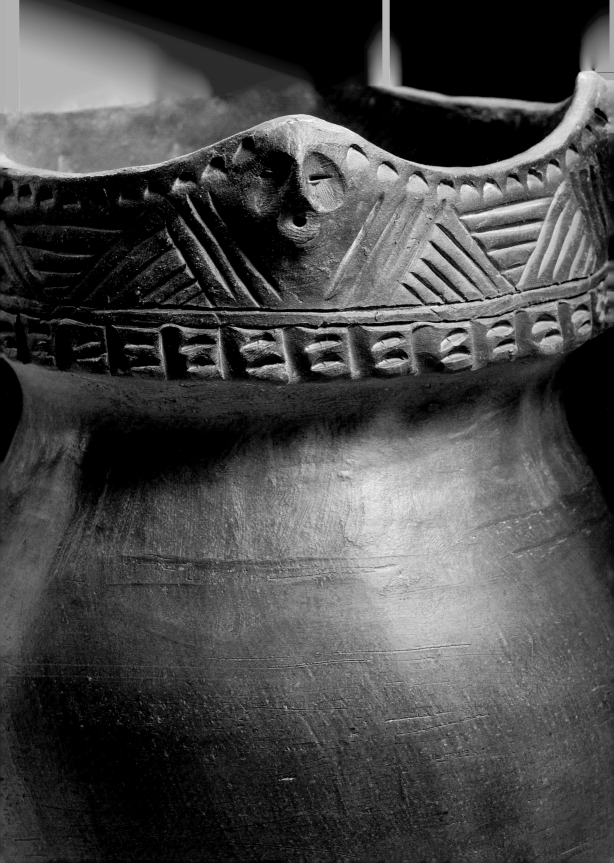

Plains, Prairie, and Plateau

The people of the Plains occupied a vast territory in the center of the North American continent, ranging from the Gulf of Mexico to Canada, and from east of the Mississippi River to the Rocky Mountains. These peoples—consisting of many different tribes but often conflated into a stereotypical unit—have come to represent Native Americans to much of the rest of the world. Their nomadic way of life, tipi dwellings, eagle-feathered warbonnets, and such rituals as the Sun Dance and sweat lodge are all part of the "exotic" mix that over time, through paintings (fig. 29), literature, film, and television, has coalesced and come to symbolize Native American life in the popular imagination, sometimes in unusual ways. Even many of the tribal names—such as Blackfoot, Crow, Sioux, Cheyenne, Arapaho, Kiowa, and Comanche—have developed a familiar ring. Yet the Plains area was a diverse region, containing distinct traditions among peoples in the Northern, Central, and Southern Plains, as well as among peoples of the eastern Prairie. Additional diversity was provided by the peoples of the Plateau—such as the Lataxat (Klikitat; see p. 147)—and Great Basin regions, neither of which is as yet represented in depth in the Museum's collection.

fig. 29. **Albert Bierstadt** (1830–1892), *Indians Near Fort Laramie*, about 1859.

The predominantly flat terrain of the interior Plains, with only the Black Hills of South Dakota and Wyoming as the exception, was formed by sedimentary deposits largely laid down during hundreds of millions of years in the Mesozoic and Cenozoic eras. Throughout history, the immense landscape of these Great Plains, extending west of the Mississippi to the Rocky Mountains, provided Native peoples with an abundance of game—in particular, herds of buffalo beyond counting. The Plains peoples depended heavily on the buffalo, utilizing

all parts of the animal for food, clothing, and other uses, until the buffalo were hunted nearly to extinction by white people in the late nineteenth century.

The presence of Native Americans on this land has varied greatly over time, as wars, disease, and many other factors altered living and settlement patterns. One of the principal changes in Plains culture was brought about by the introduction of the horse by the Spanish in the seventeenth century. Native Americans quickly adapted to the use of horses, which greatly facilitated buffalo hunting and made it easier for Indian families to travel across the expanse of Prairie grasses. By using the *travois*, a triangular framework of long wooden poles that supported food and possessions and could be dragged by a horse, the Plains Indians could move from place to place more efficiently. The horse thus made it easier for life to be lived on the Plains themselves, not just around their edges. As tribes came into contact with each other, confrontations over hunting grounds and other issues often erupted. The arts of war and the embellishment of weaponry and accoutrements, such as tomahawks—as seen in an early image of Mato-Tope of the Mandan tribe (fig. 30)—shields, headdresses, and other objects, became increasingly significant.

fig. 30. **Johann Hurlimann** (1809–1893) after **Karl Bodmer** (1809–1893), *Mato-Tope (Indian in War Dress),* 1834–43.

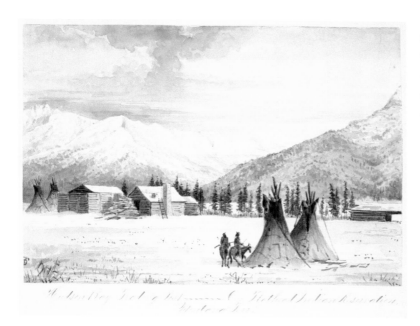

fig. 31. Peter Peterson Tofft (1825–1901), *Hudson Bay Trading Post on Flathead Indian Reservation, Montana Territory*, 1865–67.

Although Native Americans have lived on the Plains for many centuries, most of their works of art that survive today date from no earlier than the nineteenth century and often after 1850. The Plains people are especially noted for the quality of their painting on animal hides. Women painted colorful geometric designs on the hide containers or envelopes known as parfleche, and men painted more naturalistic scenes of hunts, battles, dream visions, and other important events on hide robes, shields, and tipis (as seen in fig. 31). Later, as they were confined to reservations in the nineteenth century, many essentially incarcerated Plains artists, such as Haungooah (Silver Horn; see pp. 148–49), were encouraged by early ethnographers to record images with pencil and crayon in ledgers and notebooks provided by the United States military. In addition, the Plains people were skillful users of porcupine quills and, later, of imported European glass beads obtained from traders. Plains beadwork, produced by many tribes in various styles on numerous articles of clothing, knife cases, bags, horse equipage, and other objects, has survived in substantial quantities.

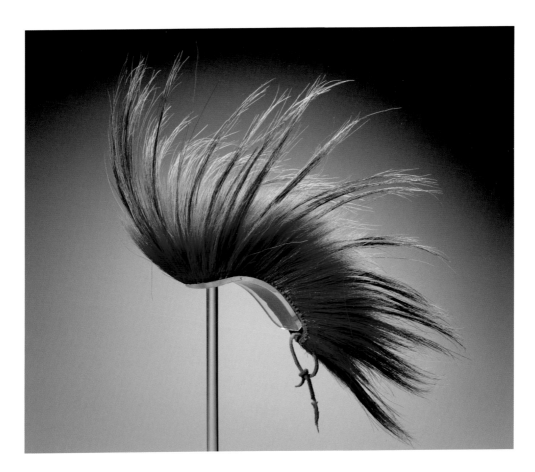

Roach

Northern Plains

Probably Wyoming or Montana, about 1880–85

Roaches—made from a variety of materials, including deer and porcupine hair (as used here) as well as turkey feathers in more elaborate examples—are an ancient form of Native American war-dance headdress, worn by men from many tribes over time and across space. Originating among eastern tribes, by the late nineteenth century, when this brightly colored roach was collected, they had become popular among men of the various Plains tribes. This example probably came from a Northern Plains people living in Montana, where it was acquired, along with other Native American objects, in the 1880s by the Reverend Herbert E. Probert of the Congregational Missionary Society, who was conducting services in the frontier settlement of Sheridan, Wyoming, at that time.

The roach was attached to the wearer's head with the assistance of a roach spreader, a small piece of bone or antler (the spreader used with this roach did not survive). A tight braid on top of the head was drawn through a hole in the base of the roach and then through another hole in the roach spreader. A small wooden pin inserted in the braid locked the headdress in position. Feathers could be inserted into additional apertures in the roach spreader, giving the wearer an even more impressive appearance.

Deer and porcupine hair, dye, leather, vegetal cord
H. 18.4 cm, w. 19.1 cm, d. 26.7 cm
(H. 7¼ in., w. 7½ in., d. 10½ in.)
Gift of Reverend Herbert Probert 87.816

Warbonnet
Probably Jicarilla Apache
Possibly northern New Mexico, early 20th century

Many Native American people revere the Thun-
derbird as one of their most powerful mythical
creatures. When he flaps his wings, the Thunder-
bird brings thunder and rain, nourishing the
planet. The earthly counterpart to the Thunder-
bird is the eagle; to wear eagle feathers was thus
a sign of great respect within the American Indian
community. Men earned the right to don eagle-
feather headdresses by proving their bravery,
measured in coups and great deeds on the battle-
field, as well as by showing leadership at home.
Eagle-feather headdresses were therefore power-
ful and important symbols, worn only by the
highest-ranking males. After their confinement
to reservations, when Native American men could
no longer prove their skill in battle, the headdress
continued to be worn for more ceremonial occa-
sions and dances.

This warbonnet was probably made by the
Jicarilla Apache people of northern New Mexico,
southern Colorado, and western Oklahoma. It dif-
fers significantly from those worn by most Plains
tribes because it is decorated with the primary
wing feathers of mature bald and golden eagles.
These feathers are mostly brown instead of the
white and brown secondary feathers more com-
monly found in warbonnets from this area.
Plume feathers of the golden eagle, dyed blue,
decorate the crown; secondary wing feathers,
aglets, and mirrors trim the long tail that falls
behind.

Leather with eagle feathers, dyed deer hair,
glass beads, fur, mirrors, white metal
Bonnet: H. 45.8 cm (H. 18 1/16 in.)
Tail: L. 185 cm (L. 73 in.)
Gift of Louise C. Carpenter in memory of her
parents, United States Senator Marcus A. and
Mrs. Ethel Warren Coolidge 1991.948

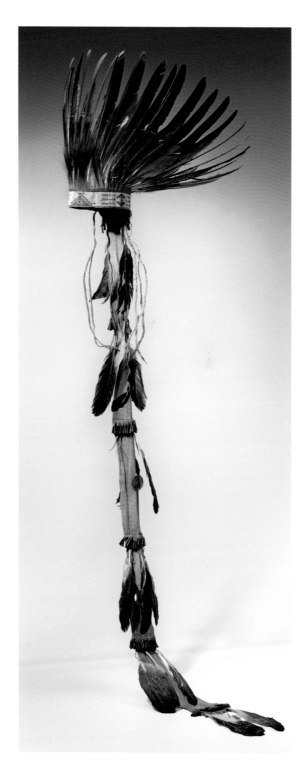

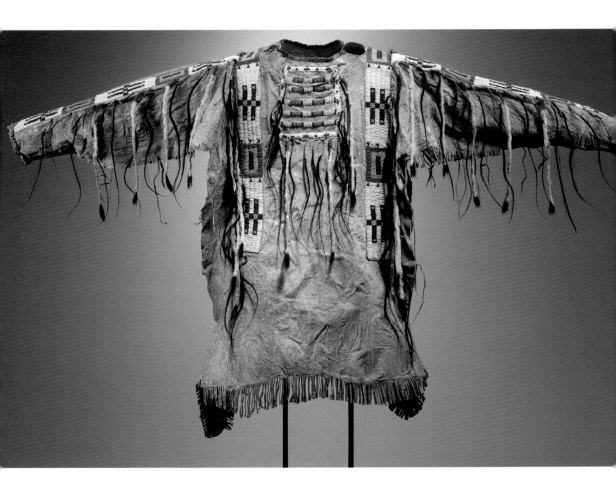

Warrior's shirt
Lakota (Sioux)
Plains region, about 1875

Warriors protected their tribe and ensured its sur-
vival by defending their people from attack or by
seeking battle with their enemies. They earned their
tribe's respect through brave deeds such as striking
a blow, touching enemies in battle, or stealing enemies'
horses. These "coups" would then be remembered and
recounted as stories. As they accumulated respect,
warriors earned the right to wear shirts such as
this. Conversely, as warriors wore the shirts, their
strength, ability, and character were absorbed into
them, making the garments objects of real power.
Among the Lakota (Sioux), painted shirts were worn
by those of high honor, and each lock of hair repre-

sented a coup taken in battle. The ermine tassels are
a sign of high status within the community and may
indicate that the original wearer was a chief. The
fierceness of the ermine made it a suitable symbol
for a man of such distinguished rank. For centuries
the beautiful white winter fur of the ermine had also
been prized in the fur trade; among Europeans, who
also used it as trim for clothing, as here, it was a sign
of nobility and royalty as early as the Renaissance.

Buckskin colored with natural pigments, human hair, ermine,
glass beads, cotton plain weave, fulled wool plain weave (trade
cloth), silk plain-weave ribbon, sinew and cotton thread
H. 127 cm, w. 78.7 cm (H. 50 in., w. 31 in.)
Gift of Louise C. Carpenter in memory of her parents, United
States Senator Marcus A. and Mrs. Ethel Warren Coolidge
1991.962

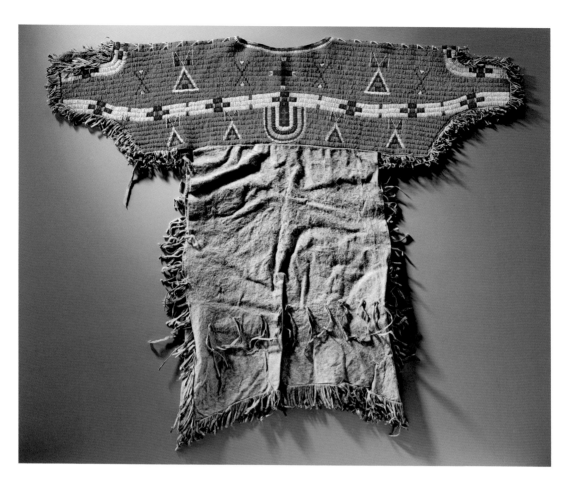

Dress

Lakota (Sioux)

Plains region, about 1910

Even when Native Americans began to be confined to reservations in the late nineteenth century, they continued to take great pride in their fine craftsmanship and artistic design. American Indian women, in particular, expressed these in the colorful clothing that they made for themselves and their families. This girl's dress, made of two buckskin hides, is typical of the style of clothing stitched by many Lakota (Sioux) women on various reservations as they experimented with different bead designs and exploited the wide range of colors available among the glass seed beads imported from Venice and later from Czechoslovakia.

About the turn of the century, fully beaded dress yokes became popular. The solid blue background used on this dress represents a lake, and the white horizontal line, the shore; the designs scattered throughout represent the reflection of the clouds on the surface of the water.

Leather, glass beads

H. 91.4 cm, w. 119.4 cm (H. 36 in., w. 47 in.)

Gift of Louise C. Carpenter in memory of her parents, United States Senator Marcus A. and Mrs. Ethel Warren Coolidge 1991.949

Knife case
Apsáalooke (Crow)
Probably Montana, about 1880

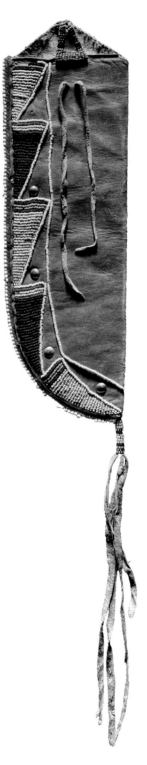

This large knife case or sheath, some sixty centimeters (two feet) long including the tassels, is typical of the beadwork produced by women of the Apsáalooke (also known as Absaroka and Crow) during the late nineteenth century. The banded triangles of light and dark blue, green, yellow, and red beads outlined in white follow the same traditional decorative schemes found on painted Apsáalooke parfleches and other cases made prior to the mid-nineteenth century, when beading became widespread. Native men and women of the Plains often carried knives as weapons or for use in food preparation and other tasks. The small losses and evidence of wear on this sheath suggest that it had been used for a period of time prior to being collected in 1884.

The 1880s were a significant decade in the long history of the Apsáalooke, who called themselves "children of the long-beaked bird" (translated as "Crow" in English). Since the 1850s, settlers increasingly encroached upon their territory in Montana, and the disappearance of the buffalo herds, largely complete by 1883, spelled the end of their traditional way of life. After a period of decline, the Apsáalooke began to recover in the 1930s; they established their own constitution in 1948 and continue to be governed by a general council.

Hide, glass beads, brass, wool trade cloth
L. 62.5 cm, w. 11 cm (L. 24⅝ in., w. 4⁵⁄₁₆ in.)
Gift of Reverend Herbert Probert 87.97

Vest

Lakota (Sioux)

Plains region, about 1900

As Native American people became confined to reservation life in the late nineteenth century, they were forced to adopt such Anglo-American traditions as sedentary agriculture and formal schooling for their children. Although many of these customs met with resistance, among those that found widespread acceptance were elements of dress, including men's shirts and vests. The vests proved particularly fashionable; Native American men often wore them while performing in popular "Wild West" shows. Featuring the reenactment of historical events from an Anglo perspective, such as early settlers defending their homesteads or wagon trains crossing the Plains and the Battle of Little Bighorn, and including displays of sharpshooting, racing, and riding, these shows were developed for an Anglo audience, though the Native Americans who performed in them were often seen as celebrities among their own people.

A particularly skilled woman created this vest, using lane stitch for the beaded design. This technique involved threading beads on a string and then couching them down in even rows to completely cover the surface of the fabric. This beading technique was developed by the Lakota during the later nineteenth century and spread to other Native American beaders. It saved time, as each bead did not have to be individually sewn to the fabric, while also lending itself to the production of bright, colorful, and solidly beaded pictorial surfaces.

Buckskin, plain-weave cotton lining, glass beads
H. 55 cm, w. 52 cm (H. 21⅝ in., w. 20½ in.)
Denman Waldo Ross Collection 03.1022

Martingale

Apsáalooke (Crow)

Plains region, probably Montana, before 1884

According to traditional stories, the Apsáalooke (Crow) moved west in the seventeenth or early eighteenth century from North Dakota into what is now Montana and Wyoming. There they established hunting grounds and became successful traders in fur pelts and hides. The Apsáalooke measured their wealth in elaborately decorated clothing and household items, as well as in horse equipment. They were particularly known for possessing numerous horses, used in migration, warfare, and hunting. Historians estimate that by the early nineteenth century, an individual Apsáalooke family may have owned somewhere between twenty and sixty horses.

When women moved from camp to camp, they wore elaborately beaded outfits, carried their warriors' weapons, and decked their horses out in colorful accoutrements that added to the pageantry. This martingale would have been one element in a large set of trappings modeled on Spanish prototypes that were, at times, traded by the Spanish along with horses. The martingale (or collar) was tied around the horse's neck and covered the front of its chest, serving more as a decorative rather than a functional object. By the late nineteenth century, Apsáalooke horse regalia, including bridles, forehead ornaments, stirrup covers, and cruppers, as well as martingales, became increasingly ornate. This outstanding martingale displays the bright color contrasts, prominent isosceles triangles, and white borders characteristic of Apsáalooke work, as also seen on the knife case in this chapter (p. 140).

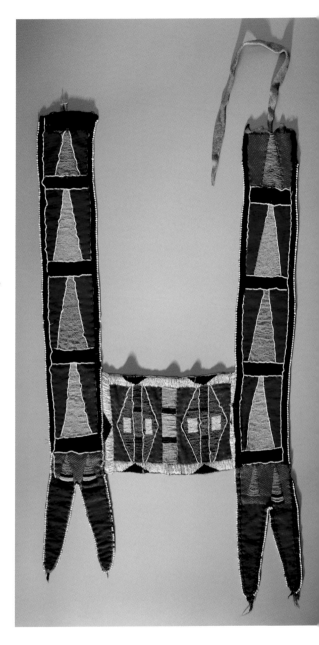

Buckskin, glass beads, wool trade cloth
H. 85 cm, w. 53 cm (H. 33½ in., w. 20⅞ in.)
Gift of Reverend Herbert Probert 87.92

Duct flute

Possibly Lakota (Sioux)

Great Plains region, mid-19th century

The duct flute (*sĭyotanka*), often referred to as a court-ing flute, was used by North American Indians of the Great Plains, Plateau, and Southwest regions and is essentially the only indigenous melodic instrument of these culture groups. It is believed to have been in use in some areas for more than two thousand years. Tra-ditionally, it was used only by men as part of courting rituals, during which they would play improvised melodies of a free and rhapsodic nature.

The flute's body is usually made from straight-grained wood (such as red cedar), split in half, hollowed out, and then bound back together with sinew or leather. Examples made from cane are also known, especially in the Southwest. The windway in these flutes is somewhat unusual in that a disk or partition is positioned partway down the tube, usually carved in place during the process of hollowing the body. This partition is straddled by two rectangular holes, above which is tied a carved block that channels the player's air up and over the partition to set the air col-umn vibrating.

The carving atop the block of this flute has been interpreted as a horse. The dangling bird claw is somewhat unusual in such instruments. It is believed to be that of a ruffed grouse (identifiable by the bris-tles between its toes), which is recognized for its dancelike mating rituals. Clearly of personal signifi-cance to the flute's owner, the claw possibly was meant to enhance the potency of his courting efforts.

The 1970s witnessed a considerable rekindling of traditionalism among American Indian peoples, and along with that movement came an interest in court-ing flutes. Through the efforts of Native scholars and musicians, such as Doc Tate Nevaquaya (Niuam [Comanche]), American Indian flute music has become much better known. Contrary to traditional practices, women flute players have actively participated in the instrument's revival. Consequently, the instrument's evocative and expressive tone has become a signature sound for almost anything relating to American Indi-ans in film and television.

Wood, sinew, leather, heart sac
L. 51.7 cm, diam. 2.7 cm (L. 20⅜ in., diam. 1¹⁄₁₆ in.)
Helen and Alice Colburn Fund 1984.315

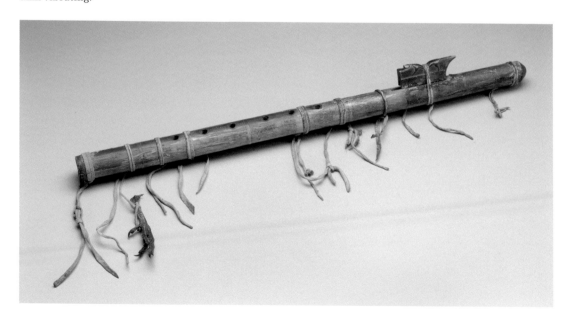

Hand drum

Probably Siksika (Blackfoot) or Apsáalooke (Crow)
Northern Plains region, about 1900

This Northern Plains drum is a typical example of a crucial implement of music making for North American Indian people across the continent. It employs a wooden frame or hoop to support the animal-hide drumhead. The slight curvature of the surface results from the drumhead's tension warping the wooden frame. Drums like this are held from the back, where, on this example, a network of intersecting leather thongs forms a handle. Such drums are often referred to as hand drums, despite scant evidence of North American Indian people striking the head of a drum with a bare hand; rather, they hold the drum in one hand and strike it with a drumstick (fig. 32).

Most drums of this size are adorned to some extent with pigment and feathers, as well as trade cloth and glass beads. This drum was made, or perhaps redecorated, at a time when its owner had access to synthetic paints. The reddish orange ground color is common on historic drums, although the repeated triangle pattern around the perimeter and the field of black dots are probably not original. These design elements are frequently found on drums, but here they have been applied over existing structural and decorative features, suggesting that they are a later addition. Traditionally, the line across the drum symbolizes the horizon, and the field of dots calls to mind hail falling over the land—a powerful force that cannot be controlled by humankind.

Wood, leather, paint
H. 7.6 cm, diam. 34.3 cm (H. 3 in., diam. 13½ in.)
Gift of Louise C. Carpenter in memory of her parents, United States Senator Marcus A. and Mrs. Ethel Warren Coolidge
1991.961

fig. 32. **De Cost Smith**
(1864–1939), *Divination*, 1906.

Gourd rattle

Possibly Arapaho

Western Plains region, about 1930

Usually referred to as a peyote rattle, instruments of this type are used by members of the Native American Church. Along with the water drum, the rattle is employed by those participating in the peyote ceremony. The rattle is held in front of the singer and shaken gently with the wrist. The tufts of horsehair protruding from the top of the gourd symbolize the blossom of the peyote cactus, the crown of which can be ingested to induce a temporary transcendent state of being. The striped beading on the handle is typical, as are the long buckskin tassels, which are meant to represent the tail feathers of the anhinga, a sacred bird.

The Native American Church, incorporated in 1918, is an organized religion combining elements of both Native American and Christian faith systems. Although the use of peyote is a continuation of traditions that are centuries old among the indigenous people of northern Mexico, the practices of the Native American Church, including playing the peyote rattle with a water drum, are unique to the religion. Because the traditions of the Native American Church have extended to indigenous peoples across North America, rattles like this one can be found throughout the continent.

Gourd, wood, seed beads, horsehair, feathers
L. 38 cm, diam. 5.5 cm (L. 14 ¹⁵⁄₁₆ in., diam. 2 ³⁄₁₆ in.)
Helen and Alice Colburn Fund 1984.314

Parfleche envelope

Lakota (Sioux)

Central Plains region, North Dakota or South Dakota, about 1860–80

Parfleche is a term for various types of rawhide containers used by the nomadic tribes of the Great Plains, principally between about 1750 and 1880. Fashioned from animal skins, often buffalo hide, as here, parfleches were made and decorated by women. Although there were many variations on the process, typically Plains women prepared the skins by scraping, cleaning, and drying them, and then applying a size derived from various gelatinous materials, including remnants from the hide itself or from the juice of the prickly pear cactus. This layer of sizing made the rawhide water resistant and provided a uniform surface. The container was then painted, re-sized, dried, and ultimately finished. This example is one of the more common types of parfleche, basically a flat, folded envelope that can be opened to house a considerable amount of clothing, foodstuffs, and other goods. Such lightweight, largely waterproof containers were invaluable in easing the burden of moving a family's goods from one location to another.

Parfleches were often made for Native families in pairs in order to take best advantage of the size of the hide, which usually provided enough material to make two envelopes; the mate to the Museum's example is in a private collection. Using a pair of parfleches, as is the case with saddlebags, also would help balance the load for the horse.

The design of this parfleche is characteristic of those made by the various component tribes of the Lakota (also known as the Teton or Western Sioux) of the North and South Dakota area of the Central Plains, including the Oglala, Brulé, Minniconjou, Sans Arcs, Two Kettles, Siksika (Blackfoot), and Hunkpapa. Their parfleches are usually brightly painted in geometric forms, as here, with the rectangles, triangles, diamonds, and other shapes outlined distinctly in black. Such abstract representation is characteristic of the art of Plains women.

Buffalo rawhide, pigment
H. 5.1 cm, w. 72.7 cm, d. 34.9 cm
(H. 2 in., w. 28⅝ in., d. 13¾ in.)
Gift of Linda and Charles Nichols in tribute
to unnamed Native artists 1995.147

Carrying basket or coiled pack basket

Lataxat (Klikitat)

Columbia River area, Washington, about 1890

Baskets made by the Plateau peoples of the mid–Columbia River area of the state of Washington are among the finest examples of Indian art produced in this country. This sturdy carrying or pack basket, used for gathering huckleberries, is attributed to the Lataxat (Klikitat), who live on the eastern slopes of the Cascade Mountains north of the Columbia River. They also produce twined hats and flat twined bags in addition to baskets of many sizes and varieties, including the type of basket shown here.

This example is made of local materials that grow abundantly in the area of its creation: coiled cedar and spruce, completely imbricated with bear grass (*yaii*), wild cherry bark, and horsetail or dyed cedar bark. The imbrication (overlapping of the edges in the design) creates the tile- or scale-like appearance of the exterior. The basket also has a complex rim with nine carrying loops.

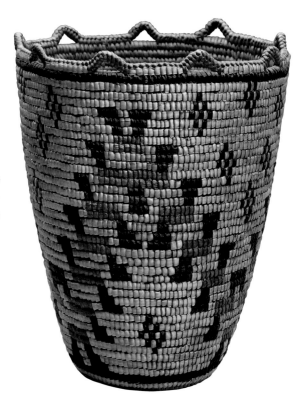

Probably made in the late nineteenth century, this basket stands in the middle of a long tradition of Lataxat basketry that was carried forward into the twentieth century by Elsie Thomas, Nettie Jackson, and many others. In 1982 Thomas, along with fellow basket makers Nettie Kuneki and Marie Slockish, published *The Heritage of Klickitat Basketry*, documenting in words and photographs the history, techniques, and meaning of their art. In that publication, the authors identify the traditional design on this basket as the "geese in flight" pattern, so named by one of their grandmothers.

Coiled cedar and spruce, bear grass,
wild cherry bark, horsetail or dyed cedar bark
H. 30.5 cm, diam. 26 cm (H. 12 in., diam. 10¼ in.)
Gift of Arthur Beale and Teri Hensick 2008.1503

Haungooah (Silver Horn)
Kiowa Apache, 1860–1940
*The Once Famous Black Eagle (Ko-et-te-Kone-Ke)
of the Ki a Was in Deadly Conflict with Ute Chief—
Ute Killed* and *Calling on the Ladies a Courting
Scene*
From *Ledger Book*, about 1885

Plains draftsmen recorded sacred visions, historical events, and pivotal battles on functional objects such as shields, robes, and tipis. Kiowa Apache artist Haungooah (Silver Horn) was part of this tradition. He was given notebooks, pencils, and crayons by ethnographers studying the Plains cultures during the last three decades of the nineteenth century, a time of intense conflict between Native Americans and the United States Army. Those ethnographers asked Haungooah about his drawings and wrote their summaries of his explanations on the front or back of his work.

Haungooah, in common with most ledger-book artists, worked in a spare style, generally omitting background detail or shadows. However, he was specific in depicting dress, body paint, and weapons. In *The Once Famous Black Eagle (Ko-et-te-Kone-Ke) of the Ki a Was in Deadly Conflict with Ute Chief—Ute Killed*, the artist devotes great attention to the feathered headdresses, clothing, and shields of two men engaged in mortal combat, creating a precise yet dramatic composition of great visual power.

Haungooah was also skilled at visual storytelling. For example, in the lighthearted *Calling on the Ladies a Courting Scene*, he depicts two potential suitors receiving quite different responses from the women they approach. On the left, the woman is described in the handwritten note by the ethnographer as "still doubtful," which Haungooah has indicated by rendering the couple as two distinct figures. On the right, the note tells us the woman has said "yes," which Haungooah has communicated visually by showing the male and female figures overlapping and merging into one.

Graphite and colored crayons on paper
1994.429.24: H. 25.7 cm, w. 35.6 cm (H. 10⅛ in., w. 14 in.)
1994.429.29: H. 25.7 cm, w. 34.6 cm (H. 10⅛ in., w. 13⅝ in.)
Gift of the grandchildren of Lucretia McIlvain Shoemaker and the M. and M. Karolik Fund 1994.429.24, 1994.429.29

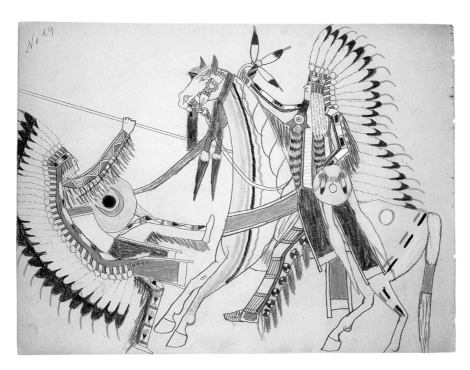

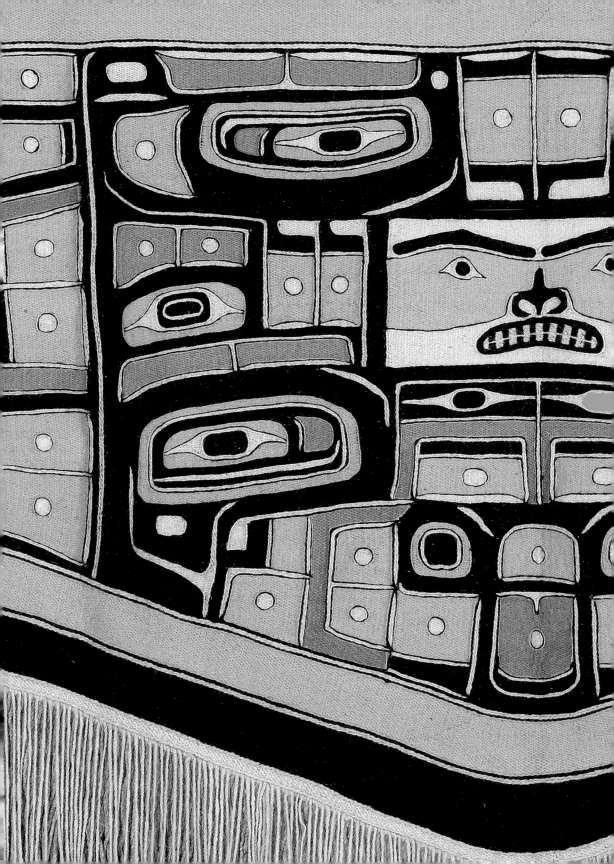

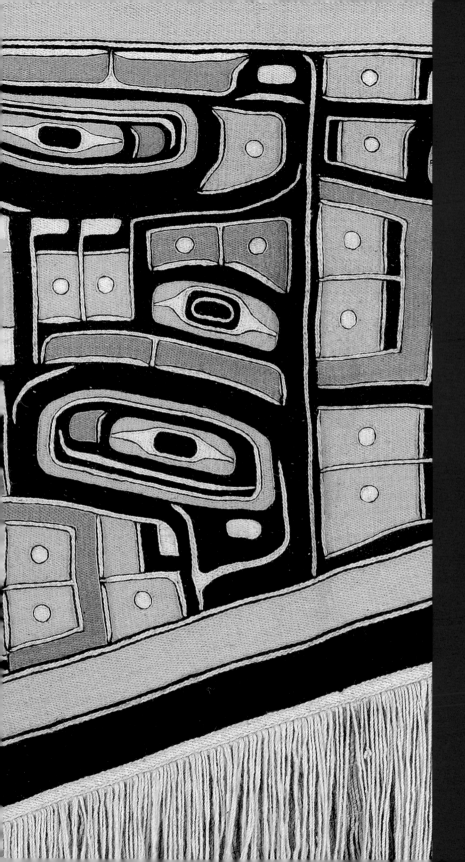

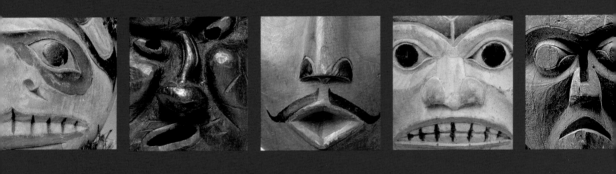

The Northwest Coast, Arctic, and Subarctic

The Northwest Coast Indians lived along a narrow strip of land hugging the Northwest Pacific coast from Puget Sound off the state of Washington in the south up to Yakutat Bay in Alaska. This land is home to several major Native American entities, among them (ranging from south to north) the Nuu-Chah-Nulth (Nootka), southern and northern Kwakwaka'wakw (Kwakiutl), Tsimshian, Haida, and Tlingit. Replete with islands, rivers, and archipelagos, this beautiful, heavily wooded area is largely isolated from interior mainland influences by coastal mountain ranges. The environment, notable for its significant rainfall and moderate temperatures, offered Native Americans abundant natural resources from the sea and the land; the annual salmon run, for example, often provided enough food for year-round subsistence. Over time, the Native Americans created an extraordinary and instantly recognizable body of works of art made from local materials such as western red cedar, bark, argillite (see p. 162), mountain-goat wool, animal hides, copper, shell, and pigments. Although many variations exist in the objects the Northwest Coast maritime communities created, there are also many similarities; a precise village of origin for any given object can often be difficult to determine, even for a specialist.

The forms of these objects, only a few of which are represented in this chapter, include a wide variety of sculptural masks and headdresses; robes, blankets, and painted hide costumes; rattles and speakers' staffs; shamans' charms and figures; wooden bowls, boxes, and chests; spoons and ladles; daggers; pipes; fishhooks; baskets; and other implements and ornaments. Several types of Northwest Coast objects—including large standing potlatch figures, bent-corner chief's chests, and memorial totem poles and carved house fronts—are distinctive to this area. Many works were made for public ceremonies such as lavish, gift-giving potlatches (see p. 161); for secret societies; for use by shamans (spiritual leaders and healers); or for heraldic purposes.

The unique Northwest Coast chests and many other forms, often painted red and black and occasionally blue-green, are decorated in an all-over, bilaterally symmetrical manner. The carved elements customarily take human, animal, or mythological forms with exaggerated features, such as eagles, beavers, seals, bears, ravens, owls, whales, thunderbirds, wolves, frogs, loons, salmon, sea monsters, and others, often representing crest symbols of specific clans or tribal stories and legends. The scholar Bill Holm recognized and defined the so-called *formline* as the essential characteristic of Northwest Coast art (see p. 160). The formline, usually painted in black, provides the overall structure of the design and defines its given subject matter. Constantly changing in thickness and direction, the curving formline characteristically contains many ovoid shapes and U- and S-shaped forms. Much as the curvilinear, S-shaped "line of beauty" (as defined

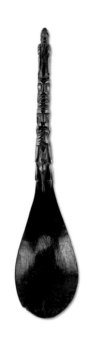

fig. 33. **Ladle, Haida, Haida Gwaii (Queen Charlotte Islands), British Columbia, Canada, about** 1890.

by the eighteenth-century English artist William Hogarth) was the essential characteristic of late-baroque art, these curvilinear formlines in their own way define the design of both two- and three-dimensional Northwest Coast objects and provide the dynamic look that gives them a recognizable regional style unparalleled in other Native American art.

Although Spanish, Russian, and British traders were also heavily involved, merchants and sailors from Boston were so ubiquitous in the fur trade off the Pacific Northwest Coast starting in the late eighteenth century that Native Americans living there at the time came to refer to all white people as "Boston men." These fur traders, and later settlers and tourists, encountered and then, as always occurred, dramatically altered the lives of the local residents, who had occupied this territory for centuries if not longer. Many took home souvenirs (fig. 33), some of which found their way to institutions such as the Museum of Fine Arts, Boston, bringing to the attention of a wider audience one of the world's most distinctive and beautiful regional styles of art.

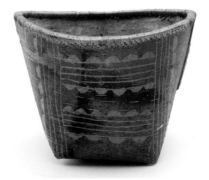

fig. 34. **Container, Kutchin, Alaska or Yukon, Canada,** 1900–1950.

Even farther to the north, the Inuit (Canadian Eskimo), Inupiaq (Alaskan Inupiat Eskimo), and other peoples adapted to the harsh climate of the subarctic and Arctic areas that extend across northern Alaska and Canada all the way to Greenland. These peoples are known for such regional specialties as the powerful com-

fig. 35. **Nuna Parr** (Inuit, born in 1949), walrus, Cape Dorset, Canada, 1992.

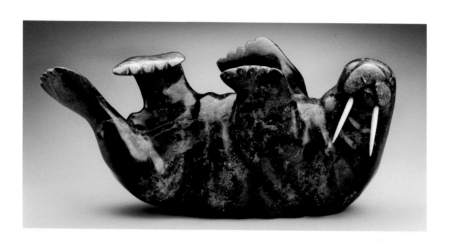

posite masks of the Central Yup'ik, fashioned of wood, fur, feathers, and pigments, and for various types of basketry (fig. 34), and other objects, including the ivory and wood carvings seen here. They are perhaps most widely recognized for their sculptural figures of animals, carved in ivory or soapstone, which were created to honor the animals they hunted for their subsistence, as shamanistic objects, and later for trade. The art of figural carving, ancient in origin, has been kept alive in modern times by many Inuit carvers such as Nuna Parr. Born in Cape Dorset, Canada, Parr now lives and works in the Nunavet Territory, just below the Arctic Circle, and maintains a traditional livelihood of hunting and carving. He is known for his lively animal carvings, such as the Museum's walrus (fig. 35), which utilize the grain of the serpentine stone to lyrical effect.

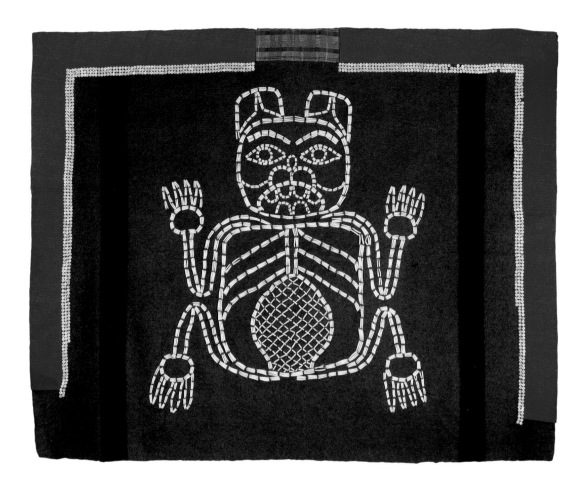

Button blanket

Haida

Haida Gwaii (Queen Charlotte Islands),
British Columbia, Canada, 1865–80

Among the Native American people of the Northwest
Coast, chiefs and people of high status traditionally
wore large fur or twined cedar-bark mantles for impor-
tant ceremonies. Some of the earliest cedar-bark robes
to have survived, such as those collected by the English
explorer Captain James Cook during his voyage of 1778,
have symbolic animals and faces painted on them. These
robes could be the precursors to the button blanket that
developed by the mid-nineteenth century. Made of the
popular and widely distributed Hudson Bay trade blan-

kets that were decorated with buttons and in this
case dentalium (a marine mollusk) shells, button
blankets became traditional wear during impor-
tant ceremonies, such as the potlatch (see p. 161),
and during funerals. A beaver clan crest is depicted
on this robe in dentalium shells, evidence that this
is probably a robe from the earlier nineteenth cen-
tury, when such shells were still used to decorate
clothing and had not yet been completely replaced
by mother-of-pearl buttons.

Wool twill embroidered with dentalium shells and
mother-of-pearl buttons
H. 139.7 cm, w. 177.8 cm (H. 55 in., w. 70 in.)
Mary S. and Edward J. Holmes Fund 2007.498

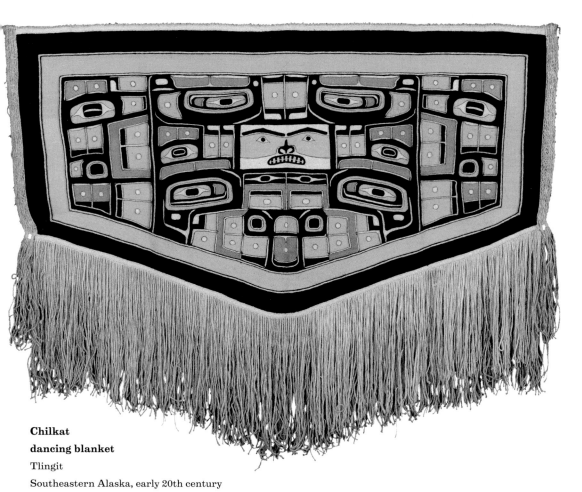

Chilkat
dancing blanket
Tlingit
Southeastern Alaska, early 20th century

Members of the Tlingit of the Northwest Coast wore intricately patterned shoulder blankets with a long fringe for ceremonial dances and during the potlatch. The blankets symbolized the wearer's high status within the community, and upon death the owner was often buried wrapped in the blanket or it was hung outside the grave. Depicted on the blankets were clan crests that usually represented stylized animals such as whales, beavers, and bears. This crest represents the diving whale, one of the most common designs found on such blankets. Some scholars theorize that its ubiquity points to the possibility that the pattern was reserved for those outside the clan system or for blankets made for trade or sale. This dancing blanket is remarkable for the intensity of its color, as the traditional dyes used in these blankets are very fugitive and normally fade relatively quickly when exposed to light. The vibrant colors here thus may be an indication that this blanket was made for trade and purchased soon after its completion.

Twined wool and cedar bark, vegetal dye
H. 114.3 cm, w. 165.1 cm (H. 45 in., w. 65 in.)
Museum purchase with funds donated anonymously
2008.650

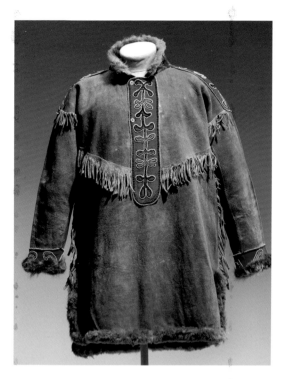
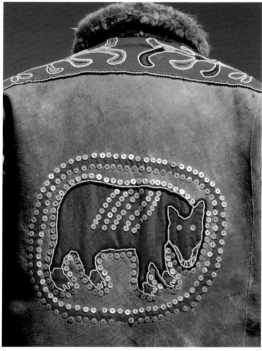

Man's ceremonial shirt

Tahltan

Stikine River area, British Columbia, Canada, late
19th–early 20th century

The Tahltan people lived along the Stikine River in
British Columbia. During the nineteenth century, they
participated in the fur trade, supplying moose, cari-
bou, mountain-goat, and sheep hides and furs to the
Tlingit people of the coast, who at the time controlled
the trade with Westerners. In return, the Tahltan
received salmon, dentalium and abalone shells, cop-
per, and slaves. By the 1870s, Europeans and Ameri-
cans settled along the Stikine River and engaged in
direct trade with the Tahltan. As a result of this con-
tact, the Tahltan were introduced to new clothing
styles, decorative techniques, and materials, such as
the buttons, red wool, and beads used in this shirt.
Cross-cultural influences from other Native Ameri-
cans are also evident in Tahltan culture: their cere-

mony and most of their ceremonial wear were adopted
from the Tlingit, including the use of clan crests such
as the bear on the back of this shirt, which recalls
the crests that ornamented Haida and Tlingit ceremo-
nial blankets.

Men's ceremonial shirts, however, continued to
reflect the shape of traditional Tahltan shirts made
of moose, elk, or caribou hide. These shirts, cut straight
across the bottom, contained little decoration except
for a fringe and a small amount of quillwork. The
style of these shirts was originally adopted from the
Athapaskan people, and the garments continued to be
used for ceremonial wear, although they were more
elaborately decorated, in this case with beaded red
epaulets and front plaquette. The more abstract
nature of the beading is typical of the Tahltan.

Possibly smoked moose hide, muskrat fur, plain-weave wool
(trade cloth), glass beads, mother-of-pearl buttons
L. 157.5 cm, w. 88.9 cm (L. 62 in., w. 35 in.)
Gift of Louise C. Carpenter in memory of her parents, United
States Senator Marcus A. and Mrs. Ethel Warren Coolidge
1991.963

Basket

Tlingit

Southeastern Alaska, mid- to late 19th century

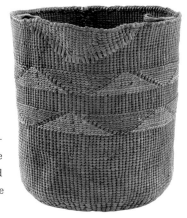

Spruce-root basketry was ubiquitous among the Tlingit of southern Alaska by the end of the eighteenth century. Numerous types and sizes of basket containers were used for gathering a wide variety of berries; small examples, such as this basket, were made to be hung from the neck via a cord attached to loop handles. This Tlingit basket was probably made for Native use in the mid- to late nineteenth century, prior to the production of related items as trade goods. The red color in the pattern was created through natural vegetal dyes, used before the widespread adoption of synthetic aniline dyes.

Significantly, this cylindrical basket, given to the Museum in 1916, shows evidence of several Native repairs, including a large patch on one side and the introduction of new loops or tabs to the inside to maintain its usefulness as a hanging basket. Such efforts to maintain the basket's utility indicate the value that this item had in the Tlingit community.

Twined spruce root, bear grass, vegetal dye
H. 13.7 cm, diam. 14 cm
(H. 5⅜ in., diam. 5½ in.)
Gift of George F. Meacham
16.152

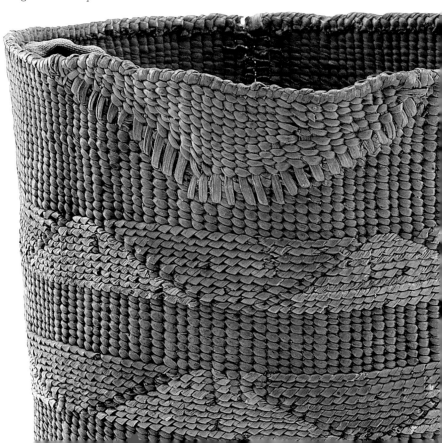

Chest
Probably Tsimshian
Coastal British Columbia, Canada, about 1860

This commodious chest was used as a seat for a Tsimshian chief and to store such personal and family treasures as headdresses, blankets, and masks. The shallow carving on the front and back and the creative use of conventional formline imagery mark this example as the work of a master. The principal continuous black painted line here possibly portrays a mythical hero named GonAqAdē't, who, having risked his life to obtain food for his starving people, is transformed into a sea monster who brings wealth and good luck to those fortunate enough to see him.

In terms of their construction, bent-corner chests of this type (as well as some smaller boxes and related forms) are unique to the Northwest Coast. The chest sides are made of a single cedar plank that was V-cut (or kerfed) on its inside corners and then steamed and bent to form a box, which was then pegged or stitched together.

Yellow cedar and red cedar with red (Chinese vermilion and red ochre) and blue pigments
H. 68 cm, w. 105.1 cm, d. 61.6 cm (H. 26¾ in., w. 41⅜ in., d. 24¼ in.)
Museum purchase with funds donated by a Friend of the Department of American Decorative Arts and Sculpture 1997.9

Potlatch figure

Kwakwaka'wakw (Kwakiutl)

Kwakwaka'wakw (northern Vancouver Island),
British Columbia, Canada, about 1840

Impressive in height, vigorous in stance, and baleful
in mien, this imposing sculpture was probably dis-
played at potlatch feasts, a crucial focus of social and
ritual life among the peoples of the Northwest Coast,
including the Kwakwaka'wakw (Kwakiutl). At the pot-
latch, the host showered his guests with food, drink,
and numerous gifts, including masks and blankets,
thus demonstrating his goodwill and reinforcing his
social status. Such figures were also displayed at other
ceremonies and were created with a variety of visages,
ranging from benign to threatening, defiant, or fool-
ish. This figure, representing the host or perhaps one
of his ancestors, probably would have stood outside
the host's house to welcome guests. The trapezoidal
shape over the chest represents a copper plaque, sym-
bolic of the real goods that guests received during
the festivities but also an indication of the family's
wealth and status.

Carved from a single piece of red cedar, the figure
retains vestiges of its original paint and exhibits
pronounced tool marks, left intentionally for decora-
tive effect, from the D-adze used in its creation. The
D-adze, named for the shape of its handle, was and
remains a popular tool among Northwest Coast Indian
craftsmen, valued for its ability to perform rough as
well as finishing work and to impart a distinctive
texture to the wood. The figure probably was once fit-
ted with a beak- or hawklike nose (now missing). The
lower end of the legs also has been lost, perhaps due
to the figure's exposure to the elements while dis-
played outside.

Red cedar, paint
H. 172.1 cm, w. 47 cm (H. 67¾ in., w. 18½ in.)
Museum purchase with funds donated by a Friend of the
Department of American Decorative Arts and Sculpture
1998.3

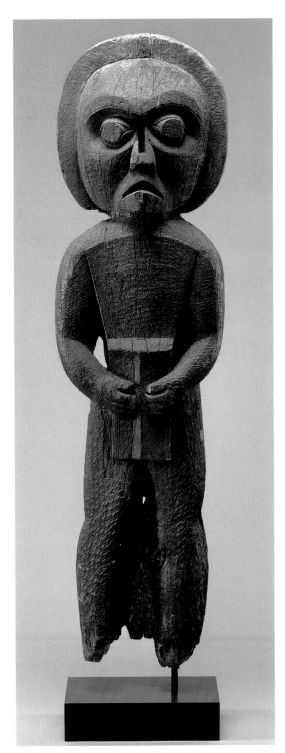

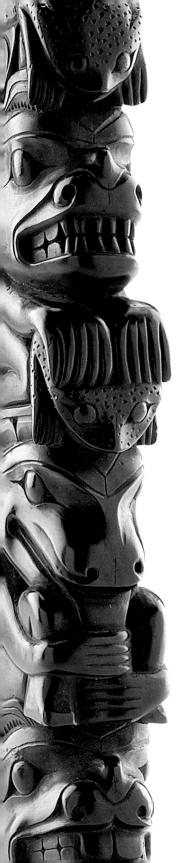

Model totem pole

Haida

Haida Gwaii (Queen Charlotte Islands), British Columbia,
Canada, about 1890

This small model of a totem pole is carved with the mythical and
crest figures often found on cedar, silver, gold, and other objects
produced by the Haida of Haida Gwaii (Queen Charlotte Islands)
in British Columbia, an archipelago of about 150 islands. Each fig-
ure, usually represented by several distinctive features, is part of
a design vocabulary developed over time by many generations of
carvers. Here they include a beaver, with its two large incisors;
frogs; a bear; and a hawk, with its recurved beak at the top.

The totem is carved from argillite, a hard, black, slatelike
stone mined only at a deposit in Slatechuck Creek on Graham
Island. About 1800, the Haida started to fashion pipes for funeral
ceremonies from argillite, and a few decades later they began to
produce substantial amounts of argillite carvings as
souvenirs for sailors. By the late nineteenth century,
when this totem was made, the village of Skidegate
had become a center of the carving trade and boasted
a number of well-known carvers, including Charles
Edenshaw (1839–1920).

This model of a totem was probably made in
Skidegate. It came to the Museum in 1899 as part of
a bequest from Mrs. John H. Thorndike of more than
130 objets d'art from around the world that she and
her husband collected in the second half of the nine-
teenth century.

Argillite
H. 22.9 cm, w. 6.4 cm, d. 5.1 cm
(H. 9 in., w. 2½ in., d. 2 in.)
Bequest of Mrs. John H. Thorndike 99.593

Joe David
Nuu-Chah-Nulth (Nootka), born in 1946
Loren White, born in 1941
Took-beek
Dayton, Oregon, 1982

Totem poles and house posts from the Northwest Coast are firmly entrenched in the public imagination as one of the characteristic forms of Native American art. Made for a variety of purposes—to be placed outside the entrance of a home as an indication of ancestry and social position, as a memorial for a deceased family member, and for other reasons—some surviving examples tower more than fifteen meters (fifty feet). The images, carved on red cedar logs, typically represent clan symbols, such as Raven, Bear, Eagle, or Killer Whale.

The art of totem-pole carving has been revived by a number of artists in the Pacific Northwest, including Joe David, who carved this totem with the assistance of Loren White. David has been immersed in the contemporary Northwest Coast art movement since 1969, creating works of art in a variety of media and participating in many aspects of Native American life.

David titled this work *Took-beek* (Sea Lion Hunter), a treasured name in his family. At the time this object was made, the name belonged to David's cousin Ernie Chester of the Ditidhat tribe of the Nuu-Chah-Nulth (Nootka) nation, located on the west coast of Vancouver Island. Chester had received the name from his father and in turn passed it along to his son. As David explains, "The top figure of a man [carved by David] represents Took-beek (Ernie) and the bottom animal figure [carved by White] represents a sea lion. The large tongue coming out of the man's mouth represents the tail of an eagle and the eagle's wing is represented along the man's arm. The sea lion is holding a boy's face which represents Ernie's father teaching him family history and songs."

Painted red cedar
H. 188 cm, w. 61 cm (H. 74 in., w. 24 in.)
Gift of Dale and Doug Anderson in honor of
Ron and Anita Wornick 2005.373

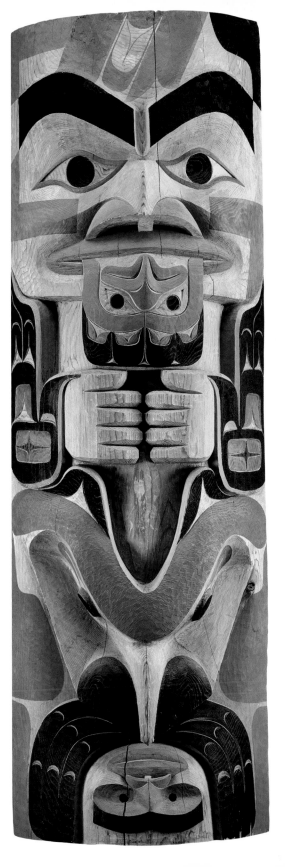

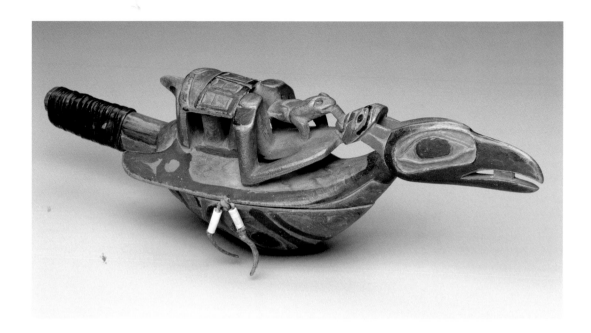

Raven rattle
Probably Haida
Haida Gwaii (Queen Charlotte Islands), British
Columbia, Canada, 19th century

Raven rattles are sometimes called chief's rattles, as typically they are used by wealthy tribal chiefs to conduct social rituals. Like many ritual instruments, the raven rattle holds greater significance for its symbolic properties than for its acoustical qualities. Raven, a mythological hero for many Native people living on the Northwest Coast of North America, is depicted carrying a box of daylight in his beak, which he has stolen from the great father of the sky. Raven then released the light contained in the box to illuminate the earth, which earlier had been in darkness. The light in this myth represents not only the physical manifestation of the sun, moon, and stars, but also sacred wisdom previously kept from humankind. On Raven's back are a reclining human and a frog; their embracing tongues symbolize a shamanic transfer of spiritual power. This exchange is akin to the gift that Raven gives to humankind. Carved on the rattle's underside is a stylized face that can be interpreted as a hawk or a sea monster, invoking the power associated with these creatures—the sky and the sea, respectively.

There are countless variations in the basic composition of raven rattles, but this example contains all of the visual elements that are considered classic in such instruments. The bluish green paint on the rattle would have been produced from a mixture of cobalt and a vegetal additive such as moss, steeped in a liquid bath.

Wood, paint, leather, dentalium shells
L. 30 cm, w. 8.2 cm (L. 11¹³⁄₁₆ in., w. 3¼ in.)
Gift of Graham Carey 1985.735

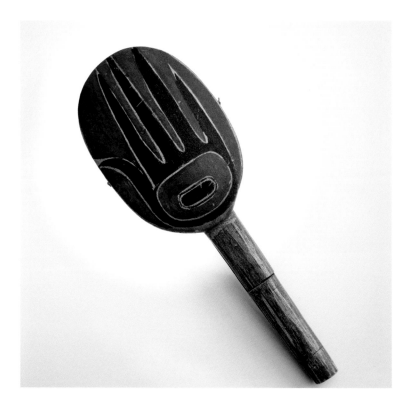

Rattle

Tsimshian

British Columbia, Canada, about 1900

Folklore of the Northwest Coast links humankind and bears, most notably in the story of a young woman who becomes lost in the woods and is taught the ways of the forest by a bear. In line with this link, the imagery on this rattle combines the human hand with the paw of a bear: the simple oval-shaped form-line figure on the palm of the hand can be perceived as the pad of a bear's paw, and the elongated fingers are suggestive of claws. Given the relationship between humans and bears, the rattle was probably conceived as a shaman's rattle and is most likely designed to invoke the strength of the bear. The vibrant color and lack of wear suggest, however, that it may have been manufactured for sale to the ever-burgeoning trade in Northwest Coast artifacts. The synthetic paint used on this rattle was introduced to the people of the Northwest Coast through trade in the late nineteenth century. Synthetic paints quickly became preferred over natural paints because of their richer hues and greater color fastness. As with other rattles of the region, this one was carved in two pieces and assembled with strips of sinew.

Wood, paint, sinew
L. 26.7 cm, w. 9.5 cm, d. 4.4 cm
(L. 10½ in., w. 3¾ in., d. 1¾ in.)
Museum purchase with funds donated by Elizabeth Wetherill McMeel and The Seminarians 1996.28

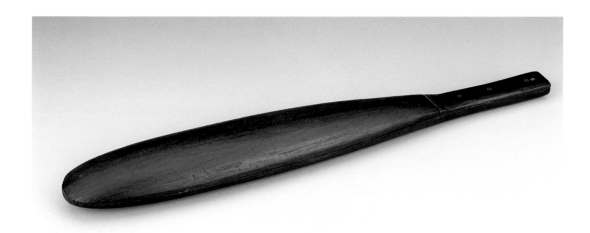

Clapper
Tlingit
Alaska, 19th century

According to an account penned by Frances Densmore, a noted late-nineteenth- and early-twentieth-century ethnologist, clappers like this one are used by medicine men in healing ceremonies; the implement is struck against the body of the afflicted person as part of the treatment. Densmore was one of the earliest and most reliable ethnologists working with Native Americans at the turn of the century. Although she may not have understood everything that she witnessed, she reported things exactly as she saw them and developed significant trust relationships with Native people.

The graceful, organic shape of this clapper is reminiscent of a paddle or, perhaps, a fin or flipper. Adept woodworking skills are evident in the consistent, smooth lines throughout, as well as in the closely matched joints and contact points of the outer edge of the clapper's blades. Constructed of two pieces of partly hollowed softwood, the clapper is bound together at the handle end by multiple wooden plugs. The hinge consists of a thin piece of whalebone inserted into both the handle and the upper blade of the instrument. The fact that this object is undecorated may or may not be significant. Often whistles were left plain, as they were not meant to be seen by uninitiated members of a society; a similar practice may be associated with clappers. The entire unadorned, smooth surface of this clapper is painted black, although such instruments are often carved and painted in the manner of Tlingit rattles, which are decorated with images of animal figures in the hope of drawing power from them, a form of totemic symbolism.

Wood
L. 39.7 cm, w. 6.2 cm, d. 3 cm (L. 15⅝ in., w. 2⁷⁄₁₆ in., d. 1³⁄₁₆ in.)
Leslie Lindsey Mason Collection 17.2249

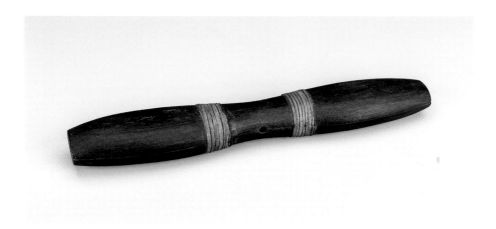

Reed pipe

Haida

Haida Gwaii (Queen Charlotte Islands), British
Columbia, Canada, before 1888

Reed instruments of this variety employ a mechanism
somewhat akin to the double reeds found in folk
instruments throughout the world. Closely related
reed pipes (*sk-â'na*) were collected from the Haida in
the nineteenth century, suggesting the same origin
for the Museum's example. The player blows through
a small hole at the center of the instrument (the
embouchure hole), which forces air through slits at
both ends, causing them to vibrate. Typically associ-
ated with secular dance settings, these reed pipes
produce a distinctive nasal sound that is somewhat
raucous and can be varied slightly by changes in air
pressure. The symmetrical form of this reed pipe is
accentuated solely by the placement of spruce root
wrappings to either side of the embouchure hole. The
spare aesthetic represented here is more commonly
found in twentieth-century wood sculpture from the
region.

There seems to be a strong correlation between the
visibility of a whistle or reed pipe and the amount of
decoration applied to it. Because this reed pipe was
played in a surreptitious manner behind a curtain or
disguised beneath a mask, it is left unadorned. The
use of such reed pipes has lessened as the spread of
secular potlatches increasingly replaces ceremonial
programs.

Red cedar, spruce root
L. 25.5 cm, w. 4.5 cm, d. 2.5 cm (L. 10 1/16 in., w. 1 3/4 in., d. 1 in.)
Leslie Lindsey Mason Collection 17.2226

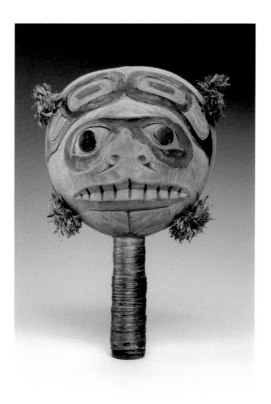 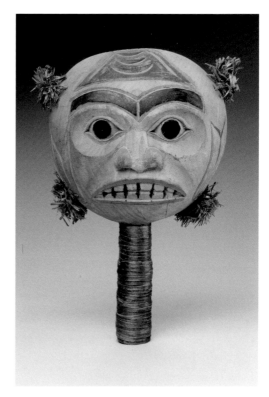

Rattle

Possibly Kwakwaka'wakw (Kwakiutl)

British Columbia, Canada, 19th century

Incorporating highly stylized and abstracted designs drawing on centuries of formline composition, the three-dimensional artwork of the Northwest Coast is singular among the wood carving of the indigenous people of North America. In this rattle, two faces—one on each side—represent the human and animal manifestations of a single being. The carved features of the faces are juxtaposed with uncarved space; different pigments are used to further define the features, which connect the components of the faces. Abstracted forms above the eyes of each face represent a whale's tail on one side (left) and fish gills, probably those of a shark, on the other (right).

Typical of rattles from the Northwest Coast, this example is carved in two pieces and joined with sinew bindings, embellished by knotted and frayed tufts of the inner bark of a cedar tree. The handle is bound with strips of split spruce root. The noise-producing contents are unknown, though a combination of pebbles and seeds was usually used. Rattles like this one are used in any number of musical contexts, including potlatch and other ceremonies involved with initiation, puberty, marriage, and death, as well as in secular pursuits. Rattles often sound incidentally with the movements of a dancer.

Wood, cedar bark, spruce root
L. 21.2 cm, diam. 13.1 cm, d. 8.5 cm
(L. 8 ⅜ in., diam. 5 ³⁄₁₆ in., d. 3 ⅜ in.)
Leslie Lindsey Mason Collection 17.2236

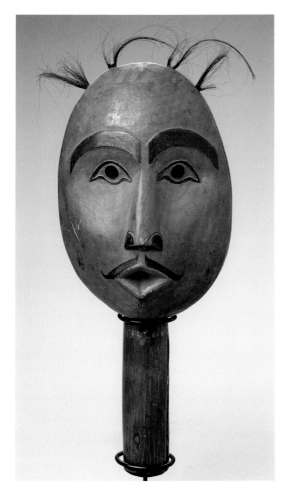

Rattle

Tlingit

Stikine River region, Alaska, 1850–66

Assembled from two carved pieces of what is probably red cedar, this rattle depicts a male figure complete with carved eyes, nose, and mouth. The sculptural elements of the man's face are emphasized with black and red pigment. The natural, open position of the mouth suggests the act of speaking or singing, as described by George T. Emmons, an ethnographic photographer known for his work among the Tlingit and Tahltan of southeastern Alaska and British Columbia. Four plugs of hair are inserted into the top of the rattle, no doubt remnants of much larger tufts.

As in other regions of the Northwest Coast, rattles like this one were used in multiple settings, both secular and sacred. The relatively unadorned surface of this rattle, as well as the treatment of the eyes, suggests a Tlingit origin in the area of the Stikine River. This instrument was collected by Captain Ira Harris of the United States Navy while serving aboard the USS *Hartford* in the mid-1860s. Rattles carved to represent human faces were increasingly popular as trade items in the late nineteenth and early twentieth centuries.

Probably red cedar, paint, pebbles, hair
L. 29.2 cm, w. 12.7 cm, d. 11.1 cm
(L. 11½ in., w. 5 in., d. 4⅜ in.)
Seth K. Sweetser Fund 1993.1

Art historian Dorothy Jean Ray in her essay "Reflections in Ivory" describes the drill-bow technique: "When in use, the thong is wrapped once around the shaft, the mouthpiece is held in the operator's mouth, and the bow is moved from side to side to revolve the shaft and drive the point into a surface."

This example, in common with many drill-bow handles produced in northern Alaska in the nineteenth century, is decorated with black line-drawings. Here the artist has illustrated what is probably a summer feast, featuring dancing people on the left (see detail), with an animal depicted vertically that will probably be the source of food at the meeting. To the right are engraved more than a dozen umiaks (Native sailing vessels) bringing people to the event. The reverse has drawings of four caribou, an animal that was central to the life of the Inupiaq.

Drill-bow handle

Inupiaq (Alaskan Inupiat Eskimo)

Probably Bering Strait, between Norton and Kotzeb, Arctic, Canada, 1825–75

This long, narrow, and slightly curved piece of walrus ivory is one part of an Inupiaq drill bow, which is used to make small holes in another piece of ivory, bone, or wood or to generate combustion. A long piece of rawhide thong was connected to each end of this handle through the round perforations, creating a bow. The second part of the drill was a wooden shaft with a bit on one end and a mouthpiece on the other.

Walrus ivory, pigment

L. 62.2 cm, h. 1.9 cm, d. 1.3 cm (L. 24 ½ in., h. ¾ in., d. ½ in.)

Museum purchase with funds donated by Independence Investment Associates, Inc. 1993.3

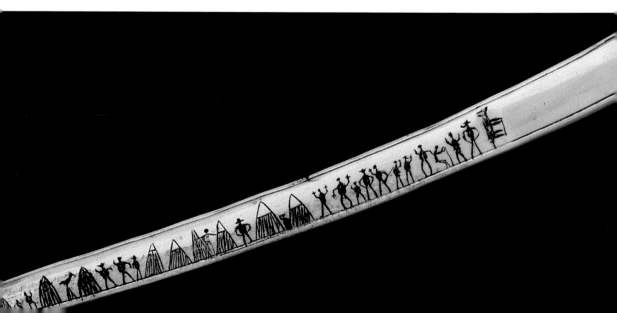

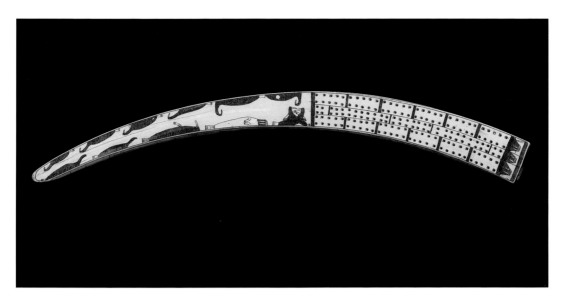

Cribbage board
Inupiaq (Alaskan Inupiat Eskimo)
Probably Alaska, about 1875–1925

The Inupiaq of Alaska and other areas of the Far Northwest have carved ivory for hundreds of years. Engraved ivory of this sort, with lines cut with a sharp needle or tool and then infilled with a black pigment, is generally referred to as scrimshaw. Beginning in the nineteenth century, interaction between the Inupiaq and whalers and traders resulted in a significant craft industry in which indigenous artists applied their traditional skills to forms and motifs that would appeal to non-Native consumers. In the 1890s, for example, whaling captain Hartson Harison Bodfish of San Francisco helped establish an Alaskan "school" of Inuit artists producing walrus-ivory carvings and cribbage boards that they could barter for manufactured goods. Some of these carvers, such as Angokwazhuk (dubbed Happy Jack by Bodfish and his sailors), achieved considerable renown. Many sailors also whiled away time at sea during the long whaling voyages by creating their own scrimshaw pieces from whalebone or walrus tusks.

This walrus tusk is an example of Native work created in the late nineteenth or early twentieth century by an unidentified artist for a sailor or the tourist market. One side of the tusk has been prepared as a board for cribbage, a playing-card game dating from at least the seventeenth century, in which pegs were inserted into the holes of a cribbage board to keep score. The board is decorated with delightful images of walrus, some fifteen in all, in various states of repose and interaction; a view of an Alaskan shoreline embellishes the reverse.

Walrus ivory, pigment
H. 57.5 cm, w. 5.1 cm, d. 4.8 cm (H. 22⅝ in., w. 2 in., d. 1⅞ in.)
Gift of Marilyn and Selwyn Kudisch 1992.460

Mask

Kalaallitt (Greenland Eskimo)

Ammassalik, East Greenland, about 1930–40

The Kalaallitt (Greenland Eskimo) of East Greenland used masks—made primarily of wood but also fashioned of sealskin, sharkskin, and other materials—for a variety of religious and ceremonial purposes, although the meaning of these masks to the early Native peoples is not well understood. This modern small face mask with asymmetrical, contorted features is a characteristic example. Fitted with cotton cordage in order to be worn or hung on the wall, this is probably a dance mask or one made to be sold or traded.

This mask is one of a small group collected by Captain Carlton Skinner (1913–2004), commander of the USS *Northland*, while stationed in Greenland during the early stages of World War II. Captain Skinner recorded his acquisition of the masks from the Kalaallitt through barter: "The invariably successful move to establish a friendly relationship was the gift of one or two packs of cigarettes. Many cartons and much used clothing were traded for handicraft, including masks and sculptures of wood and ivory. . . . The masks, we were told by the Greenlanders through the Danish hunter we carried on board ship, were used and worn by the shaman." Although the mask may have been made for Native use, it might well have been created with trade in mind.

Wood (probably driftwood), pigment, lampblack, cotton cordage
H. 18.7 cm, w. 12.7 cm, d. 8.3 cm (H. 7⅜ in., w. 5 in., d. 3¼ in.)
Gift of Governor Carlton Skinner and Solange Skinner
2002.786

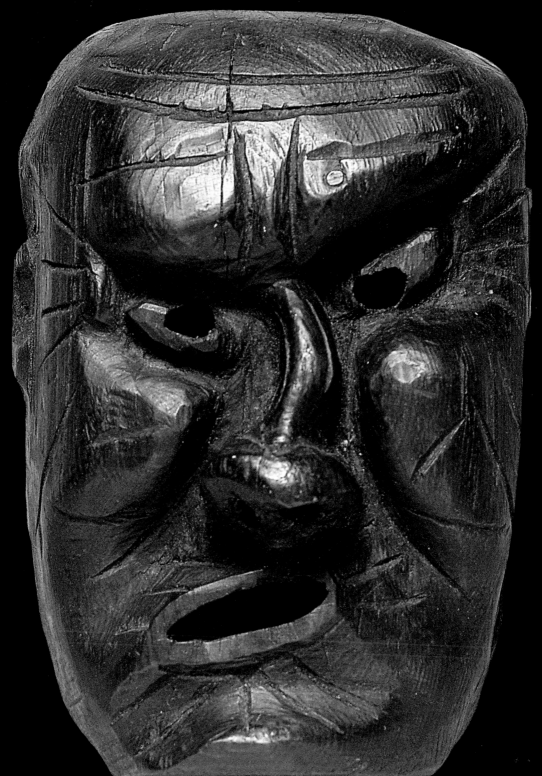

Map

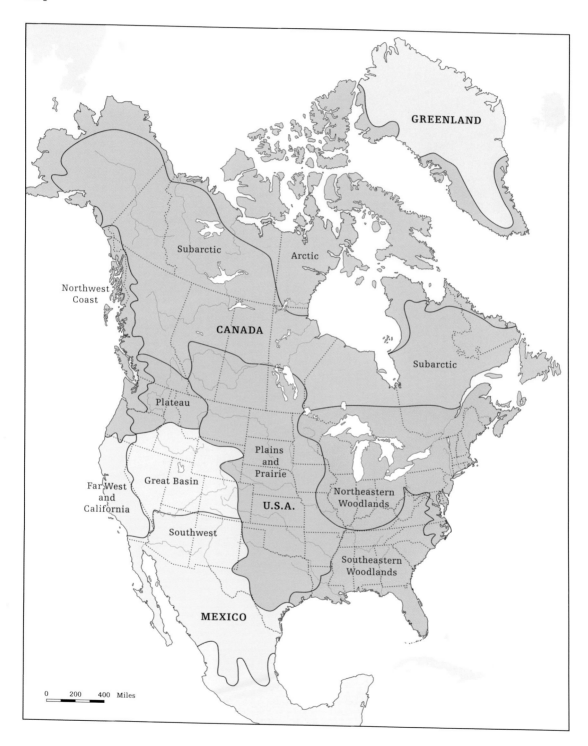

GREENLAND

Subarctic

Arctic

Northwest
Coast

CANADA

Subarctic

Plateau

Plains
and
Prairie

Great Basin

Northeastern
Woodlands

Far West
and
California

U.S.A.

Southwest

Southeastern
Woodlands

MEXICO

0 200 400 Miles

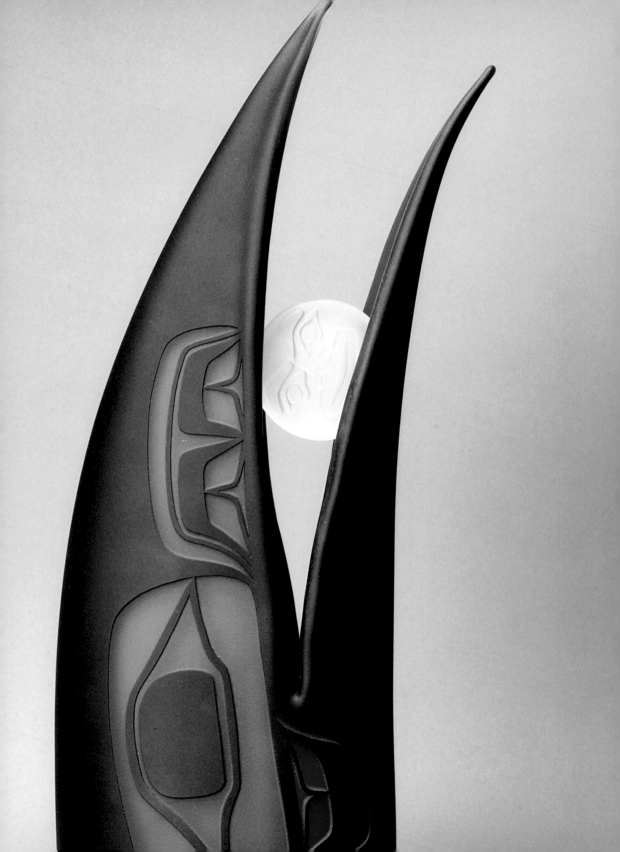

Further Reading

General Works

Baxter, Paula A., with Allison Bird-Romero. *Encyclopedia of Native American Jewelry: A Guide to History, People, and Terms.* Phoenix, AZ: Oryx Press, 2000.

Berlo, Janet Catherine, and Ruth B. Phillips. *Native North American Art.* New York: Oxford University Press, 1998.

Bernstein, Bruce, and Gerald McMaster, eds. *First American Art: The Charles and Valerie Diker Collection of American Indian Art.* Exh. cat. Washington, DC: National Museum of the American Indian in association with University of Washington Press, 2004.

Boehme, Sarah E., et al. *Powerful Images: Portrayals of Native America.* Exh. cat. Seattle: Museums West in association with University of Washington Press, 1998.

Chalker, Kari, ed. *Totems to Turquoise: Native North American Jewelry Arts of the Northwest and Southwest.* Exh. cat. New York: Harry N. Abrams in association with the American Museum of Natural History, 2004.

Coe, Ralph T. *Lost and Found Traditions: Native American Art, 1965–1985.* Ed. Irene Gordon. Exh. cat. Seattle: University of Washington Press in association with the American Federation of Arts, 1986.

Coe, Ralph T., et al. *The Responsive Eye: Ralph T. Coe and the Collecting of American Indian Art.* Exh. cat. New York: Metropolitan Museum of Art; New Haven and London: Yale University Press, 2003.

Conn, Richard. *Native American Art in the Denver Art Museum.* Denver: Denver Art Museum, 1979. Distributed by University of Washington Press.

Davis, Mary B., ed. *Native America in the Twentieth Century: An Encyclopedia.* New York: Garland, 1994.

Douglas, Frederic H., and Rene d'Harnoncourt. *Indian Art of the United States.* Exh. cat. New York: Museum of Modern Art, 1941.

Dubin, Lois Sherr. *North American Indian Jewelry and Adornment from Prehistory to the Present.* New York: Harry N. Abrams, 1999.

Fane, Diana, Ira Jacknis, and Lise M. Breen. *Objects of Myth and Memory: American Indian Art at the Brooklyn Museum.* Exh. cat. Brooklyn, NY: Brooklyn Museum in association with University of Washington Press, 1991.

Glenbow Museum. *The Spirit Sings: Artistic Traditions of Canada's First Peoples.* Toronto: McClelland and Stewart and the Glenbow Museum, 1987.

Johnson, Michael G., and Richard Hook. *Encyclopedia of Native Tribes of North America.* 1993. 3rd rev. ed. Buffalo, NY: Firefly Books, 2007.

Josephy, Alvin M., Jr. *500 Nations: An Illustrated History of North American Indians.* New York: Alfred A. Knopf, 1994.

Kennedy, Roger G. *Hidden Cities: The Discovery and Loss of Ancient North American Civilization.* New York: Free Press, 1994.

Krech, Shepard, III, and Barbara A. Hail, eds. *Collecting Native America, 1870–1960.* Washington, DC: Smithsonian Institution Press, 1999.

Malinowski, Sharon, and Anna Sheets, eds., with Jeffrey Lehman and Melissa Walsh Doig. *The Gale Encyclopedia of Native American Tribes.* 4 vols. Detroit: Gale, 1998.

Milner, George R. *Moundbuilders: Ancient Peoples of Eastern North America.* New York: Thames and Hudson, 2005.

Nabokov, Peter, and Robert Easton. *Native American Architecture.* New York: Oxford University Press, 1989.

Paterek, Josephine. *Encyclopedia of American Indian Costume.* New York: W. W. Norton, 1994.

Penney, David W. *North American Indian Art.* New York: Thames and Hudson, 2004.

Roosevelt, Anna Curtenius, and James G. E. Smith, eds. *The Ancestors: Native Artisans of the Americas.* New York: Museum of the American Indian, 1979.

Silverberg, Robert. *Mound Builders of Ancient America: The Archaeology of a Myth.* Greenwich, CT: New York Graphic Society, 1968.

Sturtevant, William C., ed. *Handbook of North American Indians.* 17 vols. Washington, DC: Smithsonian Institution, 1978–.

Thomas, David Hurst, et al. *The Native Americans: An Illustrated History.* New York: Turner Publishing, 1993.

Townsend, Richard F., and Robert V. Sharp, eds. *Hero, Hawk, and Open Hand: American Indian Art of the Ancient Midwest and South*. Exh. cat. New Haven: Art Institute of Chicago in association with Yale University Press, 2004.

Turnbaugh, Sarah Peabody, and William A. Turnbaugh. *Indian Baskets*. West Chester, PA: Schiffer Publishing in collaboration with the Peabody Museum of Archaeology and Ethnology, Harvard University, 1986.

Vincent, Gilbert T., Sherry Brydon, and Ralph T. Coe, eds. *Art of the North American Indians: The Thaw Collection*. Seattle: Fenimore Art Museum and University of Washington Press, 2000.

Wade, Edwin L., ed. *The Arts of the North American Indian: Native Traditions in Evolution*. Exh. cat. New York: Hudson Hills Press in association with Philbrook Art Center, 1986.

West, Richard, Wilma Mankiller, et al. *Do All Indians Live in Tipis? Questions and Answers from the National Museum of the American Indian*. New York: Collins in association with the National Museum of the American Indian, 2007.

Native American Artists in the Contemporary Art World

Anthes, Bill. *Native Moderns: American Indian Painting, 1940–1960*. Durham, NC: Duke University Press, 2006.

Clark, Garth. *Free Spirit: The New Native American Potter*. 's-Hertogenbosch, The Netherlands: SM's – Stedelijk Museum 's-Hertogenbosch, 2006.

Gritton, Joy L. *The Institute of American Indian Arts: Modernism and U.S. Indian Policy*. Albuquerque: University of New Mexico Press, 2000.

Hammond, Harmony, and Jaune Quick-to-See Smith. *Women of Sweetgrass, Cedar, and Sage*. Exh. cat. New York: Gallery of the American Indian Community House, 1985.

Hutchinson, Elizabeth. *The Indian Craze: Primitivism, Modernism, and Transculturation in American Art, 1890–1915*. Durham, NC: Duke University Press, 2009.

Jersey City Museum. *Subversions/Affirmations: Jaune Quick-to-See Smith: A Survey*. Exh. cat. Jersey City, NJ: Jersey City Museum, 1996.

McFadden, David Revere, and Ellen Napiua Taubman, eds. *Changing Hands: Art without Reservation*. Exh. cat. London: Merrell; New York: American Craft Museum, 2002.

McMaster, Gerald, ed. *Reservation X: The Power of Place in Aboriginal Contemporary Art*. Exh. cat. Seattle: University of Washington Press and Canadian Museum of Civilization, 1998.

McMaster, Gerald, and Clifford E. Trafzer, eds. *Native Universe: Voices of Indian America by Native American Tribal Leaders, Writers, Scholars, and Storytellers*. Washington, DC: National Museum of the American Indian in association with the National Geographic Society, 2004.

Monroe, Dan L., et al. *Gifts of the Spirit: Works by Nineteenth-Century and Contemporary Native American Artists*. Exh. cat. Salem, MA: Peabody Essex Museum, 1997.

Rushing, W. Jackson, III. *Native American Art in the Twentieth Century: Makers, Meanings, Histories*. London: Routledge, 1999.

Ryan, Allan J. *The Trickster Shift: Humour and Irony in Contemporary Native Art*. Vancouver and Toronto: UBC Press; Seattle: University of Washington Press, 1999.

Smith, Paul Chaat. *Everything You Know about Indians Is Wrong*. Minneapolis: University of Minnesota Press, 2009.

Tucson Museum of Art. *Jaune Quick-to-See Smith: Postmodern Messenger*. Exh. cat. Tucson, AZ: Tucson Museum of Art, 2004.

Beginnings: The Ancient Southwest

Brody, J. J., et al. *Mimbres Pottery: Ancient Art of the American Southwest*. Exh. cat. New York: Hudson Hills Press in association with the American Federation of Arts, 1983.

Brody, J. J., and Rina Swetzell. *To Touch the Past: The Painted Pottery of the Mimbres People*. Exh. cat. New York: Hudson Hills Press in association with Frederick R. Weisman Art Museum at the University of Minnesota, 1998.

Fagan, Brian M. *Ancient North America: The Archaeology of a Continent*. 3rd ed. London: Thames and Hudson, 2000.

Mann, Charles C. *1491: New Revelations of the Americas Before Columbus*. New York: Alfred A. Knopf, 2005.

Meltzer, David J. *First Peoples in a New World: Colonizing Ice Age America*. Berkeley: University of California Press, 2009.

Peckham, Stewart. *From This Earth: The Ancient Art of Puebloan Pottery*. Santa Fe: Museum of New Mexico Press, 1990.

Plog, Stephen. *Ancient Peoples of the American Southwest*. London: Thames and Hudson, 1997.

The Southwest and Far West

Anderson, Duane, with a foreword by Lonnie Vigil. *All That Glitters: The Emergence of Native American Micaceous Art Pottery in Northern New Mexico*. Santa Fe, NM: School of American Research Press, 1999.

Bibby, Brian. *The Fine Art of California Indian Basketry*. Exh. cat. Sacramento, CA: Crocker Art Museum in association with Heyday Books, 1996.

Blomberg, Nancy J. *Navajo Textiles: The William Randolph Hearst Collection*. Exh. cat. Tucson: University of Arizona Press, 1988.

Cirillo, Dexter. *Southwestern Indian Jewelry*. New York: Abbeville Press, 1992.

Dillingham, Rick. *Fourteen Families in Pueblo Pottery*. Rev. ed. Albuquerque: University of New Mexico Press, 1994.

Dittert, Alfred E., Jr., and Fred Plog. *Generations in Clay: Pueblo Pottery of the American Southwest*. Exh. cat. Flagstaff, AZ: Northland Publishing in cooperation with the American Federation of Arts, 1980.

Frank, Larry, with the assistance of Mildred Holbrook. *Indian Silver Jewelry of the Southwest, 1868–1930*. Atglen, PA: Schiffer Publishing, 1990.

Harlow, Francis H., and Dwight P. Lanmon. *The Pottery of Zia Pueblo*. Santa Fe, NM: School of American Research Press, 2003.

Harlow, Francis H., Duane Anderson, and Dwight P. Lanmon. *The Pottery of Santa Ana Pueblo*. Santa Fe: Museum of New Mexico Press, 2005.

Kent, Kate Peck. *Navajo Weaving: Three Centuries of Change*. Santa Fe: School of American Research Press, 1985.

King, Charles S. *Born of Fire: The Life and Pottery of Margaret Tafoya*. Santa Fe: Museum of New Mexico Press, 2008.

Kramer, Barbara. *Nampeyo and Her Pottery*. Albuquerque: University of New Mexico Press, 1996.

Lanmon, Dwight P., and Francis G. Harlow, with the assistance and cooperation of the Zuni people. *The Pottery of Zuni Pueblo*. Santa Fe: Museum of New Mexico Press, 2008.

Lincoln, Louise, ed. *Southwest Indian Silver from the Doneghy Collection*. Exh. cat. Minneapolis, MN: Minneapolis Institute of Arts; Austin: University of Texas Press, 1982.

Nichols, Linda Foss. *Voice of Mother Earth: Art of the Puebloan Peoples of the American Southwest*. Exh. cat. Nagoya, Japan: Nagoya/Boston Museum of Fine Arts, 2000.

Peterson, Susan. *The Living Tradition of Maria Martinez*. Tokyo, New York, and San Francisco: Kodansha International, 1977.

———. *Lucy M. Lewis: American Indian Potter*. Tokyo, New York, and San Francisco: Kodansha International, 1984.

———. *Pottery by American Indian Women: The Legacy of Generations*. Exh. cat. New York: Abbeville Press for the National Museum of Women in the Arts, 1997.

Spivey, Richard L. *The Legacy of Maria Poveka Martinez*. 3rd rev. ed. Santa Fe: Museum of New Mexico Press, 2003.

Tanner, Clara Lee. *Apache Indian Baskets*. Tucson: University of Arizona Press, 1982.

———. *Indian Baskets of the Southwest*. Tucson: University of Arizona Press, 1983.

Webster, Laurie D. *Collecting the Weaver's Art: The William Claflin Collection of Southwestern Textiles*. Cambridge, MA: Peabody Museum Press, Harvard University, 2003.

Wheat, Joe Ben. *Blanket Weaving in the Southwest*. Ed. Ann Lane Hedlund. Tucson: University of Arizona Press, 2003.

Northeastern and Southeastern Woodlands

Barbeau, Marius. *Assomption Sash*. Bulletin 93, Anthropological Series 24. Ottawa: National Museum of Canada, 1972.

Gookin, Daniel. *Historical Collections of the Indians in New England*. Boston: Massachusetts Historical Society, printed at the Apollo press by Belknap and Hall, 1792.

Hill, Sarah H. *Weaving New Worlds: Southeastern Cherokee Women and Their Basketry*. Chapel Hill: University of North Carolina Press, 1997.

McMullen, Ann, and Russell G. Handsman, eds. *A Key into the Language of Woodsplint Baskets*. Washington, CT: American Indian Archaeological Institute, 1987.

Phillips, Ruth B. *Trading Identities: The Souvenir in Native North American Art from the Northeast, 1700–1900*. Seattle: University of Washington Press; Montreal and Kingston: McGill-Queen's University Press, 1998.

Whitehead, Ruth Holmes. *Elitekey: Micmac Material Culture from 1600 A.D. to the Present.* Halifax: Nova Scotia Museum, 1980.

————. *Micmac Quillwork: Micmac Indian Techniques of Porcupine Quill Decoration, 1600–1950.* Halifax: Nova Scotia Museum, 1982.

Plains, Prairie, and Plateau

Berlo, Janet Catherine, ed. *Plains Indians Drawings, 1965–1935: Pages from a Visual History.* Exh. cat. New York: Harry N. Abrams in association with the American Federation of Arts and the Drawing Center, 1996.

Conn, Richard. *Circles of the World: Traditional Art of the Plains Indians.* Exh. cat. Denver: Denver Art Museum, 1982.

Donnelley, Robert G., et al. *Transforming Images: The Art of Silver Horn and His Successors.* Exh. cat. Chicago: David and Alfred Smart Museum of Art, University of Chicago, 2000.

Ewers, John C. *Plains Indian Sculpture: A Traditional Art from America's Heartland.* Washington, DC: Smithsonian Institution Press, 1986.

Greene, Candace S. *Silver Horn: Master Illustrator of the Plains.* Norman: University of Oklahoma Press, 2001.

Harless, Susan E., ed. *Native Arts of the Columbia Plateau: The Doris Swayze Bounds Collection.* Bend, OR: High Desert Museum; Seattle: University of Washington Press. 1998.

Her Many Horses, Emil, ed. *Identity by Design: Tradition, Change, and Celebration in Native Women's Dresses.* Exh. cat. New

York: Collins in association with the National Museum of the American Indian, 2007. See also the online exhibition, 2008, at http://www.nmai.si.edu/exhibitions/identity_by_design/IdentityByDesign.html.

Horse Capture, Joseph D., and George P. Horse Capture. *Beauty, Honor, and Tradition: The Legacy of Plains Indians Shirts.* Exh. cat. Minneapolis, MN: Minneapolis Institute of Arts; Washington, DC: National Museum of the American Indian, 2001.

Kunecki, Nettie, Elsie Thomas, and Marie Slockish. *The Heritage of Klickitat Basketry: A History and Art Preserved.* Portland: Oregon Historical Society, 1982.

Markoe, Glenn E., ed. *Vestiges of a Proud Nation: The Ogden B. Read Northern Plains Indian Collection.* Burlington: Robert Hull Fleming Museum, University of Vermont, 1986. Distributed by University Press of Nebraska.

Maurer, Evan M. *Visions of the People: A Pictorial History of Plains Indian Life.* Exh. cat. Minneapolis, MN: Minneapolis Institute of Arts, 1992.

Mercer, Bill. *People of the River: Native Arts of the Oregon Territory.* Exh. cat. Portland, OR: Portland Art Museum in association with University of Washington Press, 2005.

Penny, David W. *Art of the American Indian Frontier: The Chandler-Pohrt Collection.* Seattle: Detroit Institute of Arts and University of Washington Press, 1992.

Schlick, Mary Dodds. *Columbia River Basketry: Gift of the Ancestors, Gift of the Earth.* Seattle: University of Washington Press, 1994.

Torrence, Gaylord. *The American Indian Parfleche: A Tradition of Abstract Painting.* Exh. cat. Seattle: University of Washington Press in association with the Des Moines Art Center, 1994.

The Northwest Coast, Arctic, and Subarctic

Brown, Steven C. *Native Visions: Evolution in Northwest Coast Art from the Eighteenth through the Twentieth Century.* Exh. cat. Seattle: Seattle Art Museum in association with the University of Washington Press, 1998.

Busby, Sharon. *Spruce Root Basketry of the Haida and Tlingit.* Seattle: Marquand Books in association with the University of Washington Press, 2003.

Collins, Henry B., et al. *The Far North: 2000 Years of American Eskimo and Indian Art.* Exh. cat. Washington, DC: National Gallery of Art, 1973.

Hessel, Ingo. *Inuit Art: An Introduction.* Vancouver and Toronto: Douglas and McIntyre, 1998.

Holm, Bill. *Northwest Coast Indian Art: An Analysis of Form.* Seattle: University of Washington Press, 1965.

————. *Spirit and Ancestor: A Century of Northwest Coast Indian Art at the Burke Museum.* Seattle: Burke Museum; Seattle and London: University of Washington Press, 1987.

Jacknis, Ira. *The Storage Box Tradition: Kwakiutl Art, Anthropologists, and Museums, 1881–1981.* Washington, DC: Smithsonian Institution Press, 2002.

Jensen, Doreen, and Polly Sargent. *Robes of Power: Totem Poles on Cloth*. 4th ed. Vancouver and Toronto: University of British Columbia Press in association with the UBC Museum of Anthropology, 2003.

Jonaitis, Aldona, ed. *Chiefly Feasts: The Enduring Kwakiutl Potlatch*. Exh. cat. Seattle: University of Washington Press, 1991.

Kaalund, Bodil. *The Art of Greenland: Sculpture, Crafts, Painting*. Trans. Kenneth Tindall. Berkeley: University of California Press, 1979.

Lobb, Allan. *Indian Baskets of the Pacific Northwest and Alaska*. Portland, OR: Graphic Arts Center Publishing, 1990.

MacDonald, George F. *Haida Art*. Brussels: G+B Arts International, 1996.

McLennan, Bill, and Karen Duffek. *The Transforming Image: Painted Arts of the Northwest Coast First Nations*. Vancouver and Toronto: University of British Columbia Press; Seattle: University of Washington Press, 2000.

Ostrowitz, Judith. *Privileging the Past: Reconstructing History in Northwest Coast Art*. Seattle: University of Washington Press; Vancouver and Toronto: University of British Columbia Press, 1999.

Ray, Dorothy Jean. "Reflections in Ivory." In *Inua: Spirit World of the Bering Sea Eskimo*, by William W. Fitzhugh et al. Washington, DC: National Museum of Natural History, 1982.

Samuel, Cheryl. *The Chilkat Dancing Blanket*. Seattle: Pacific Search Press, 1992.

Seattle Art Museum. *The Spirit Within: Northwest Coast Native Art from the John H. Hauberg Collection*. Seattle: Seattle Art Museum; New York: Rizzoli, 1995.

Wardwell, Allen. *Objects of Bright Pride: Northwest Coast Indian Art from the American Museum of Natural History*. Exh. cat. New York: Center for Inter-American Relations and the American Federation of Arts, 1978.

Figure Illustrations

p. 13, fig. 1
Effigy
Mississippian Tradition
Diehlstaat, Missouri, 900–1400
Earthenware
H. 16.5 cm, diam. 14 cm
(H. 6½ in., diam. 5½ in.)
Gift of Mr. and Mrs. George
Washington Wales 95.1430

p. 14, fig. 2
Aerial view of Serpent Mound, Adams
County, Ohio. Photograph courtesy Ohio
Historical Society.

p. 15, fig. 3
Effigy pitcher
Santo Domingo
Santo Domingo Pueblo, New Mexico, 1870s
Earthenware with white and brown slip
paint
H. 19.4 cm, w. 16.5 cm, d. 22.9 cm
(H. 7⅝ in., w. 6½ in., d. 9 in.)
Gift of Charles Greely Loring 79.100

p. 15, fig. 4
Moccasin vessel
A:shiwi (Zuni)
Zuni Pueblo, New Mexico, about 1880
Earthenware with red and brown slip paint
W. 6.7 cm, l. 16.2 cm (W. 2⅝ in., l. 6⅜ in.)
Everett Fund 87.36

p. 17, fig. 5
Saddle blanket
Diné (Navajo)
Probably Arizona, about 1895
Wool slit tapestry
H. 136 cm, w. 100 cm
(H. 53%₁₆ in., w. 39⅜ in.)
Museum purchase with general funds
99.77

p. 19, fig. 6
Helen T. Naha (Feather Woman)
Hopi, 1922–1993
Jar
Polacca Village, Hopi, Arizona, 1985
Earthenware with slip paint
H. 11.1 cm, diam. 19.1 cm
(H. 4⅜ in., diam. 7½ in.)
Museum purchase with funds donated by
a Friend of the Department of American
Decorative Arts and Sculpture 1985.453

p. 20, fig. 7
Haungooah (Silver Horn)
Kiowa Apache, 1860–1940
***Desperate Encounter between Ute and
Ki a wa. Ute Killed***
From *Ledger Book*, about 1885
H. 25.4 cm, w. 35.3 cm (H. 10 in., w. 13⅞ in.)
Gift of the grandchildren of Lucretia
McIlvain Shoemaker and the M. and M.
Karolik Fund 1994.429.20

p. 21, fig.8
Diego Romero
Cochiti, born in 1964
Mok a sushi bowl
Santa Fe, New Mexico, 1999
Earthenware with slip paint
H. 15.2 cm, diam. 30.5 cm
(H. 6 in., diam. 12 in.)
Gift of James and Margie Krebs 2006.2016

p. 30, fig. 9
Mateo Romero
Cochiti, born in 1966
Scalp Chief/Prayer/Vietnam, 1998
Chalk and oil pastel
Sheet: H. 76.2 cm, w. 106.7 cm
(H. 30 in., w. 42 in.)
Gift of James and Margie Krebs 2008.1452

p. 31, fig. 10
Painted by Diego Romero
Cochiti, born in 1964
Made by Nathan Begaye
Hopi / Diné (Navajo), born in 1969
***Death of Hector* canteen**
Española, New Mexico, 2003
Earthenware with slip paint
H. 30.5 cm, diam. 26.7 cm
(H. 12 in., diam. 10½ in.)
Gift of James and Margie Krebs 2006.1908

p.37, fig. 11
Major General George A. Custer.
Photograph by George L. Andrews.
Courtesy National Archives, photo number
200-CA-10.

p. 42, fig. 12
Nathan Begaye at work on the ***Squash
Maiden*** vessel. Photograph by James
Krebs.

p. 47, fig. 13
Jar
Anasazi
Northeastern Arizona and northwestern
New Mexico, 900–1100
Corrugated earthenware; Anasazi Utility
tradition
H. 13.7 cm, diam. 14.6 cm
(H. 5⅜ in., diam. 5¾ in.)
Gift of Laura F. Andreson 1984.611

p. 52, fig. 14
Grinding stone and hand stone
Probably northern Arizona, 700–1400
Extrusive igneous rock
Grinding stone: H. 7.6 cm, w. 43.2 cm,
l. 21 cm (H. 3 in,. w. 8¼ in., l. 17 in.)
Gift of Linda and Thomas Makris
1999.213–214

p. 52, fig. 15
Mortar and pestle
Probably northern Arizona, 700–1400
Extrusive igneous rock
Mortar: H. 10.5 cm, diam. 15.9 cm
(H. 4⅛ in., diam. 6¼ in.)
Gift of Linda and Thomas Makris
1999.215, 1999.212

p. 53, fig. 16
Ansel Adams
American, 1902–1984
Cliff Palace, Mesa Verde National Park, Colorado, 1941
Photograph, gelatin silver print
Image/Sheet: H. 19.1 cm, w. 23.8 cm
(H. 7½ in., w. 9⅜ in.)
The Lane Collection

p. 55, fig. 17
Carmel Lewis
Acoma, born in 1947
Jar
Acoma Pueblo, New Mexico,
about 2000–2002
Earthenware with slip paint
H. 20.3 cm, diam. 10.2 cm
(H. 8 in., diam. 4 in.)
Gift of James and Margie Krebs
2006.1919

p. 67, fig. 18
Ansel Adams
American, 1902–1984
Taos Pueblo, New Mexico, 1941
Photograph courtesy National Archives,
photo number 79-AA-Q02

p. 68, fig. 19
Concha belt
Diné (Navajo)
Arizona, about 1875–1900
Silver, leather
L. 106.7 cm (L. 42 in.)

Gift of Ruth S. and Bertram J. Malenka and
their sons, David J. and Robert C. Malenka
2008.2004

p. 69, fig. 20
Jar
Western Apache
Southeastern Arizona (San Carlos or White
Mountain Reserve), about 1880–90
Willow, cottonwood, dark brown
decoration in devil's claw (black martyuia)
H. 26 cm (H. 10¼ in.)
Gift of George F. Meacham 16.126

p. 69, fig. 21
Gathering basket
Karuk (Karok)
Northern California, 1880–1900
Hazel and pine, white bear grass, black
maidenhair fern, red alder-dyed fern root,
leather
H. 55.9 cm (H. 22 in.)
Samuel Putnam Avery Fund 1992.150

p. 74, fig. 22
Edward S. Curtis
American, 1868–1952
At the Old Well of Acoma, 1904
Photograph, gelatin silver print, brown-toned
H. 31.9 cm, w. 40.7 cm (H. 12⁹⁄₁₆ in., w. 16 in.)
Lucy Dalbiac Luard Fund 1979.402

p. 76, fig. 23
Maria Lilly Salvador (Dzai-sra-tyai-ts'a, or
Lilies of the Cornfield)
Acoma, born 1944
Water jar
Acoma Pueblo, New Mexico, 1984
Earthenware with slip paint
H. 22.9 cm, diam. 28.6 cm
(H. 9 in., diam. 11¼ in.)
Museum purchase with funds donated
by a Friend of the Department of American
Decorative Arts and Sculpture 1984.540

p. 102, fig. 24
Possibly by Beshthlagai-ithline-athlsosigi
(Slender Maker of Silver)
Diné (Navajo), died in 1916
Ketoh (**wrist guard**)
Arizona, about 1890–1910
Silver, leather
H. 4.4 cm, w. 6.4 cm, d. 8.6 cm
(H. 1¾ in., w. 2½ in., d. 3⅜ in.)
Gift of Ruth S. and Bertram J. Malenka and
their sons, David J. and Robert C. Malenka
2008.2010

p. 106, fig. 25
Tohono O'odham (Papago) basketmaker at
work, Arizona, 1916. Photograph by H. T.
Cory. Courtesy National Archives, photo
number 115-L-2-32.

p. 112, fig. 26
Basket
Mi'kmaq (Micmac)
Maine or Nova Scotia, Canada, about 1875
Porcupine quills, birch bark
H. 10.8 cm, w. 13 cm, d. 20.3 cm
(H. 4¼ in., w. 5⅛ in., d. 8 in.)
Gift of Mr. and Mrs. William White
Howells 1973.161a–b

p. 112, fig. 27
Container
Penobscot or Passamaquoddy
Maine, 1930–1950s
Birchbark, spruce root
H. 8.6 cm, w. 16.5 cm, d. 15.9 cm
(H. 3⅜ in., w. 6½ in., d. 6¼ in.)
Museum purchase with funds donated by
the Barra Foundation, Inc. 1992.524a–b

p. 112, fig. 28
Anna Belle Sixkiller Mitchell
Cherokee, born in 1926
Bowl
Vinita, Oklahoma, 1993
Earthenware

H. 17.5 cm, diam. 20.3 cm
(H. 6⅞ in., diam. 8 in.)
Museum purchase with funds donated
anonymously 1994.46

p. 133, fig. 29
Albert Bierstadt
American (born in Germany), 1830–1892
Indians Near Fort Laramie, about 1859
Oil on paper mounted on paperboard
H. 34 cm, w. 48.9 cm (H. 13⅜ in., w. 19¼ in.)
Bequest of Martha C. Karolik for the M.
and M. Karolik Collection of American
Paintings, 1815–1865 48.411

p. 134, fig. 30
Johann Hürlimann
Swiss, 1809–1893
After Karl Bodmer
Swiss (active in France), 1809–1893
*Mato-Tope (Indian in War
Dress)*, 1834–43
Engraving, hand-colored on paper
Sheet: H. 59.8 cm, w. 44.3 cm
(H. 23⁹⁄₁₆ in., w. 17⁷⁄₁₆ in.)
Fund in memory of Horatio Greenough
Curtis 1971.229

p. 135, fig. 31
Peter Peterson Tofft
Danish (active in the United States and
England), 1825–1901
*Hudson Bay Trading Post on
Flathead Indian Reservation,
Montana Territory*, 1865–67
Watercolor on paper
Image: H. 15.2 cm, w. 23.2 cm
(H. 6 in., w. 9⅛ in.)
Gift of Maxim Karolik for the M. and
M. Karolik Collection of American
Watercolors and Drawings, 1800–1875
53.2464

p. 144, fig. 32
De Cost Smith
American, 1864–1939
Divination, 1906
Oil on canvas
H. 76.2 cm, w. 61.3 cm (H. 30 in., w. 24⅛ in.)
Gift of Clement C. Sawtell 1973.198

p. 154, fig. 33
Ladle
Haida
Haida Gwaii (Queen Charlotte Islands),
British Columbia, Canada, about 1890
Mountain goat horn, abalone
L. 29.8 cm (L. 11¾ in.)
Bequest of Mrs. John H. Thorndike 99.572

p. 154, fig. 34
Container
Kutchin
Alaska or Yukon, Canada, 1900–1950
Bark, probably spruce root
H. 23.5 cm, w. 31.1 cm, d. 22.2 cm
(H. 9¼ in., w. 12¼ in., d. 8¾ in.)
American Decorative Arts Curator's Fund
1992.253

p.155, fig. 35
Nuna Parr
Inuit, born in 1949
Walrus
Cape Dorset, Canada, 1992
Serpentine stone, walrus tusk
H. 24.1 cm, w. 52.1 cm, d. 15.2 cm
(H. 9½ in., w. 20½ in., d. 6 in.)
Gift of Jan and Lawrence Dorman
2007.977

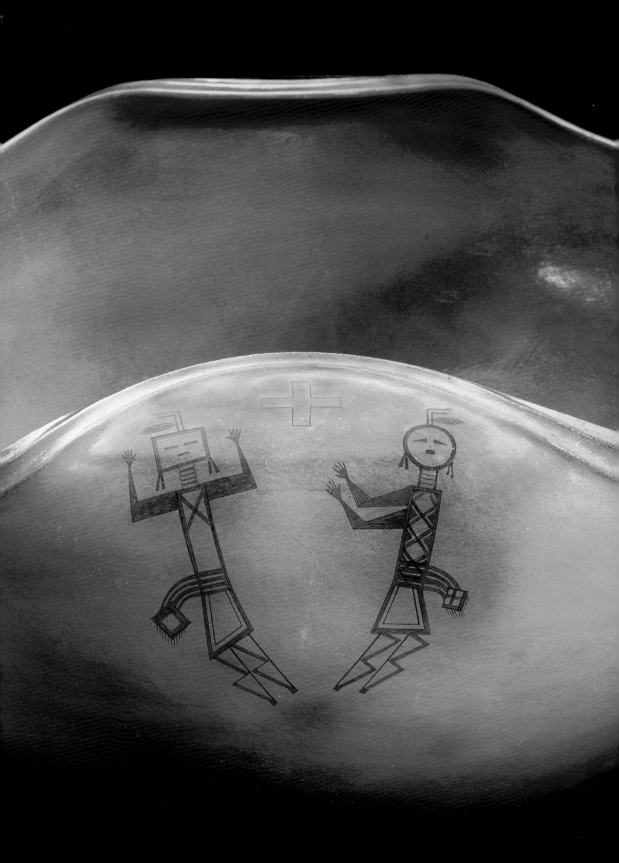

Index

Page numbers in italics indicate illustrations.

Absaroka. *See* Apsáalooke (Crow)

Acoma, 55, *55*, 74–77, *74–77*, 85

Adams, Ansel, *53*, 67

Aguilar, Tony and Ernestine: necklace, 96, *97*

Aguilar pottery style (Santo Domingo), 83, *83*

Akimel O'odham (Pima), 106

Alaskan Inupiat Eskimo. *See* Inupiaq (Alaskan Inupiat Eskimo)

American Indian Movement (AIM), 18, 30

American Museum of Natural History (New York), 118

Amon Carter Museum (Texas), 18

Anasazi, 43, 46, 51, 54, 56, 60, *60*, 62, *62–63*, 116

Anderson, Dale and Doug, 19, 20

Andreson, Laura F., 18

Andrews, George L.: photograph of Custer, 37, *37*

anhinga (sacred bird), 145

animal and fish motifs, 154, 155, 168, *168*; bear-paw print, 90, *91*, 165, *165*; deer, 78, *78*, 85, *85*; frog, 88, *88*; Gila monster, 106, *106*; insect, 78, *78*, 88, *88*, 105, *105*; snake, 90, *91*, 94, *94*, 107, *107*; tadpole, 71, *71*, 88, *88*; turtle, 114; walrus, 155, *155*. *See also* fetish figure

Apache, 68–69, 89; Jicarilla (probably), 137, *137*; Kiowa, 148, *149*; Western, 69, *69*; White Mountain, 105, *105*

Appeal to the Great Spirit (Dallin), 17

Apsáalooke (Crow)**, 140, *140*, 142, *142*; hand drum (Siksika [Blackfoot] or Apsáalooke [Crow], probably), 144, *144*

Arapaho: gourd rattle, possibly by, 145, *145*

archeological excavations, 13, 51, 53; Chaco Canyon, 52, 60; Diehlstaat (Missouri), *13*, 13–14; Four-Mile Ruin (Arizona), 62

Arenas, Guadalupe, attributed to: tray, 107, *107*

argillite (stone), 153, 162, *162*

Arts and Crafts movement, 14

A:shiwi (Zuni), 15, *15*, 56, 62, 73, 84–89, *84–89*, 100

At the Old Well of Acoma (Curtis), 74, *74*

avian effigy (Mogollon), 56, *56*

bag. *See* parfleche container; shot pouch

bark-made objects, 156; birchbark, 112, *112*, 120, *121*, 126, *126*

basket: Cherokee, 123, *123*; Mi'kmaq (Micmac), 112, *112*; Mission, 107; Mohegan-Pequot, probably, 122, *122*; Nipmuc, 124, *124*; southern Innu (Montagnais), possibly, 120, *121*; Tlingit, 159, *159*; Tohono O'odham (Papago), 21, 106, *106*

basket, carrying (or coiled pack basket) (Lataxat [Klikitat]), 21, 147, *147*

basket, gathering (Karuk [Karok]), 69, *69*

basket dyes, 122, *122*, 123, *123*, 159

basketry: checker-plaited, 124, *124*; Chief's Daughter weave (Cherokee), 123, *123*; imbrication (technique), 147; splint, 112

baskets, stacking (set of twelve): southern Innu (Montagnais), possibly, 120, *121*

battles and wars, Native American, 15, 34, 134; Battle of Little Bighorn (Battle of Greasy Grass Creek), 15, 37, 141; King Philip's War, 119; Pueblo Revolt of 1680, 78, 80

beading technique, 141

beadwork, 112, 116, 135, 140; dress yokes (Lakota [Sioux]), 139, *139*; gourd rattle (Arapaho, possibly), 145, *145*; knife case (Apsáalooke [Crow]), 140, *140*; man's ceremonial shirt (Tahltan), 158, *158*; vest (Lakota [Sioux]), 141, *141*

beadwork, shell (Santo Domingo), 96

Beale, Arthur, 20–21

Begaye, Nathan, *42*, 43; *Death of Hector* canteen (Romero/Begaye), 31, *31*; *Squash Maiden*, 42, *42*

belt. *See* sash

Beshthlagai-ithline-athlsosigi, (Diné [Navajo]), possibly by: ketoh, 102, *102*

Bierstadt, Albert: *Indians Near Fort Laramie*, 133, *133*

birchbark objects, 112, *112*, 120, 126, *126*

bird imagery, 54, *54*, 56, *56*, 57, *57*, 62, *62*, 71, *71*; anhinga, 145, *145*; bird claw, 143, *143*; eagle, 70, *70*; feathers, 70, 145, *145*; "geese in flight," 147, *147*; macaw, 60, *60*; owl, 89, *89*; parrot, 60, *60*, 76, *76*; rainbird, 84, *84*, 86, 87; roadrunner/Zia bird, 80, *80*, 81, *81*; Thunderbird, 137

black-on-black pottery (San Ildefonso), 94, *94*

blanket, button (Haida), 19–20, 156, *156*

blanket, saddle (Diné [Navajo]), 16, *17*

blanket (Chilkat dancing blanket) (Tlingit), 19, 157, *157*

blanket (sarape) (Diné [Navajo]), 99, *99*, 100, *100*

Bodfish, Hartson Harison, 171

Bosque Redondo Reservation (New Mexico), 98, 99

bowl: Anasazi, 60, *60*, 62, *62–63*; Cochiti, 20, *21*; Hohokam, 54, *54*; Hopi-Tewa, attributed to, 71, *71*; Mimbres, 55, *55*, 57, *57*; Mogollon, 59, *59*; San Ildefonso, 94, *94*; unknown culture, 61, *61*; Western Band Cherokee, 112, *112*

bowl, corn or prayer-meal (A:shiwi [Zuni]), 88, *88*

bowl, pipe (Northeastern Woodlands), 128

bracelet: Diné (Navajo), 104–5, *105*; Santo Domingo, 96, *97*

Bradley, David, 32; *Greasy Grass Premonition #2*, 37, *37*

Brewer, Caroline A. *See* Croft, Mrs. Arthur (Brewer)

Brewer, Mrs. Gardner, 13, 14

burial and memorial objects: bowl with kill hole (Mimbres), 55, *55*, 57, *57*; Chilkat dancing blanket (Tlingit), 19, 157, *157*; totem pole memorial, 163

Burning Airplanes (Romero), 43, *43*

button blanket (Haida), 19–20, 156, *156*

Calling on the Ladies a Courting Scene (Haungooah [Silver Horn]), 148, *149*

canteen (Cochiti/Hopi/Diné [Navajo]), 31, *31*

Carpenter, Louise C., 19

carrying basket or coiled pack basket (Lataxat [Klikitat]), 147, *147*

carving, three-dimensional (Northwest Coast), 168, *168*

carving (scrimshaw), 171, *171*

castellated-rim pottery, 128, *128*

Cata, Myrtle: water jar, 95, *95*

Cates (potters), 83

Cauhilla, 107, *107*

ceremonies and rituals, 53, 61, *61*, 67, 168, 172; courting, 143, *143*, 148, *149*; funeral/burial, 55, *55*, 156, 162; healing, 114, *114*, 166, *166* (*see also* shaman); nuptial, 92, *92*; peyote, 145, *145*; potlatch, 153, 156, *156*, 157, *157*, 161, *161*, 167, *167*, 168, *168*; social, 164, *164*; Sun Dance, 133

chair. *See* quillwork panels, side chair with checkerboard (motif), 61, *61*, 120, *121*

Cherokee, 112, *112*, 123, *123*

Cheromiah, Evelyn (Sru tsi rai): water jar, 78, *78*, *79*

chest, probably Tsimshian, 19, 160, *160*

Chester, Ernie, 163

Cheyenne, 15, 37

chief's and high-status objects, 137, 138, 156, *156*, 157, *157*, 160, *160*, 161, *161*, 163, 164, *164*

Chilkat dancing blanket (Tlingit), 19, 157, *157*

Chinle revival-style rug (Diné [Navajo]), 101, *101*

Chino, Marie Z., 77

Chino, Velma (Tsninahzite): jar, 77, *77*

Chippewa. *See* Ojibwa (Chippewa)

Chitimacha, 112

cigar case (Wendat [Huron]), 126, *126*

"Circles of the World" exhibition (Denver Art Museum), 18

clan crest symbols, 154, 156, *156*, 157, 158, 163

clan lineage, 128

clapper (Tlingit), 166, *166*

Cliff Palace, Mesa Verde National Park, Colorado (Adams), 52, *53*

clothing. *See specific type*

Cochiti, 20, *21*, *30*, 31, 36, *36*, 43, *43*; canteen (Cochiti and Hopi/Diné [Navajo]), 31, *31*; storage jar (Cochiti or Santo Domingo), 82, *82*

Cochiti Redskins (Mateo Romero), 36, *36*

coiled pack basket or carrying basket (Lataxat [Klikitat]), 147, *147*

coiling method, pottery: ancient method, 47, 52, 54

Collecting American Decorative Arts and Sculpture (Fairbanks), 22n5

College Art Association, 22n3

concha belt (Diné [Navajo]), *68*, 69

concha (ornament), 104, *104*

container: Alaska or Canada, *154*, 155; Penobscot or Passamaquoddy, 112, *112. See also specific usage type*

container, storage (Tohono O'odham [Papago]), 106, *106*

coups, 137, 138

corn or prayer-meal bowl (A:shiwi [Zuni]), 88, *88*

courting flute. *See* duct flute (possibly Lakota [Sioux])

courting ritual, 143, *143*, 148, *149*

Cowboy Indian (Scholder), 38, *38*

cribbage board (Inupiaq [Alaskan Inupiat Eskimo]), 171, *171*

Croft, Mrs. Arthur (Brewer), 13

Crow. *See* Apsáalooke (Crow)

Curtis, Edward S.: *At the Old Well of Acoma*, 74, *74*

Cushing, Frank Hamilton, 85

Custer, George A., 15, 37, *37*

Dallin, Cyrus, 17

dance ceremony: healing, 114; San Felipe Corn Dance, 95

dance headdress. *See* roach (Northern Plains)

dancing blanket, Chilkat (Tlingit), 19, 157, *157*

David, Joe (with Loren White): *Took-beek*, 163, *163*

Death of Hector canteen (Romero/Begaye), 31, *31*

Delaware. *See* Lenape (Delaware)

Delgarito, Jereme: bracelet, 104–5, *105*

Densmore, Frances, 166

Denver Art Museum, 18

Desperate Encounter between Ute and Ki a wa. Ute Killed (Haungooah [Silver Horn]), 19, *20*

Diehlstaat, Missouri, archeological excavation at, *13*, 13–14

Diné (Navajo), 89, 98, 99; artwork, 39, *39*; clothing and textile, 16, *17*, 69, 98–101, *98–101*; horse equipment, 16, *17*, 102, 104, *104*; jewelry, 102, *103*, 104–5, *105*; pottery, 45, *45*; settlements, 67, 68–69, 98; silversmithing, *68*, 69, 96, 102–4, *102–5. See also* Diné (Navajo)/Taos; Hopi/Diné (Navajo)

Diné (Navajo)/Taos: storage jar, 46, *46*

Divination (Smith), 144, *144*

dress, girl's: Lakota (Sioux), 139, *139*

dress, woman's: panel from (Diné [Navajo]), 98, *98*

dress yokes, beaded (Lakota [Sioux]), 139, *139*

drill-bow handle (Inupiaq [Alaskan Inupiat Eskimo]), 170, *170*

drum, hand (Siksika [Blackfoot] or Apsáalooke [Crow], probably), 144, *144*

drum, water, 145

duct flute (possibly Lakota [Sioux]), 143, *143*

dye jar (A:shiwi [Zuni]), 84, *84*

dyes, 84, 86; aniline, 123, *123*, 159; and fading, 157; laundry bluing, 122, *122*; mineral, 116; Mohegan pink, 122, *122*; vegetal, 101, 125, *125*, 159, *159*, 164, *164*

eagle imagery, 70, *70*

Eastern Woodlands, 116, *117*

effigy: Mississippian Tradition, *13*, 13–14

effigy, avian (Mogollon), 56, *56*

effigy, owl (A:shiwi [Zuni]), 89, *89*

effigy pitcher (Santo Domingo), 15, *15*

effigy pot (Onondaga/Seneca), 128, *128*, *129*

embroidery (Wendat [Huron]), 126, *126*, 127, *127*

Emmons, George T., 169

envelope, parfleche (Lakota [Sioux]), 135, 146, *146*

envelope case (Wendat [Huron]), 127, *127*

ermine (material), 138, *138*

Everything You Know about Indians Is Wrong (Paul Chaat Smith), 32

exhibitions, Native American art, 18, 19, *19*, 22n3–6

"Exposition of Indian Tribal Arts" (traveling exhibition, 1932), 22n3

Fairbanks, Jonathan L., 18, 22n5

False Face Society, 114

"Far North, The" exhibition (Museum of Fine Arts, Boston, 1973–74), 18

Faxon, Dr. H. L., 16

feathers: adornment of musical instruments with, 114, 144, 145; as sign of status, 137, *137*

fertility motifs, 53, 61, *61*, 88, *88*

fetish figure, 68, 86

fiddle (White Mountain Apache), 105, *105*

fine-line painting (pottery), 77, *77*

Flathead. *See* Salish (Flathead)

flower motifs, 78, *78*, 120, *121*, 127, *127*; peyote blossom, 145; squash-blossom, 102, *103*

flute, duct (Lakota [Sioux], possibly), 143, *143*

formline, 154, 160, *160*, 165, *165*, 168, *168*

Foss Nichols, Linda, 19, 56

Four Directions imagery, 59, *59*, 128, *128*

Fourmile Polychrome pottery style, 62, *62*

Four-Mile Ruin (Arizona), 62

Freeland, Aaron Leonard, 30; *My Mother's Uncle When He Was Young*, 39, *39*

"Frontier America" exhibition (Museum of Fine Arts, Boston, 1975), 22n4

funeral/burial ceremonies, 55, *55*, 156, 162

furniture: chest (Tsimshian, probably), 19, 160, *160*; side chair with quillwork panels (Mi'kmaq [Micmac]), 125, *125*

Galpin, Francis W., 16

game: cribbage board (Inupiaq [Alaskan Inupiat Eskimo]), 171, *171*

Garcia, Jesse, 77

gathering basket (Karuk [Karok]), 69, *69*

George Washington Wales, Mr. and Mrs., 14

glass sculpture: *Raven Steals the Moon* (Singletary), 20, 41, *41*

Gookin, Daniel, 122

gourd rattle (Arapaho, possibly), 145, *145*

Greasy Grass Premonition #2 (Bradley), 37, *37*

Greenland Eskimo. See Kalaalit (Greenland Eskimo)

grinding stone and hand stone (northern Arizona, probably), 52, *52*

guard, warrior (tile motif) (Hopi), 73, *73*

guard, wrist or bow (*ketoh*) (Diné [Navajo]), 102, *102*

Haida, 19–20, 154, *154*, 156, *156*, 162, *162*, 167, *167*; rattle, probably by, 164, *164*

Haungooah (Silver Horn), 19, *20*, 135, 148, *149*; *Calling on the Ladies a Courting Scene*, 148, *149*; *Desperate Encounter between Ute and Ki a wa. Ute Killed*, 20; *Once Famous Black Eagle (Ko-et-te-Kone-Ke) of the Ki a Was in Deadly Conflict with Ute Chief—Ute Killed, The*, 148, *149*

headdress, 134; roach (Northern Plains), 136, *136*; warbonnet (Jicarilla Apache, probably), 137, *137*

healing objects: clapper (Tlingit), 166, *166*; rattle (Seneca), 114, *114*

heart-line (motif), 85, *85*

Hemenway, Mary, 15

Hensick, Teri, 21

Heritage of Klickitat Basketry, The (Thomas/Kuneki/Slockish), 147

Hilsinger, Arthur R., 21

Historical Collections of the Indians in New England (Gookin), 122

Ho-bo-bo (Keeper of Wind), 61

Ho-Chunk (Winnebago), 47, *47*

Hohokam, 51, 52, 54, *54*, 56, 96, 106

Holm, Bill, 154

Hopi, 47, 62, 73, *73*, 85, 100; rattle, probably by, 72, *72*

Hopi/Diné (Navajo), 42, *42*; canteen (Cochiti and Hopi/Diné [Navajo]), 31, *31*

Hopi-Tewa, 70, *70*, 71, *71*

horse equipment: headstall (Diné [Navajo]), 102, 104, *104*; martingale (Apsáalooke [Crow]), 142, *142*; parfleche envelope (Lakota [Sioux]), 146, *146*; saddle blanket (Diné/Navajo), 16, *17*

house post (Northwest Coast), 163

Houser, Allan Houser, 29–30

Hudson Bay Company, 116, 135, *135*, 156

Hudson Bay Trading Post on Flathead Indian Reservation (Tofft), 135, *135*

Hurd, Nathaniel, 118

Hurlimann, Johann, after Karl Bodmer: *Mato-Tope (Indian in War Dress)*, 134, *134*

Huron. *See* Wendat (Huron)

Indian Arts and Crafts Act of 1990, 32, 37

Indian Market (Santa Fe), 32, 44, 81

Indian Removal Act (1830), 111

Indians Near Fort Laramie (Bierstadt), 133, *133*

Indian Wars, 15

Innu. *See* southern Innu (Montagnais)

Institute of American Indian Arts (IAIA) (Santa Fe), 29–30, 39, 42, 45, 47, 83, 96, 128

Inuit, 154, 155, *155*

Inupiaq (Alaskan Inupiat Eskimo), 154, 170, *170*, 171, *171*

Iroquois Confederacy, 111, 114, 128

ivory carving (Inupiaq [Alaskan Inupiat Eskimo]), 170, *170*, 171, *171*

Janson, Barbara J., 21

jar: Acoma, 55, *55*, 77, *77*; Apache, 69, *69*; Diné (Navajo), 46, *46*; Hopi, 19, *19*; Santa Clara, 90, *90*, *91*; Western Apache, 69, *69*; Zia, 80, *80*

jar, melon (Santa Clara), 93, *93*

jar, seed (Hopi-Tewa), 70, *70*

jar, storage: Acoma, 76, *76*; Cochiti or Santo Domingo, 82, *82*; Diné (Navajo)/Taos, 46, *46*; Santo Domingo, 82, *82*

jar, water: Acoma, 74, *75*, 76, *76*; A:shiwi (Zuni), 84, *84*, 85, *85*, 86, 87; Laguna, 78, *78*, *79*; Mogollon, 58, *58*; Nambe, 95, *95*; San Felipe/San Juan, 95, *95*; Santa Clara, 44, *44*, 90, *91*; Santo Domingo, 83, *83*; Zia, 81, *81*

jar, wedding (Santa Clara), 92, *92*

jewelry, 68. *See also* bracelet; necklace

Jicarilla Apache: warbonnet, probably by, 137, *137*

Jones, Peter B.: effigy pot, 128, *128*, *129*

kachina, described, 53, 67

kachina (tile motif) (Hopi), 73, *73*

Kalaallitt (Greenland Eskimo), 172, *173*

Kalestewa, Quanita, 89

Karuk (Karok), 69, *69*

Keam, Thomas Varker, 73

ketoh (wrist or bow guard) (Diné [Navajo]), 102, *102*

Kiapkwa Polychrome pottery style (A:shiwi [Zuni]), 84, *84*

kill hole, bowl with (Mimbres), 55, *55*, 57, *57*

Kiowa Apache, 19, *20*, 148, *149*

Kiua Polychrome pottery style, 82, *82*

kiva, 67, 88

Klee, Paul, 34

Klikitat. *See* Lataxat (Klikitat)

knife case (Apsáalooke [Crow]), 140, *140*

Kramer, Barbara, 70

Krebs, James and Margie, 20

Kwakwaka'wakw (Kwakiutl), 19, 161, *161*; rattle, possibly by, 168, *168*

ladle (Haida), 154, *154*

Laguna, 78, *78*, *79*, 85

Lakota (Sioux), 15, 37, 40; *Appeal to the Great Spirit* sculpture (Dallin), 17; clothing, 138, *138*, *139*, 141, *141*; duct flute, possibly by, 143, *143*; parfleche envelope, 146, *146*

Lataxat (Klikitat), 21, 147, *147*

laundry bluing (dye), 122, *122*

ledger-book art, 19, *20*, 37, 135, 148, *149*

ledger books, 37

Lenape (Delaware): powder horn and shot pouch, possibly by, 20, 118, *118*

Lewis, Carmel: jar, 55, *55*

Lewis, Lucy, 70, 77

Linder, Mrs. George, 16

Lindsey, William, 16

Little, Nina Fletcher, 119

Loloma, Otellie, 47, 128

Loring, Charles Greely, 15, 89

Lowell, Guy, 17

Luiseño, 38, *38*

macaw (bird) motif, 60, *60*

Malenka, Ruth and Bert, and sons, 20

Maliseet, 112

man's ceremonial shirt (Tahltan), 158, *158*

Martinez, Julian (Po'kanu, or Animal Kingdom), 128; bowl, 94, *94*

Martinez, Maria Montoya (Poveka, or Water Pond Lily), 70; bowl, 94, *94*

martingale (Apsáalooke [Crow]), 142, *142*

mask, 67, 155; Kalaallitt (Greenland Eskimo), 172, *173*

Mato-Tope (Indian in War Dress) (Hurlimann), 134, *134*

McHorse, Christine Nofchissey, 46; vessel, 45, *45*

McHorse, Joel C.: storage jar, 45, 46, *46*

Meacham, George F., 16

medicine and healing objects. *See* healing objects

Medina, Trinidad, 81

melon jar (Santa Clara), 93, *93*

Mesa Verde National Park (Colorado), 52, *53*

Mètis, 35, *35*, 112, 116, *117*

micaceous clay (pottery medium), 44–46, *44–46*, 95, *95*

Mi'kmaq (Micmac), 112, *112*, 125, *125*

Mimbres, 43, 51, 55, *55*, 57, *57*

Mission, 107

Mississippian Tradition, *13*, 13–14, 112

Mitchell, Anna Belle Sixkiller: bowl, 112, *112*

moccasins, 112; Wendat (Huron), probably, 115, *115*

moccasin vessel (Zuni), 15, *15*

model totem pole (Haida), 162, *162*

Mogollon, 51, 54, 56, *56*, 58–59, *58–59*

Mohawk, 128, *128*

Mohegan-Pequot: basket, probably by, 122, *122*

Mohegan pink (dye), 122, *122*

Mok a sushi bowl (Diego Romero), 20, *21*

Monk's Mound (Cahokia, Missouri), 14

monotype, art, 39, *39*

Montagnais. *See* southern Innu (Montagnais)

Moqui (or Moki) blanket (Diné [Navajo]), 100, *100*

Morro #27, El (Smith, Jaune Quick-to-See), 34, *34*

Morro #34, El (Smith, Jaune Quick-to-See), 34, *34*

mortar and pestle (northern Arizona, probably), 52, *52*

mosaic bracelet (Santo Domingo), 96, *97*

motifs and imagery: arrow, 85, *85*, 116, *117*; fertility, 53, 61, *61*, 88, *88*; flower, 78, *78*, 102, *103*, 120, *121*, 127, *127*, 145; glyphs, 45, *45*; human-image, 128, *128*; prehistoric, 52–53, 77. *See also* animal and fish motifs; bird imagery; rain and natural forces (motifs); patterns and forms (motifs); mythology and spirituality, Native American

Mound Builders' culture, 13

Museum of Fine Arts, Boston: *Appeal to the Great Spirit* (Dallin) (entrance sculpture), 17; Art of the Americas Wing, 22; at Copley Square, 14, 15, 17; curatorial departments, 18, 22n5, 24; Decorative Arts Wing, 17–18; Elizabeth Day McCormick Collection, 17; exhibitions, 18, 19, 22nn3–6; Hilsinger Janson Fund for Native American Art, 21; Huntington Avenue, move to, 17; Leslie Lindsey Mason Collection, 16; Linde Family Wing for Contemporary Art, 22; Nagoya/Boston Museum of Fine Arts,

19, 22n6; Native American art collecting strategy, 13–22; Web site, 24

Museum of New Mexico, 94

Museum of Northern Arizona, 71

musical instruments: duct flute (Lakota [Sioux], possibly), 143, *143*; fiddle (White Mountain Apache), 105, *105*; hand drum (Siksika [Blackfoot] or Apsáalooke [Crow], probably), 144, *144*; reed pipe (Haida), 167, *167*. *See also* rattle

My Mother's Uncle When He Was Young (Freeland), 39, *39*

mythology and spirituality, Native American, 55, 57, 114; anhinga (sacred bird), 145, *145*; Avanyu (rain-bringing serpent), 90, *91*, 94, *94*; creation story, 54, *54*, 56, *56*, 89, *89*; Four Directions, 59, *59*, 72, *72*, 128, *128*; GonAqAdë't (mythical hero), 160, *160*; heart-line, 85, *85*; Ho-bo-bo (Keeper of Wind), 61; kachina, 53, 67, 73, *73*; Raven, 41, *41*, 163, 164, *164*; sacred breath of life, 85, *85*; Thunderbird, 137, *137*; White Buffalo Woman, 40, *40*

Nagoya/Boston Museum of Fine Arts, 19, 22n6

Naha, Helen T.: jar, 19, *19*

Nambe, 95, *95*

Nampeyo, Dextra Quotskuyva, 70

Nampeyo (Sand Snake): seed jar, 70, *70*

Naranjo pottery, 44

Natchez, Stan: *White Buffalo—We the People*, 40, *40*

National Gallery of Art (Washington, D.C.), 18

National Museum of the American Indian (Washington, D.C.), 24

Native American Church, 145

Native Americans: battles (*see* battles and wars, Native American); cross-cultural influences, 25, 111–12, 154, 158; forced relocation of, 98, 111, 123, 135, 137, 139, 141; Indian Arts and Crafts Act of 1990, 32, 37; languages, 68; map of tribal regions, *175*; North American migration theory, 51; prehistoric culture, 51–53; trading posts, 101, 135, *135*; "Wild West" shows, 141. *See also* mythology and spirituality, Native American

Native American (term), 24, 31, 36

Navajo Nation, 69

necklace: Santo Domingo, 96, *97*; squash-blossom (Diné [Navajo]), 102, *103*

"New England Begins" exhibition (Museum of Fine Arts, Boston, 1982), 22n4

Nipmuc, 124, *124*

Niuam (Comanche), 143

Nootka. *See* Nuu-Chah-Nulth (Nootka)

Northern Plains, 136, *136*

Nuu-Chah-Nulth (Nootka), 163, *163*

Ojibwa (Chippewa), 37, *37*

Once Famous Black Eagle (Ko-et-te-Kone-Ke) of the Ki a Was in Deadly Conflict with Ute Chief—Ute Killed, The (Haungooah [Silver Horn]), 148, *149*

Onondaga/Seneca, 128, *128*, *129*

Owen, Angelita (Angie) Reano: bracelet, 96, *97*

owl effigy (A:shiwi [Zuni]), 89, *89*

Paiute. *See* Shoshone/Paiute

panel, quillwork (side chair): Mi'kmaq (Micmac), 125, *125*

panel from woman's dress (Diné [Navajo]), 98, *98*

Papago. *See* Tohono O'odham (Papago)

parfleche container, 135, 140; envelope (Lakota [Sioux]), 146, *146*

Parr, Nuna: walrus sculpture, 155, *155*

Passamaquoddy, 112; container (Penobscot or Passamaquoddy), 112, *112*; container (Wolastoqiyik [Maliseet] or Passamaquoddy, probably), 119, *119*

pastel (artistic medium), 34

patterns and forms (motifs): checkerboard, 61, *61*, 120, *121*; Complicated Stamp, 112, *112*; cross-hatch, 78, *78*, 84; curvilinear, 105, *105*, 154; dots, 144, *144*; formline, 154, 160, *160*, 165, *165*, 168, *168*; fretwork, 58, *58*, 61, *61*; geometric, 55, *55*, 105, *105*, 125, *125*, 146, *146*; line, 144, *144* (*see also* formline; heart-line); naja (crescent form), 102, *103*, 104; sky band, 71, *71*; spirals, 61, *61*; triangle, 61, *61*, 78, *78*, 140, *140*, 142, *142*, 144, *144*; weaving, 59, *59*; zigzag, 55, *55*, 58, *58*, 82, *82*

Peabody Essex Museum (Salem, Massachusetts), 16

Peabody Museum (Harvard University), 16

Penobscot, 112, 116

Penobscot or Passamaquoddy: container, 112, *112*

petroglyphs, 34, 45

peyote rattle. *See* gourd rattle (Arapaho, possibly)

Phillips, Tim, 20

piñon pine pitch, resinous (pottery coating), 45

pipe, funeral, 162
pipe, reed (Haida), 167, *167*
pipe bowl (Northeastern Woodlands), 128
pitcher, effigy (Santo Domingo), 15, *15*
Pop Art, as contemporary art influence, 31, 37, 38
potlatch ceremony, 153, 156, *156*, 157, *157*, 161, *161*, 167, *167*, 168, *168*
potlatch figure (Kwakwaka'wakw [Kwakiutl]), 19, 161, *161*
pottery, castellated-rim, 128, *128*
pottery, corrugated, 46, 47, *47*
pottery, fine-line, 77, *77*
pottery binding, rawhide (Santo Domingo), 82, *82*
pottery coating: resinous piñon pine pitch, 45. *See also* pottery glaze; pottery slip paint
pottery-firing process: ancient method, 52; for coloration, 93, *93*, 94; smoke or fire clouds, in, 45, *45*, 46, *46*; for tiles, 73
pottery glaze, 62, *62*; black-on-black (San Ildefonso), 94, *94*; black or red (Santa Clara), 90, *91*; black ware pottery (Santa Clara), 93
pottery-making process: hand-coiling, 47, 52, 54
pottery medium: micaceous clay, 44–46, *44–46*, 95, *95*; tempered with basalt, 80
pottery paint brush, yucca, 77
pottery polishing methods, 94; stone polishing, 93, *93*, 95, *95*, 128
pottery slip paint style, 47; Aguilar, 83, *83*; black-and-cream (Santo Domingo), 82, *82*; fine-line painting, 77, *77*; Fourmile Polychrome, 62, *62*; Kiapkwa Polychrome, 84, *84*; Kiua Polychrome, 82, *82*; prehistoric culture, 52, 60, *60*; Sikyatki Polychrome, 70; Sikyatki revival, 70, *70*
powder horn and shot pouch (Lenape [Delaware], possibly), 20, 118, *118*
prayer-meal bowl. *See* corn or prayer-meal bowl (A:shiwi [Zuni])
prehistoric pottery making, 52–53
Probert, Herbert, 16, 22n2, 136
pueblo, described, *67*, 67–68
Pueblo Revolt of 1680, 78, 80
pueblos. *See individual pueblos:* Acoma, Cochiti, Hopi, Laguna, Nambe, San Ildefonso, San Juan, Santa Clara, Santo Domingo, Zia, Zuni
Pullen, Clarence, 15

quillwork basket: Mi'kmaq (Micmac), 112, *112*; southern Innu (Montagnais), possibly, 120, *121*

quillwork mocassins (Wendat [Huron], probably), 115, *115*
quillwork panels, side chair with (Mi'kmaq [Micmac]), 125, *125*

rain and natural forces (motifs), 105, *105*; Avanyu (rain-bringing serpent), 90, *91*, 94, *94*; clouds, 88, *88*, 105, *105*, 122, *122*, 139, *139*; hail, 144, *144*; lightning, 55, *55*; rain, 53, 55, *55*, 58, *58*, 61, *61*, 68, 76, *76*, 78, *78*, 80, *80*, 84, *84*, 86, *87*, 90, *91*, 137; rainbird, 84, *84*, 86, *87*; rainbow arc, 80, *80*
rattle: Hopi, probably, 72, *72*; Kwakwaka'wakw (Kwakiutl), possibly, 168, *168*; Seneca, 114, *114*; Tlingit, 169, *169*; Tsimshian, 165, *165*
rattle, gourd (Arapaho, possibly), 145, *145*
rattle, raven (Haida, probably), 164, *164*
raven rattle (Haida, probably), 164, *164*
Raven Steals the Moon (Singletary), 20, 41, *41*
rawhide binding, on pottery (Santo Domingo), 82, *82*
Ray, Dorothy Jean, 170
reed pipe (Haida), 167, *167*
religion. *See* mythology and spirituality, Native American
rituals. *See* ceremonies and rituals
Rivet, Rick: *String Game—2 (Kayaker)*, 35, *35*
roach (Northern Plains), 136, *136*
Robbins, Caira, 115
robe. *See* button blanket (Haida)
Roller, Toni (Ka-Tsawe, or Green Leaves): jar, 90, *90*, *91*
Romero, Diego, 42; *Burning Airplanes*, 43, *43*; *Death of Hector* canteen (Romero/Begaye), 31, *31*; *Mok a sushi* bowl, 20, *21*
Romero, Edna: water jar, 44, *44*
Romero, Mateo, 43; *Cochiti Redskins*, 36, *36*; *Scalp Chief/Prayer/Vietnam*, *30*, 31
Ross, Denman Waldo, 16
rug, Chinle revival-style (Diné [Navajo]), 101, *101*

saddle bag. *See* parfleche envelope (Lakota [Sioux])
saddle blanket, Diné (Navajo), 16, *17*
Salish (Flathead), 34, *34*, 135, *135*
Salvador, Maria Lilly: water jar, 76, *76*
San Felipe/San Juan, 95, *95*
San Ildefonso, 82, 94, *94*, 128
San Juan. *See* San Felipe/San Juan
Santa Clara, 44, *44*, 82, 90–93, *90–93*

Santa Fe Indian School. *See* Institute of American Indian Arts (IAIA) (Santa Fe)
Santo Domingo, 15, *15*, 82, *82*, 83, *83*, 96, 97; storage jar (Cochiti or Santo Domingo), 82, *82*
sarape (Diné [Navajo]), 99, *99*, 100, *100*
sash: *ceinture fléchée* (Mètis), 112, 116, *117*; Eastern Woodlands, 112, 116, *117*; Wendat (Huron), possibly, 112, 116, *117*
Scalp Chief/Prayer/Vietnam (Mateo Romero), *30*, 31
Scholder, Fritz, 31; *Cowboy Indian*, 38, *38*
School of American Research (Santa Fe), 83
scrimshaw, 171, *171*
seed jar (Hopi-Tewa), 70, *70*
Seneca, 114, *114*. *See also* Onondaga/Seneca
Serpent Mound (Ohio), 14, *14*
shaman, 35, 153, 164
shamanistic objects, 155, 165, *165*, 172, *173*
shaman's rattle. *See* rattle (Tsimshian)
Shije, Eusebia Toribio (Kirani'): water jar, 81, *81*
Shoshone/Paiute: *White Buffalo—We the People* (Natchez), 40, *40*
shot pouch and powder horn (Lenape [Delaware], possibly), 20, 118, *118*
Shupla, Helen (Kahtséh, or Yellow Leaf): melon jar (two works), 93, *93*
side chair, with Mi'kmaq (Micmac) quillwork panels, 125, *125*
Siksika (Blackfoot): hand drum (Siksika [Blackfoot] or Apsáalooke [Crow], probably), 144, *144*
Sikyatki Polychrome pottery style, 70
Sikyatki revival pottery style (Hopi-Tewa), 70, *70*
silversmithing, 24, 104; Diné (Navajo), 68, 69, 96, 102–4, *102–5*; Santo Domingo, 96
Singletary, Preston, 31–32; *Raven Steals the Moon*, 41, *41*
Sioux. *See* Lakota (Sioux)
Sitting Bull, 37
Skinner, Captain Carlton, 172
Skinner, Solange, 20
Smith, De Cost: *Divination*, 144, *144*
Smith, Jaune Quick-to-See: *El Morro #27*, 34, *34*; *El Morro #34*, 34, *34*
Smith, Paul Chaat, 32
Smithsonian Institution, 88; National Museum of the American Indian, 24
snapping turtle rattle (Seneca), 114, *114*
southern Innu (Montagnais): baskets, set of twelve, possibly by, 120, *121*
spirituality, Native American. *See* mythology and spirituality, Native American
Spooner, Sarah M., 16

Squash Maiden (Begaye), 42, *42*
status, signs of, 137, 138, 156, 157, 161
Stephen, Alexander, 61, 73
Stevens, Jacquie, 128; vessel, 47, *47*
Stevenson, James, 88
storage container (Tohono O'odham [Papago]), 106, *106*
storage jar: Acoma, 76, *76*; Cochiti or Santo Domingo, 82, *82*; Diné (Navajo)/Taos, 46, *46*; Santo Domingo, 82, *82*
storage jar, with rawhide binding (Santo Domingo), 82, *82*
String Game—2 (Kayaker) (Rivet), 35, *35*

Tafoya, Alcario: water jar, 90, *91*
Tafoya, Margaret (Kohn Powi, or Corn Blossom): water jar, 90, *91*
Tafoya, SaraFina Gutierrez (Ka-saweh, or Autumn Leaf): water jar, 90, *91*; wedding jar, attributed to, 92, *92*
Tahltan, 158, *158*, 169
Taos, 44, 45, 46. See also Diné (Navajo)/Taos
Taos Pueblo, New Mexico (Adams), 67, *67*
Tarbell-Boehning, Tammy: vessel, 128, *128*
Tenorio, Robert: water jar, 83, *83*
Tewanginema (Hopi-Tewa), attributed to: bowl, 71, *71*
textile. See specific type
textile materials, and cross-cultural exchange, 99, 112
textile technique (finger weaving), 116, *117*
Thorndike, Mrs. John H., 16, 162
Thunderbird (mythical creature), 137, *137*
tiger cowrie (material), 96, *97*
tile (Hopi), 73, *73*
Tlingit, 19, *157*, 157–59, *159*, 166, *166*, 169, *169*
Tofft, Peter Peterson: *Hudson Bay Trading Post on Flathead Indian Reservation*, 135, *135*
Tohono O'odham (Papago), 21, 106, *106*
Took-beek (David/White), 163, *163*
tools: D-adze, 161; drill-bow handle (Inupiaq [Alaskan Inupiat Eskimo]), 170, *170*; grinding stone and hand stone (northern Arizona, probably), 52, *52*; knife case (Apsáalooke [Crow]), 140, *140*; ladle (Haida), 154, *154*; mortar and pestle (northern Arizona, probably), 52, *52*

Torivio, Frances (Sra-ma-tyai, or Singing Child): storage jar, 76, *76*
totem pole, 41, 163; Nuu-Chah-Nulth (Nootka), 163, *163*; *Took-beek* (David/White), 163, *163*
totem pole, model (Haida), 162, *162*
trading posts, Native American, 101, 135, *135*
tray (Cauhilla): attributed to Arenas, 107, *107*
triangle (motif), 61, *61*, 78, *78*, 140, *140*, 142, *142*, 144, *144*
Tsimshian, 165, *165*; chest, probably by, 19, 160, *160*
Tsninahzite, 77, *77*
turquoise (material): A:shiwi (Zuni), 86, 88; Diné (Navajo), 69, 102, 104; Santo Domingo, 68, 82, 96, *97*

U.S. Army, 98, 135, 148; Battle of Little Bighorn, 37, *37*; massacre at Wounded Knee, 15, 30

vase, wedding, attributed to Tafoya (Santa Clara), 92, *92*
vessel: A:shiwi (Zuni), 15, *15*; Diné (Navajo), 45, *45*; Ho-Chunk (Winnebago), 47, *47*; Mohawk, 128, *128*. See also specific usage type
vessel, moccasin-shaped (Zuni), 15, *15*
vest (Lakota [Sioux]), 141, *141*
Vigil, Lonnie: water jar, 95, *95*
"Voice of Mother Earth" exhibition (Nagoya/Boston Museum of Fine Arts), 19, *19*, 22n6

warbonnet (Jicarilla Apache, probably), 137, *137*
war dress: *Mato-Tope (Indian in War Dress)* (Hurlimann), 134, *134*; roach (headdress) (Northern Plains), 136, *136*; tile art (Hopi), 73, *73*; warbonnet (Jicarilla Apache, probably), 137, *137*; warrior's shirt (Lakota [Sioux]), 138, *138*
warrior's shirt (Lakota [Sioux]), 138, *138*
warrior weapons. See weapons
Washington Redskins (football team), lawsuit against, 36
water drum (peyote ceremony), 145

water jar: Acoma, 74, *75*, 76, *76*; A:shiwi (Zuni), 84, *84*, 85, *85*, 86, 87; Laguna, 78, *78*, *79*; Mogollon, 58, *58*; Nambe, 95, *95*; San Felipe/San Juan, 95, *95*; Santa Clara, 44, *44*, 90, *91*; Santo Domingo, 83, *83*; Zia, 81, *81*
water jar (with fingerholds) (Anasazi), 58, *58*
water motifs. See rain and natural forces (motifs)
Waters, Adelaide Ludlam, 99
weapons: *ketoh* (wrist or bow guard) (Diné [Navajo]), 102, *102*; knife case (Apsáalooke [Crow]), 140, *140*; powder horn and shot pouch (Lenape [Delaware], possibly), 20, 118, *118*
weaving. See textile; basketry
wedding jar, attributed to Tafoya (Santa Clara), 92, *92*
Wendat (Huron), 126, *126*, 127, *127*; moccasins, probably by, 115, *115*; sash, possibly by, 112, 116, *117*
Western Apache, 69, *69*
Western Band Cherokee: bowl, 112, *112*
White, Loren (with Joe David): *Took-beek*, 163, *163*
White Buffalo—We the People (Natchez), 40, *40*
White Mountain Apache, 105, *105*
White Mountain Red (pottery slip), 60, *60*
"Wild West" shows, 141
Willard, John Ware, 16
Winnebago. See Ho-Chunk (Winnebago)
Withers, Margret Craver, 18
Wolastoqiyik (Maliseet) or Pasamaquoddy: container, probably by, 119, *119*
Wounded Knee, massacre at, 15, 30

Zia, 80, *80*, 81, *81*
zigzag (motif), 55, *55*, 58, *58*, 82, *82*
Zuni. See A:shiwi (Zuni)
Zuni Trail, 34